S0-AVY-623

WOMEN
AND ART

WOMEN

CONTESTED TERRITORY

AND ART

JUDY CHICAGO AND EDWARD LUCIE-SMITH

RAINCOAST BOOKS

Vancouver

Design copyright © THE IVY PRESS LIMITED 1999
Text copyright © EDWARD LUCIE-SMITH and JUDY CHICAGO 1999

First published in Canada in 1999 by
RAINCOAST BOOKS
8680 Cambie Street, Vancouver B.C. V6P 6M9
(604) 323-7100
www.raincoast.com

The moral right of the authors have been asserted.

All rights reserved. No part of this book may be reproduced
or used in any form or by any means – graphic, electronic,
or mechanical, including photocopying, recording, taping, or
information storage and retrieval systems – without written
permission of the publisher.

Canadian Cataloguing in Publication Data
Chicago, Judy and Lucie-Smith, Edward/Women and Art
1. Women and Art I. Title
N7630.M37 1999 704.9'424 CPP-910195-1

ISBN: 1-55192-239-8

This book was conceived, designed and produced by
THE IVY PRESS LIMITED
2/3 St. Andrews Place
Lewes, East Sussex
BN7 1UP

Editorial Director: Sophie Collins
Art Director: Peter Bridgewater
Managing Editor: Anne Townley
Senior Project Editor: Rowan Davies
Editor: Lindsay McTeague
Designer: Angela Neal
Calligraphy: Trevor Marchant
Picture Researcher: Liz Eddison

This book is set in 10.5/16.5 Bembo
Printed and bound in Singapore by Star Standard

Front cover illustration: Tamara de Lempicka, detail, *Les Deux Amies* (page 175),
© ADAGP, Paris and DACS, London 1999
Frontispiece: Laura Knight, *Self-Portrait* (page 123), © Laura Knight,
reproduced with the kind permission of Curtis Brown Ltd., London,
on behalf of the Estate of Dame Laura Knight
Right: Georg Grosz, *Beauty, I Praise Thee* (page 110), courtesy of the
Museum of Modern Art, New York
Back cover illustration: Marie Bashkirtseff, *Self-Portrait
with Jabot and Palette* (page 118), © Musée des Beaux-Arts, Nice;
photographed by Michel de Lorenzo

CONTENTS

PLEASE NOTE THAT, *throughout the main body of the book, the text has been arranged according to authorship. Commentaries which appear in the side columns on the pages are by Judy Chicago; text which appears in the central column has been written by Edward Lucie-Smith, in collaboration with Judy Chicago.*

Picture locations are stated in the captions unless the piece is in a private collection.
Dimensions are given against the title of the relevant work in the index.

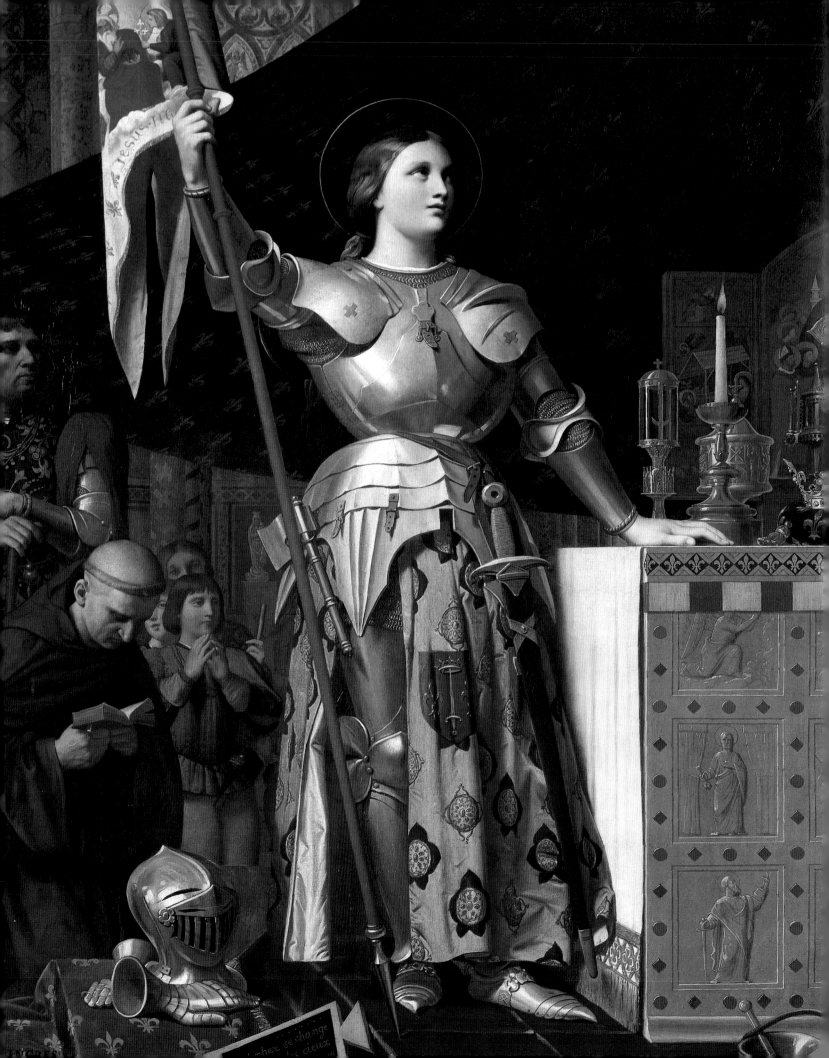

PREFACE

Why a white, male, European critic as one of the joint authors of this book? Nearly all the writing about women in art, as either makers or subjects, has been the work of female critics and art historians, and the majority of these have been American.

I think I can give several reasons for my interest in the theme announced by our title. First, feminist criticism since the 1970s has built up the most coherent and also the most cogent body of new writing about the visual arts. Some of this writing has been distorted by anger. Some of it has been afflicted by jargon. Some strikes me as wrongheaded. Nevertheless, beneath all of it there lies an important body of theory.

One of the most fundamental changes in art writing, since the middle 1970s, is the way in which criticism has increasingly tended to turn away from analysis of the formal qualities of the artwork—composition, color, technical structure—and has returned to a consideration of subject matter. Partly this is due to the way in which artworks themselves have changed. It is difficult, for instance, to provide a formalist analysis of a performance or of an example of environmental art made ad hoc from salvaged materials. The subject and attitudes to the subject lie at the heart of most feminist writing about art, and so too does a consideration of the social and historical context.

One thing which lies at the heart of all this is a renewed interest in moral considerations. Feminism was born from the feeling that one half of the human race was being mistreated and oppressed by the other half, and that something ought to be done about it. It is not new to treat artworks as moral emblems. This is what most art criticism did, from its appearance in the mid-eighteenth century to the end of the Victorian era. Anyone who doubts this assertion should reread both Diderot and Ruskin. But feminism construes morality in sometimes novel ways and in so doing brings to light new and interesting moral dilemmas. It is impossible to resist the temptation to examine these, to see if they have anything new to say about human nature.

However, there have also been some weaknesses in feminist discourse: first a tendency to place women's art in a totally separate sphere; second, the rather defensive insistence that only women themselves have any right to talk about the subject. I must admit I would not have undertaken this book alone. I have been fortunate in having Judy Chicago, the best-known of all feminist artists and a well-established writer, as my collaborator. Our discussions have been extremely wide-ranging, and her input has affected every part of my text. One thing, however, we agreed on from the beginning: that any examination of women's role in art must include what men have done as well as what women have done. Only that way could we highlight differences in attitude, and only that way could we illustrate not only women's achievements but also the difficulties they have faced and still continue to face.

For me this book has been an educational journey. It has demolished some ideas I thought firmly established in my mind, but confirmed others. While I hope many women will read it and draw strength from it, I also hope it will be read by members of my own sex. They might find some things in it they really ought to know.

Edward Lucie-Smith

EDWARD LUCIE-SMITH
October 1998

left: **J. A. D. INGRES**
Joan of Arc (1853); Louvre, Paris

Introduction

I am not an art historian, though after many decades of looking at and making images, it might not be immodest to claim that I know a lot about art. Nor am I an art critic, even though I have looked at art critically for a long time. In fact, even before there was such a term as what the writer and feminist theorist bell hooks describes as an "oppositional gaze," I found myself in opposition to the prevailing values and perspective of art professional practice. This stance might best be described as learning to look against the preconceptions of the dominant culture in order to resist its perspective and its expectations.

As hooks points out in her essay "The Oppositional Gaze: Black Female Spectators" (in *Feminism and Tradition in Aesthetics*, edited by Peggy Zeglin Brand and Carolyn Korsmeyer, 1995), this has been a survival mechanism for many people who find themselves as subordinates in relation to power, as I did as a woman in a man's world.

My own resistance began very early on, when I was a child. From the time I was five, I began the practice of studying art, visiting the Art Institute of Chicago to take classes, and to wander through the galleries where my ambition was shaped. From very early on, I had set my sights upon becoming the

kind of artist who would make a contribution to art history. However, the kind of art on display in the galleries through which I walked was sending a contradictory message.

On the one hand, I felt inspired by the wonderful paintings I saw in the museum and would spend hours studying the millions of colored dots that together form Seurat's *La Grande Jatte* (1884–86), learning a great deal from his use of color opposites. But when I looked at, for example, Degas's sensuous images of women, I could not relate to them or to many other male artists' depictions of the female, primarily because too many of those pictured seemed content to just lie around being gazed at, something I myself had no intention of doing.

One might say that this was when I began to experience "rupture," as it is sometimes described, and to develop the oppositional gaze described by hooks. I set myself against these images because they did not have anything to do with me. Even then, I knew that I did not wish to become the object of the male gaze. Rather, I wanted to be the one who did both the gazing and the painting. Later, I came to understand that some of the confusion I felt as a female child was the consequence

right: **JUDY CHICAGO**

spraying *Double Jeopardy*, from *The Holocaust Project* (1989)

8

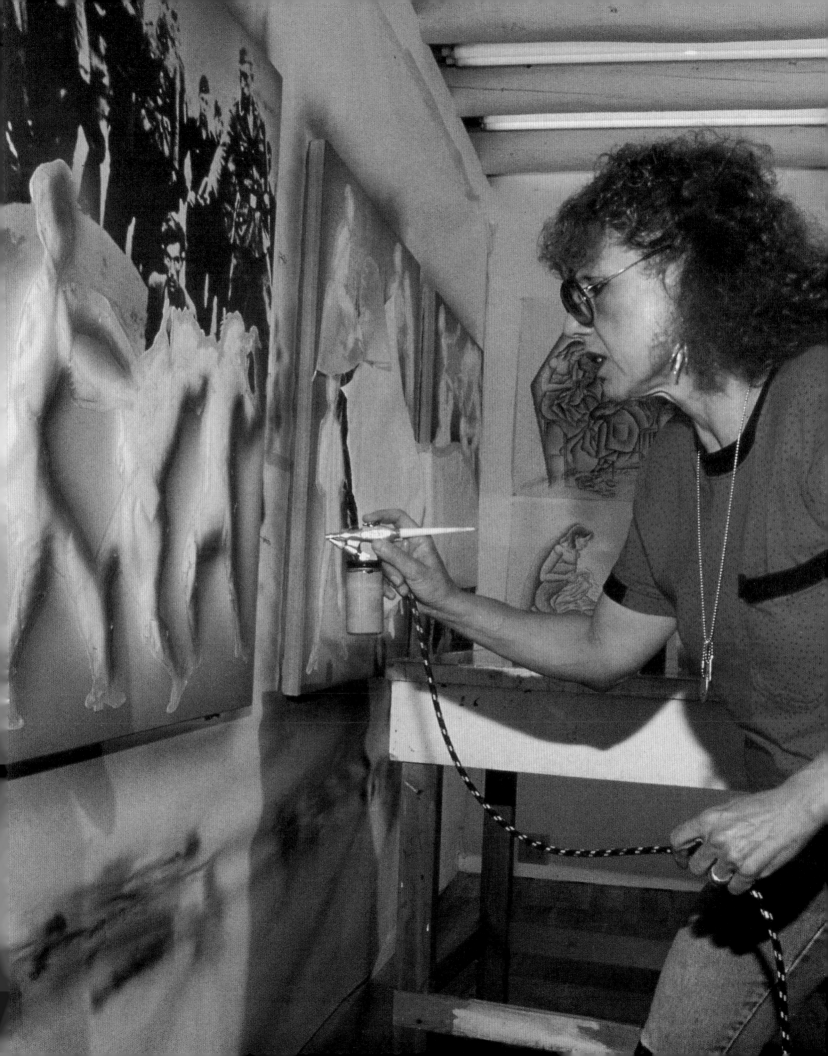

of an art system that privileges male artists, as evidenced by the centuries of discrimination against women artists; the omission of their achievements from the canon of art history; and the fact that even today, only five percent of the art found in American museums consists of work by women artists.

Then there were my experiences as a young woman artist struggling to be taken seriously. With considerable effort, I managed to wedge myself into an art system in which few women were visible, primarily by adopting what might best be described as "male drag," i.e., banishing any indication of my gender from my art and assuming an aggressive stance that was false to my nature as a person.

However, I still found myself feeling opposed to and isolated from the type of art-making that has dominated much of what we have considered great art, a good deal of which seems to privilege form over content and technical innovation over human meaning, or at least meaning that affirms rather than denies my experience and feelings as a female person.

As Gerda Lerner, a pioneer in the field of women's history, states in *Why History Matters* (1997):

> *I believe all hitherto created systems of ideas—religions, philosophies* . . . [and I here add art along with all other] *systems of explanation—were created with unacknowledged patriarchal assumptions and therefore marginalize women.*

She goes on to say that "women have not held power over symbols and thus have been truly marginal to one of the essential processes of civilization." My problem was that I did not wish to be marginalized, nor did I want my experiences as a woman to be considered less central to the human dialogue than those of men. And it is crucial to understand that one of the ways in which the importance of male experience is conveyed is through the art objects that are exhibited and preserved in our museums. Whereas men experience presence in our art institutions, women experience primarily absence, except in images that do not necessarily reflect women's own sense of themselves.

Consequently, since the early 1970s, I have been on a path whose goal has been to bring the female experience into the very mainstream of art history rather than its being—as it is

too often—an "add-on," at the end of the text as it were. When I began down this path, I was quite alone and, it seemed, without any historical context—at least that's what people said to me.

And here I paraphrase a museum curator who, in an effort to explain some of the intense art-world hostility to which my work and even my very person have been subjected, said that there was no context for my art. As a result, he suggested, people in the art community did not know how to deal with my work, particularly because many of the issues it raised made them uncomfortable, which, according to him, was another reason they reacted negatively to it.

However, I had discovered from the research I had done in the late 1960s and throughout the 1970s in relation to my best-known project, *The Dinner Party* (a monumental, multimedia tribute to women's history), that I did indeed have a context. This context extends back in time hundreds of years and consists not only of countless writings by women but also of a large body of art that, to my mind, evidences a different perspective from the art of men, along with a range of responses to the questions with which I was then concerned, questions concerning the nature of female identity. The trouble seemed to be that this context was not visible to most people.

This was the problem I set out to redress with *The Dinner Party*, one of my goals being to provide a tangible symbol of the many achievements and something of the historical context of women in Western civilization. Like most young women of my generation, I had grown up without any knowledge of this information, and, after I discovered it, I dedicated myself to breaking what seems a terrible historical cycle of erasure, a process which results in successive generations of women remaining ignorant of their marvelous heritage as women.

Not that I believed that this information would be valuable only to women, not at all. In fact, I was and am deeply convinced that men and women alike need exposure to a broader range of human experience than that which is transmitted through our educational institutions, if only so that they might be better equipped to embrace the diversity of the world in which we now live. *The Dinner Party* was, in part, intended to call into question the way history has been written, demonstrating that

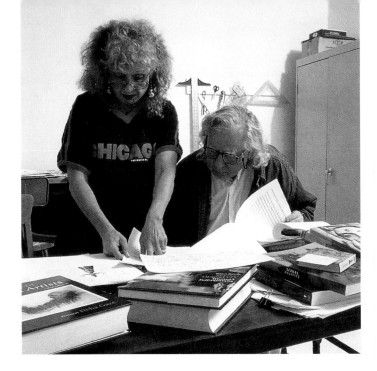

an equally biased and exclusive historical picture could be assembled from any number of viewpoints—in this case, from the perspective of women. The piece might also be considered a corrective to the notion transmitted to me through my own education that women had made no significant contributions to history and—more pernicious in terms of my fierce ambitions as an artist—the idea that there had never been any really great women artists.

During my years of research for *The Dinner Party*, I stumbled upon dozens of images by women artists that made me feel affirmed in a way that the work of their male counterparts never did. These included, for example, the self-portraits I discovered in basements or dark corners of European museums, which, as a happy result of recent feminist scholarship, have begun to emerge from obscurity to take their place in the art historical canon. We have incorporated some of these into this book so that viewers may see some of the differences between male images of women and those painted by women themselves.

As for the widely accepted argument that many of the famous, even iconical, paintings by men constitute great art, I hope that the arguments put forth in the pages of this book might serve to call into question some of the criteria by which greatness has been measured. Certainly, that is one of our intentions. After all, how "great" is yet another image of a nude woman displayed upon a couch, no matter how well it might be painted?

One reason I wanted to confront the issue of what constitutes great art is that I am concerned for the ways in which young women develop their sense of self. Still, despite my matu-

left: **Judy Chicago and Edward Lucie-Smith working on** *Women and Art*, **fall 1998**

rity, when I visit museums filled with work by men, I feel my sense of self challenged to the point that I experience a sense of dissolution—as if I do not exist.

Even when the paintings do not evidence overt hostility toward women or the sense of entitlement with which most male artists approach the female body, I believe that they inevitably produce the same kind of confusion for many young women that I experienced when I was young. And I cannot help but wonder how many of these young women will have the wherewithal to develop and sustain the type of oppositional gaze to which I referred earlier.

Almost three decades ago, I was motivated to make visible my own opposition to an art system which, I had come to realize, disempowers women, in large part through the erasure of our aesthetic heritage. Once I began to encounter the rich history of women's art, it changed my life, partly because much of the work I discovered was—to me—important, sometimes even great art. But, more significantly, the knowledge I acquired about the bravery of the women who had made the work gave me strength to continue in the face of innumerable obstacles.

In addition, women's images and the achievements represented by these images helped me to see myself as *part* of history rather than in opposition to it, even though it was a history which was largely invisible. Thus, one might say that I have lived in opposition to the prevailing system, but in harmony with an alternative system, one which has nurtured my sense of self.

I carried this new-found context within my mind for more than 15 years, and during that time I was engaged in an image-making whose focus was both an alternative female identity and also the assertion of an oppositional set of values. These values were oppositional in the sense that they challenged many prevailing ideas as to what art was to be about (female rather than male experience); how it was to be made (in an empowering, cooperative method rather than a competitive, individualistic mode); and what materials were to be employed in creating it (any that seemed appropriate, irrespective of what socially constructed gender associations particular media might be perceived to have).

By the mid-1980s, I felt that I had realized many of my aesthetic goals, in particular those which involved the creation of images about my discoveries about women's history and my exploration into what it means to be a woman. My primary intention in terms of this body of art was for it to reach others, especially young women, so that they might be strengthened by it to the point that they might not be persuaded by the plethora of images of women that can so threaten a woman's sense of herself that she ends up retreating from her own perspective.

When the British art historian Edward Lucie-Smith (Ted to his friends) first approached me about this book, I was not at all sure that I wanted to retrace my steps back to issues of female identity (or identities as the case may be). I felt that I was finished with this subject, that I had finally answered for myself what had once been a burning question for me, i.e., what does it mean to be a woman, historically, experientially, as well as personally?

In my own work, I had moved on in an effort to broaden my point of view beyond the female experience. I examined, first, the construct of masculinity—in a series entitled *Powerplay* (1982–86)—and then, how the oppression of women intersects with a larger, global system of injustice, exploitation, intolerance, and even genocide—in *The Holocaust Project: From Darkness into Light* (1987–93). Finally, after years of immersion in dark subject matter, I turned my attention to the challenge of formulating images of hope based upon my own world view, which, like a number of my other ideas, finds its reflection in another comment by Gerda Lerner in *Why History Matters*:

below: **JUDY CHICAGO**
Lesbian Triangle, from
The Holocaust Project (1989)

below: **JUDY CHICAGO**
Crippled by the Need to Control (1983)

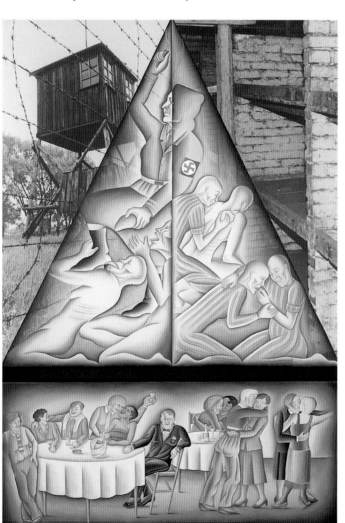

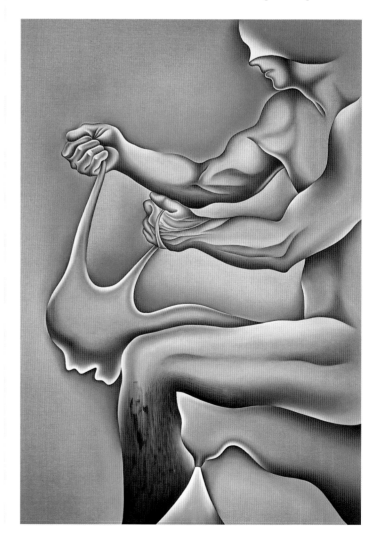

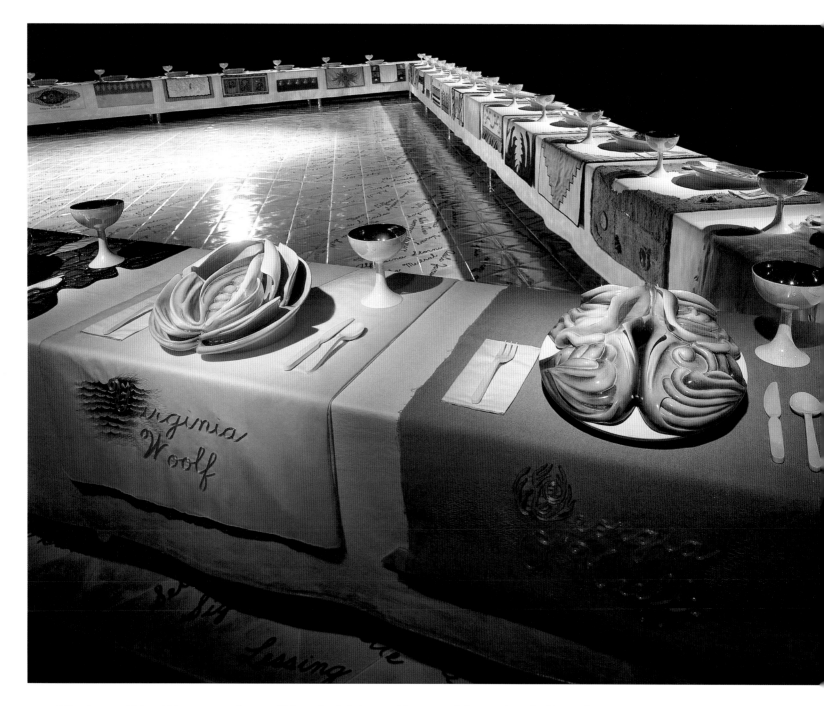

above: **JUDY CHICAGO**
The Dinner Party (1979)

Mine is a world in which women and men will have freed their minds from patriarchal thought and which will therefore be free of dominance and hierarchy, a world that will be truly human.

Translating this world view into accessible images is what occupies me these days. So why did I decide to reengage with issues of female identity, and, if that is its subject, why does this book include images of women by both male and female artists?

Also, one might wonder why I have chosen to work with a man. In terms of the first question, I began this introduction by stating that I am neither an art historian nor an art critic. Rather, I am an artist who has fought for the right to be who I am as a woman and an artist and, most recently, as a Jew—in my life and in my art. However, even though issues of female identity are no longer my primary focus, I have brought to this book my own

memories of how desperately I used to long for a sense of belonging, for a world in which I was not always the "other" everywhere but in my studio.

It was only there that my gender seemed to cease to matter, where I could be all that I was. But, as I described in *Through the Flower* (the first volume of my autobiography), whenever I tried to bring what I had created out of my wholeness into the world, the problem of my gender continually interfered. It was this problem that initially caused me to take up the issue of female identity in my art, as if by understanding its meaning I could escape its constraints.

In the decades since I found my own path as an artist—one whose aim has been to contribute to ending the cycle of erasure of women's achievements, attested to by *The Dinner Party*—women's studies courses have abounded; feminist theory has evolved into a formidable body of intellectual challenges to traditional thought; and women artists all over the world have internalized the freedom that female artists of my generation fought so hard to acquire. As a result, an enormous body of art by women of the past has emerged from the shadows of history through the scholarship of countless feminist art historians. And new and exciting art by women is being created everywhere.

Nevertheless, I receive innumerable letters from female students and, when I lecture at universities in various parts of the world, often hear stories that repeat the same complaint. Too many educational and art institutions continue to present women's work in a token way, and hence, young women are still being deprived of knowledge about what women before them thought, taught, and created. Rather than inheriting a world made different by the infusion of oppositional ideas, new generations of women are experiencing the same identity problems that motivated my own search for a female history and for images which affirmed rather than negated my existence.

In terms of young women artists, it is my perception that too many of them continue to feel isolated and contextless with the same sense of belonging nowhere that I had. And since I do not think that art is intended only for artists, I believe many women will become inspired by some of the images in this book, created by women artists who have managed—in the face of countless obstacles—to fashion a range of art that, though still far less known than it should be, offers a variety of answers as to what it means to be a woman. (It is my intention with this book to honor this legacy and to pass on to young women a more engaged and also more critical way of approaching art.)

However, I am sure that there will be some who will ask, if their work is so important, why we don't know of more of these supposedly marvelous artists, or if we have heard of one or another, why do we know them by only one or two works? I am afraid the answer is that the continued erasure of women's art—through neglect, misunderstanding, and the absence of a context in which it can be fully understood, as well as outright discrimination—still confines too much of it to the margins rather than the museums of the world. This makes me angry and also provided another reason for my decision to coauthor this book. As I have said many times in the past, rage can fuel positive action.

The decision to include images of women by both male and female artists was based upon the fact that, as stated earlier, my goals have always included bringing women's art into the mainstream. As long as women's art is treated as an "exotic other" it will continue to be marginalized. Also, it is high time that men's images, which have been one of the primary ways through which both men and women have formulated their ideas about the female, start to be re-examined in relation to the ever-increasing body of art by women which challenges male perception.

In addition, by focusing exclusively upon women's images of women, I believe that only part of the story of women's art would have been told, for it is within the structure of art history that many of the best women artists have fought for acceptance. In actuality, we have been part of that history even though our artistic production is not adequately represented in our museums. This is something which we must seek to change in the future.

As for why I have chosen Ted as my collaborator (or rather, accepted his offer to cooperate on this book), I must state that another of my goals has always been to demonstrate that women's art could be as interesting to men as men's art has been to women

throughout history. In contrast to some feminists, I firmly believe that women's art can and should be understood by men, and that the body of art by women about the female experience can help to expand men's understanding of women and to broaden their views of what constitutes the human experience.

However, too few men have been willing to acknowledge or accept that they have much to learn from women and from women's art. One explanation for this resistance might be that many men find it difficult to be open to a different way of seeing, particularly one which demands the recognition that the universality of perspective too often claimed for male art (especially white male art) is, in reality, a view of the world shaped and limited by men's experience, which has generally been based upon the privilege of being male in a male-dominated world.

Of course, some of the limitations of the male view of women—as expressed in art—become evident only when men's work is juxtaposed with that of women with an oppositional view, which not all female artists have put forward. But then not all men are able to accept that male reality is not universal. Fortunately, Ted seems to be so inclined, which is one reason I decided to do this book with him.

Although we don't always agree, as will become evident in the dialogue between us, I hope that his goodwill in undertaking this project—along with his willingness to bring his vast art historical knowledge to the task of looking at a range of art by women and looking anew at some of the familiar images of women by men—will provoke in our readers a similar goodwill. Also, it is my hope that our effort to construct a new context for looking at both familiar and unfamiliar images of women will yield a refreshing point of departure or, at least, some new insights in terms of thinking about some of the issues we raise.

Before ending, I feel obliged to discuss why I have included my own work in this publication. Previously I mentioned how I had carried the context I had discovered—of women's history and the development of an oppositional, or feminist, art—with me through years of struggle. I had hoped that this context would become more widely known, understood, and appreciated. This has still not happened, or at least not to the degree that I had hoped it would.

Ted and I have attempted to demonstrate that women have been involved in art for many centuries—often meeting obstacles in obtaining training and the right to professional opportunities, as well as having to face social disgrace at worst, extreme isolation at best. We have also set out to show that some of the most important art created by women is that which has become ever more oppositional to the images of women that have been forged by men. This struggle over representation, about who is to determine the nature of female identity and, of course, ultimately, who decides what constitutes great art are some of the questions we focus upon, both through our choices of images and through our text.

And since these are some of the very issues that have been central to my own work for many years, I wanted my art to be seen in this context, if only to set to rest the misguided notion that my work is contextless. In closing, let me simply say that, above all, I have involved myself in this book because my deepest desire is to make a contribution to a more equitable world and to do so through what is dearest to me, which is—and always has been—visual art.

Judy Chicago

JUDY CHICAGO
October 1998

The Divine

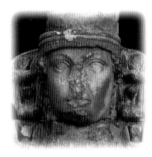

The main theme of Goddess symbolism is the mystery
of birth and death and the renewal of life . . .

MARIJA GIMBUTAS, 1989

THE NATURE OF THE DIVINE

Judy Chicago When I was young, I felt desperate for images of women that affirmed rather than denied my sense of self. Everywhere I looked, I saw representations of the female as passive, seductive, even destructive. None of these descriptions corresponded with what I felt myself to be—or what I wanted to be. During the 1970s, I undertook a self-guided research program into women's history, in the process discovering an ancient iconography of goddess figures which were very important to me in my efforts to claim for myself a visual history that evidenced strength and power. My memory of this personal hunger guided our selection of images in chapter one.

A new interest in female divinities and in spirituality involving the worship of a goddess or goddesses has been one of the more striking results of the Women's Movement. It is something which stretches well beyond the boundaries of the art world. Within the art world, as also in archaeological studies, fascination with visual representations of goddess figures has been fueled by the publications of feminist archaeologists like the late Marija Gimbutas (1921–94). Though these interpretations have inevitably been contested, sometimes by other feminists, they have seized the imaginations of many women and have been a continuing source of energy within feminism. They necessarily shift our perspective in looking not only at extremely ancient works but also at all art in which a goddess figure or some equivalent appears.

Making images of deities is an age-old human occupation. The very first three-dimensional representations of human beings, dating from the Paleolithic period and usually interpreted by modern scholars as divinities, are those of females rather than males. Nevertheless, when one attempts to discuss this long series of divine images, one

right: **AUDREY FLACK**
Egyptian Rocket Goddess (1990);
Louis K. Meisel Gallery, New York

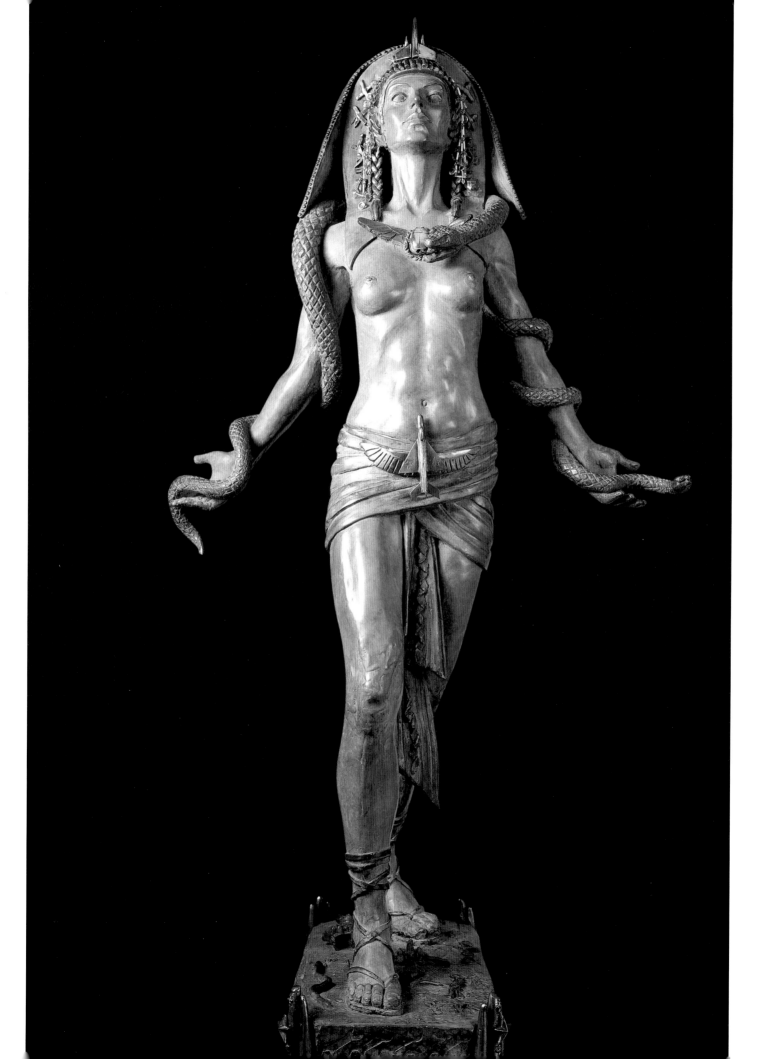

Judy Chicago In examining creation myths from around the world, one discovers that in most cultures there existed the notion of a female divinity who created the world either parthenogenically or in partnership with a male god. Gradually, these myths gave way to the notion of creation as the consequence of the destruction of a female god by a male divinity (as in, for example, the ancient Babylonian epic poem *Enuma Elish*) and, finally, to the idea of the male god as both the sole source of creation and the image of the divine (as in Genesis in the Bible).

It is interesting to note that one Jewish *midrash*, or biblical exposition, dealing with the origin of the human race describes Adam and Eve as an androgynous creature who was separated by God, thereby implying no distinction between male and female.

However, the other creation story is better known and has been far more influential historically. To quote Genesis,

> *And God said, let us make man in our image, after our likeness ... And the rib, which the Lord God had taken from man, made he a woman ... (1:26–2:22).*

This biblical injunction of inequality has cast a shadow on women's position and also on relations between women and men. In terms of women and art, this notion—along with the association between women and evil—has led to many images of women as the embodiment of temptation, a perception women have had to struggle against, not only in terms of their personal identities but also in relation to the types of images of women female artists fashion.

immediately starts to run into some problems. Are they, for example, representations of a mythical universal mother figure, who manifests herself in a variety of physical guises? Or do they simply represent the common cultural phenomenon of fertility figures, responsible for only one—albeit a very important—aspect of human life?

Images like those of the celebrated Minoan snake goddesses or the snake priestesses discovered by Sir Arthur Evans in the ruins of the ancient palace at Knossos in Crete have been absorbed into contemporary consciousness and have thus acquired a popular life of their own. Contemporary artists like the American painter and sculptor Audrey Flack (b.1931) have used the Minoan snake goddess as a symbol of female empowerment. Flack's *Egyptian Rocket Goddess*, illustrated on page 17, is a sophisticated postmodern sculpture which combines Minoan elements with others borrowed from the ancient Egyptian representations of Isis and yet others taken from Art Deco.

When confronted with such an unusually complicated play of imagery borrowed from several different epochs and major civilizations, it is impossible to be sure just how seriously the artist intends her divine symbolism to be taken. One thing of which we can be certain is that the sculpture forms part of a resurgence of interest in making representations of the divine female.

While Flack's figure may not actually be intended as an object of worship, it does make a statement about the importance of the feminine element within the world. Furthermore, it presents this element as an active force and, as such, is a positive image of femininity. Association with the divine helps to reinforce the image.

main picture:
CAROLEE SCHNEEMAN
Eye Body: 36 Transformative Actions (photograph of performance, 1963)

below: *Minoan Snake Goddess* (seventeenth century BC); Archaeological Museum, Crete

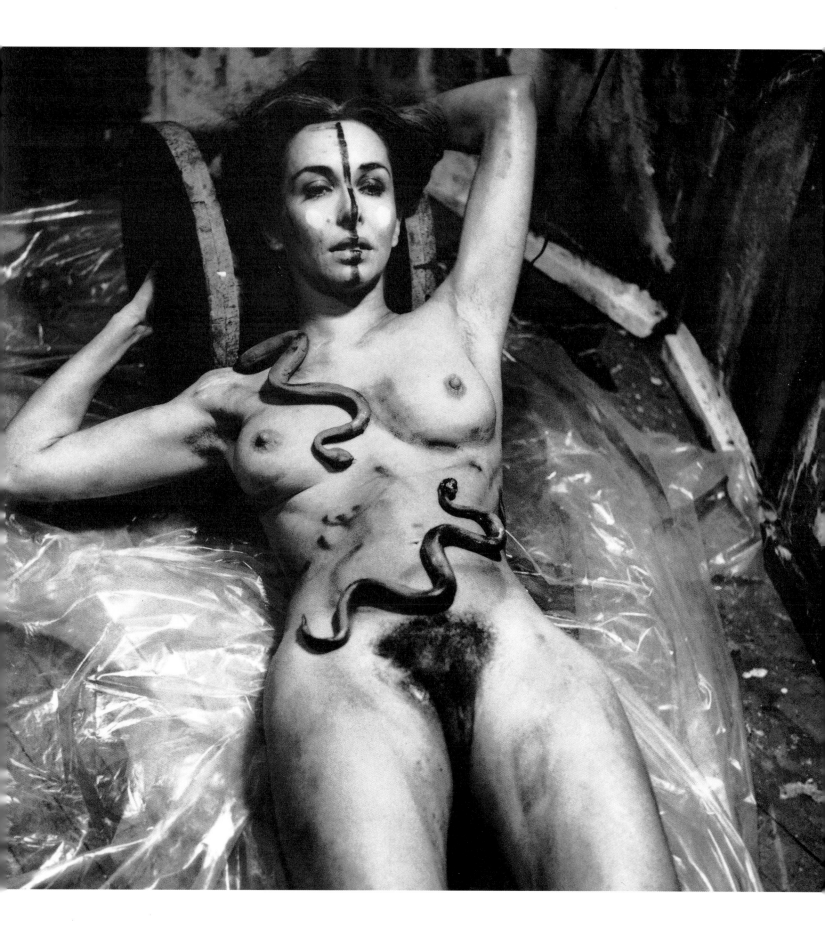

The definition and the image of the divine are crucial in the formation of self-image; if women are not allowed the possibility of being seen in the image and likeness of God, they cannot avoid being considered (or considering themselves) lesser beings. Thus the focus in contemporary art upon images of the goddess can be understood as part of an effort to reclaim the lost biblical concept of equality in the eyes of God, as well as an attempt to recast the divine in female terms.

As Marija Gimbutas wrote in *The Language of the Goddess* (1989):

> *Symbols and images cluster around the parthenogenetic (self-generating) Goddess and her basic functions ... She was the single source of all life ... Goddess-centered art, with its striking absence of images of warfare and male domination, reflects a social order in which women ... played a central part.*

Recently, Gimbutas's work has come in for a considerable amount of criticism, notably by a new generation of feminist scholars. Nevertheless, her original view of ancient images of the female opened up a wealth of material for women artists, particularly those who believe that the suppression of the feminine is directly connected to the structure of male dominance on the planet today.

main picture: **Aña Mendieta**
Untitled (Guanaroca—First Woman) (1981–84); carved cave wall, Cueva del Aguila, Cuba

right: *Venus of Willendorf* (c. 20,000 BC); Museum of Natural History, Vienna

RE-ENVISIONING THE GODDESS

Separated from the ambiguous position she has long occupied in the traditional Christian hierarchy, the goddess figure is once again thought of as a force existing in her own right, rather than being, as the Virgin Mary is, a divinized human who exercises powers of intercession and redemption delegated to her by the Father and the Son. But the analysis of the earliest goddess figures is, because of the complete absence of all written evidence, inevitably beset with difficulties.

The most celebrated of all Paleolithic goddess figures, the so-called *Venus of Willendorf*, is an example. We can go only by what we see. The Venus is a small statuette—only 4½ in. (11.5 cm) high—a steatopygous nude with massive buttocks and

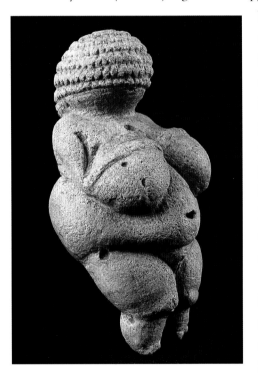

breasts, her head sunken toward her chest, and with a complete absence of facial features. She is usually interpreted as an image of the life-giving mother—her rounded belly suggests she may be pregnant—whose characteristics emphasize her power to give birth, her power to nourish the infant once it is born, and her power to survive famine because of her surplus body fat. In other words, she creates, she nurtures, and she endures.

However, other, rather different, interpretations can be attached to the same figurine. Physically she is close to the women of the Kung tribes of the Kalahari Desert. Recent research confirms that these tribespeople are the closest living relatives of the earliest humans so far known to us, whose remains have been found in the Rift Valley in East Africa. The *Venus of Willendorf* can therefore be regarded as another piece of evidence for humankind's descent from an originally black race. The "naturalistic" interpretation—that this is a closely observed portrayal of a particular type of female—in some respects conflicts with the symbolic one. The symbolism becomes less powerful if the artist simply portrayed what he or she saw, and the religious significance is correspondingly diminished, even if it does not vanish altogether.

The response of some contemporary artists might be that this is essentially irrelevant. They have ritually identified themselves with the imagined Mother Goddess, seeking to revive and reinterpret the myth in their own work and to make it valid for others in their own time. Their attitude corresponds with a general tendency in

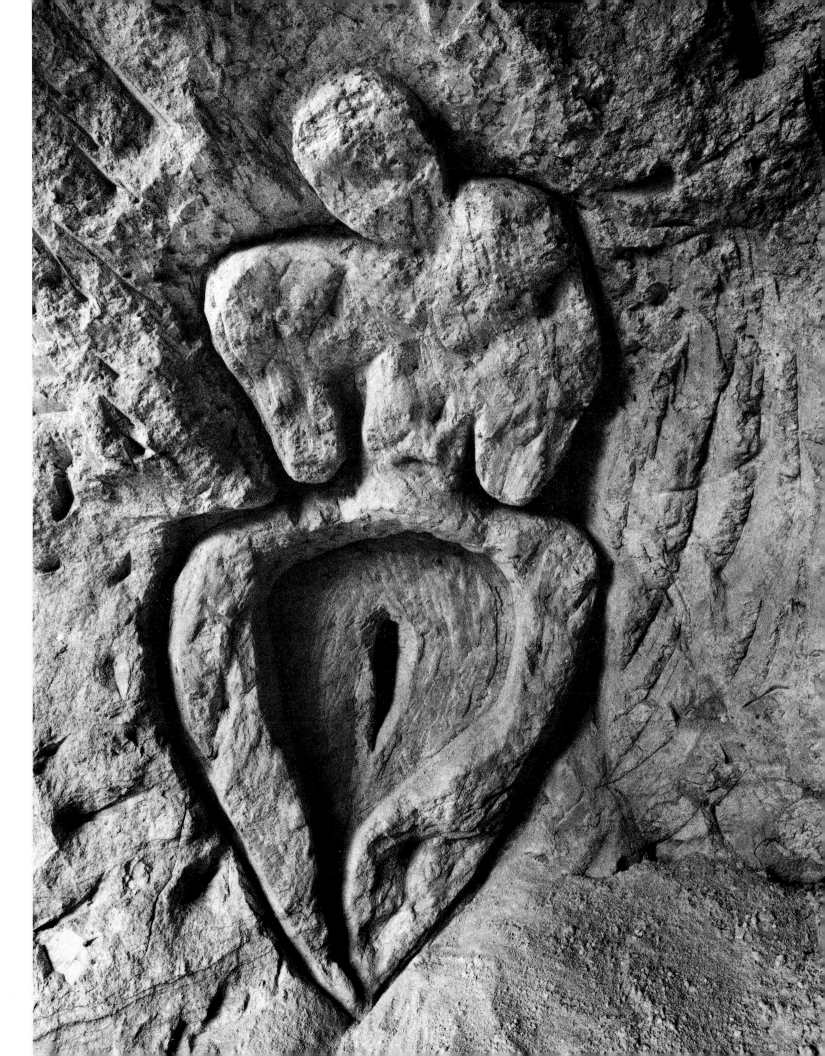

Judy Chicago Images of the Great Goddess —like this powerful statue of *Diana of Ephesus* (far right)—spoke to many women artists, myself included. As well as motivating Louise Bourgeois and countless others, this same image also inspired the "Ishtar" plate in *The Dinner Party*, the monumental tribute to women I created over a five-year period during the 1970s.

The Great Goddess was revered for thousands of years in the ancient Near East. She was worshiped in Anatolia and in Syria, for example, as the giver and taker of life, conceived by those who worshiped her as a being whose power was infinite. She expressed the power of the female as life-giving, protective, and nourishing, imagery I incorporated into the many-breasted and gilded china-painted plate which is her symbol in *The Dinner Party*.

far right: *Diana of Ephesus* (Roman copy of Greek original, second century AD); Ephesus Archaeological Museum, Selçuk, Turkey

above: **LOUISE BOURGEOIS** as *Artemis* From the performance *A Banquet/A Fashion Show of Body Parts* (1980)

above right: **BETSY DAMON** *The 7,000-Year-Old Woman* (street performance, 1977)

contemporary art, which is to see the modern artist, despite the wide difference in social context, as the equivalent of the primitive shaman, who performs redemptive rituals to preserve the health of the tribe.

One of the best known of the artists who have shaped their work following this assumption is the Cuban Aña Mendieta (1948–85), whose mud figures based on imprints made by her own body have helped to generate one of the most powerful legends in recent art. Mendieta came from a mixed culture, in which African elements were prominent, though she herself was not of African descent. Arriving at a very young age in the United States, as a refugee from Castro's revolution, she rebelled against American culture and tried to reintegrate herself with things remembered from Cuba, borrowing from Cuban Santería rituals, which are themselves remnants of Yoruba religion brought from Africa by the victims of the slave trade.

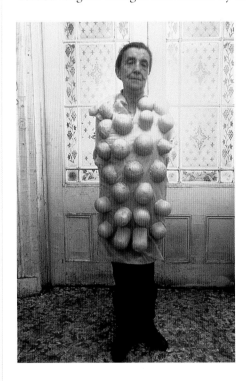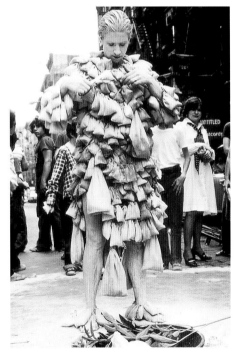

One feature of these rituals, as with similar voodoo rituals in Haiti, is that the participants offer themselves to be "ridden," or taken possession of, by a god or goddess. Essentially this is what is implied by Mendieta's images, which she preserved by taking photographs of them. They were acts of possession. A similar attitude is implied by the performance artist Carolee Schneeman (b. 1939) in the image of herself reclining, entwined with snakes. Here, as in Minoan art, snakes are emblematic of the power of the goddess. A woman who entwines herself with them is wrapped in the goddess's aura. The phallic interpretation suggested by the story of the Fall, and followed by Freud, is here replaced by another, in which the goddess, and the priestess who is her representative, demonstrates her dominion over venomous things.

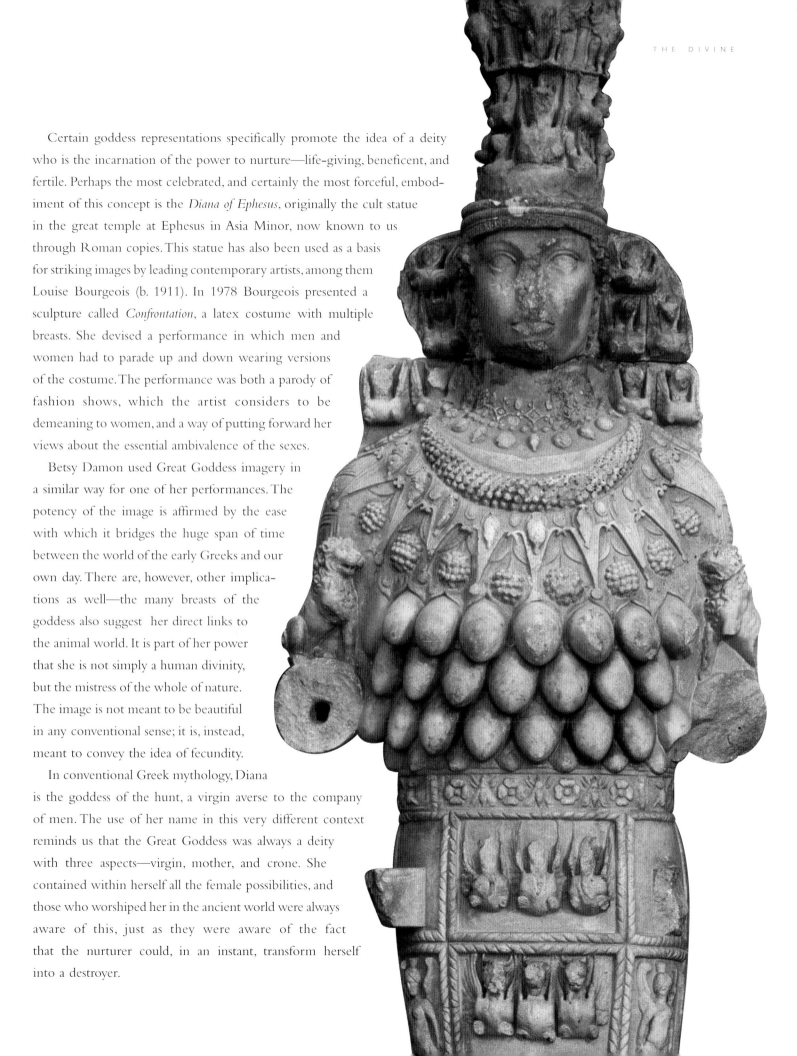

Certain goddess representations specifically promote the idea of a deity who is the incarnation of the power to nurture—life-giving, beneficent, and fertile. Perhaps the most celebrated, and certainly the most forceful, embodiment of this concept is the *Diana of Ephesus*, originally the cult statue in the great temple at Ephesus in Asia Minor, now known to us through Roman copies. This statue has also been used as a basis for striking images by leading contemporary artists, among them Louise Bourgeois (b. 1911). In 1978 Bourgeois presented a sculpture called *Confrontation*, a latex costume with multiple breasts. She devised a performance in which men and women had to parade up and down wearing versions of the costume. The performance was both a parody of fashion shows, which the artist considers to be demeaning to women, and a way of putting forward her views about the essential ambivalence of the sexes.

Betsy Damon used Great Goddess imagery in a similar way for one of her performances. The potency of the image is affirmed by the ease with which it bridges the huge span of time between the world of the early Greeks and our own day. There are, however, other implications as well—the many breasts of the goddess also suggest her direct links to the animal world. It is part of her power that she is not simply a human divinity, but the mistress of the whole of nature. The image is not meant to be beautiful in any conventional sense; it is, instead, meant to convey the idea of fecundity.

In conventional Greek mythology, Diana is the goddess of the hunt, a virgin averse to the company of men. The use of her name in this very different context reminds us that the Great Goddess was always a deity with three aspects—virgin, mother, and crone. She contained within herself all the female possibilities, and those who worshiped her in the ancient world were always aware of this, just as they were aware of the fact that the nurturer could, in an instant, transform herself into a destroyer.

Judy Chicago While doing research for *The Dinner Party*, I came across information about Asherah, who, for many centuries, was the female analogue to the Hebrew god Yahweh. I was astounded by the fact that, as a Jewish woman, I had never known about this traditionally female face of God, a realization which made me angry.

It also made me wonder exactly what Abraham meant when, in the Bible, he commanded Sarah to put aside her graven images. Was that the historic moment at which a monolithic male god took permanent precedence over his female counterpart, the moment at which women's voices were silenced and women's divinity denounced? How can one have a voice if one is absented from the image of God?

main picture: **DANTE GABRIEL ROSSETTI** *Astarte Syriaca* (1877); Manchester City Art Gallery, U.K.

right: *Asherah* (second millennium BC); Rockefeller Museum, Jerusalem

ASPECTS OF THE GODDESS

The suppression of goddess worship is believed to date from the triumph of the Christian faith, which imposed on its adherents the worship of a God in three persons whose identity was either wholly masculine—in the case of the Father and the Son—or sexless in the case of the Holy Ghost, who is portrayed, if at all, in the form of a dove. Christianity derived from Judaism—a religion which had already been powerful for centuries in the ancient world, and especially in what became the eastern half of the Roman Empire. In fact, long before Christianity began to spread through the imperial realms, often in the face of savage persecution by the authorities, Judaism had attracted camp followers who were not Jewish by birth but who adhered to many of the Jewish dietary and other laws. These non-Jewish adherents had lost faith in the gods and goddesses of the Greco-Roman pantheon. They were looking for a less complicated faith with an authoritarian ethical structure that offered worshipers a clearer part in securing their own salvation.

The Jewish Diaspora, which began long before the destruction of the Second Temple in Jerusalem by the Emperor Titus in AD 70, also altered Judaism itself, as it took Jews and their religion to every corner of the Near East. Jews, for example, became interested in Greco-Roman philosophy. Philo Judaeus (c. 20 BC–AD 40) saw Platonism as a version, albeit an inferior one, of the Jewish faith. Some authorities are persuaded that, with this Diaspora, there came a dilution of the strictest Jewish tenets. More especially, they see a tendency to dilute Jewish monotheism by the worship of a goddess who was the consort of Yahweh. The literary and archaeological evidence seem to indicate a different explanation.

For example, Jewish women who settled in Hellenistic times at the extreme limits of Upper Egypt, at Elephantine, are known from archaeological evidence to have had a cult of a female goddess, consort to Yahweh, who was called Asherah—clearly a version of the goddess of the same name who had been worshiped in Syria, at Ugarit, and other cities. She had, however, also been worshiped in Israel itself, though the biblical record is at pains to assert that the cult was alien—the work, for example, of the hated Tyrian princess Jezebel, wife of King Ahab (ninth century BC). The accumulated evidence, including a number of Hebrew inscriptions, now suggests that Asherah was not a foreign importation into Israel itself, but something indigenous, and that the Jewish women of Elephantine brought her with them, rather than borrowing her from their surroundings. Her cult was an independent form of worship confined to females, resented and often persecuted by the parallel, official cult run by males.

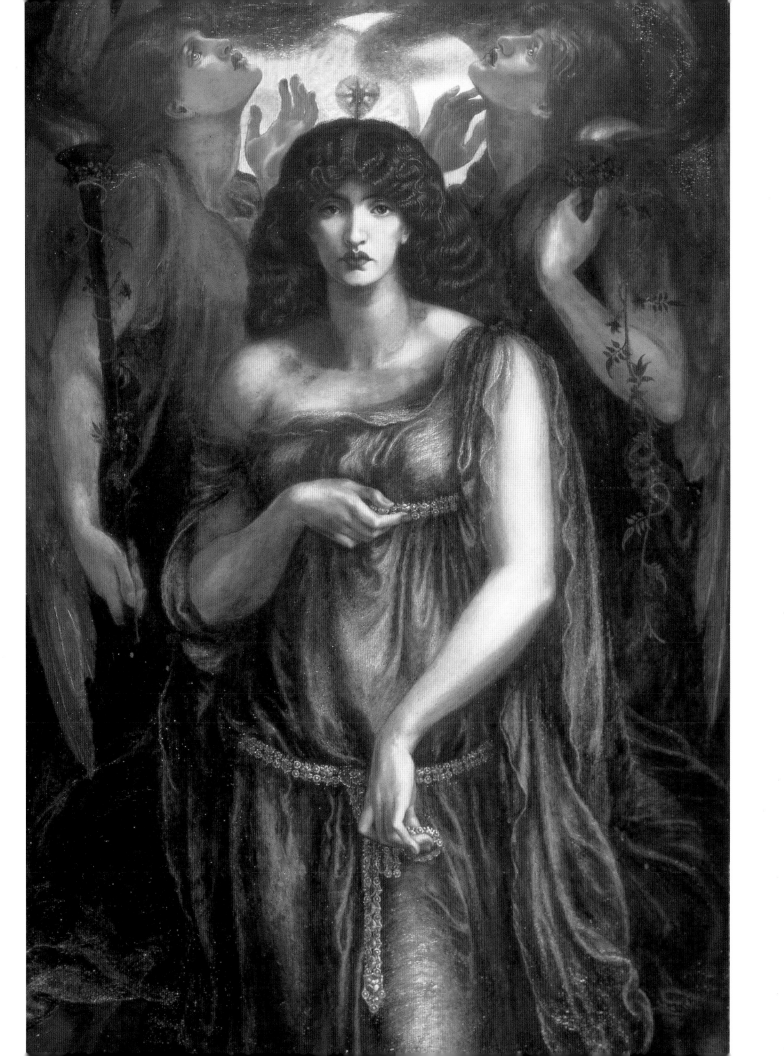

Despite having stated my desire for a place in the definition of the divine, I must protest—in relation to this celebrated Botticelli painting — not this place. The image of the female as a love goddess is a long way from the earlier concept of the Great Goddess as the source of all life, a concept I much prefer because it bestows less passivity and more dignity and power upon women.

> I am the poet of the woman the same as
> the man,
> And I say it is as great to be a woman as to
> be a man,
> And I say there is nothing greater than the
> mother of men.

WALT WHITMAN, "SONG OF MYSELF," 1855

Conversion to Christianity could not subdue the impulse to worship female incarnations of the divine, and the newly triumphant faith accommodated this in various ways. A local goddess would often be transformed into a saint, and a church would be built on top of, or into the ruins of, an established pagan shrine. An example of this is the church of Santa Maria sopra Minerva in Rome, which, as its name suggests, occupies the site of a temple dedicated to Athena. The cult of the Virgin had reached such heights by around the year 1200 that protests were heard that the Mother of God was displacing Christ himself as the chief object of Christian worship.

Even in near-modern times, Asherah, also known as Astarte, retained her grip on the Christian imagination, not least because of the fervent denunciations of the Old Testament prophets, known to every student of the Bible. Her image renewed its potency as a symbol of rebellion as late as the time of the Pre-Raphaelite painter Dante Gabriel Rossetti (1828–82). Rossetti's painting *Astarte Syriaca* romantically evokes the divine power of women, within the context of the nascent pan-European Symbolist Movement, and can at the same time be read as a covert denunciation of patriarchal Victorian Christianity. The painting carries other messages as well. It is a near-portrait of Janey Morris, wife of Rossetti's fellow Pre-Raphaelite William Morris (1834–96), with whom Rossetti was conducting an adulterous affair. The two male figures placed symmetrically in the background speak of the goddess's—and by implication Janey's—power to ensorcell men. She is therefore both an incarnation of the goddess of love and the personification of the Fatal Woman.

One fascinating aspect of Rossetti's image, and of the other, closely similar paintings he made at this time, is that he simultaneously exalts the power of women and condemns it. The same theme can be found spelled out explicitly in some of the poetry that Rossetti wrote.

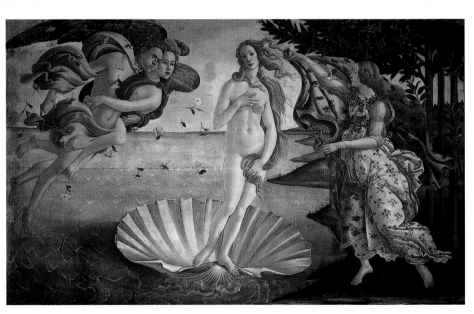

right: **SANDRO BOTTICELLI**

The Birth of Venus (c. 1482); Uffizi Gallery, Florence,

THE GODDESS AS LOVE

The image of the love goddess—Astarte's primary role—has in fact occupied a
powerful place in the human psyche whatever religion happened to hold sway. The
Hellenistic terra-cotta statuette of her illustrated here comes from well to the east—
it is Babylonian—but it shows the impact made on the art of the region by the
conquests of Alexander the Great. He and his successor kings disseminated Greek
culture throughout their realms, which stretched as far as India. One of the ancestors
of this comparatively humble work is Praxiteles' *Aphrodite of Cnidus* (see page 140*)*,
which in the mid-fourth century BC displaced the male nude from its central posi-
tion in Greek art. Other ancestors are primitive representations of Asherah such
as the one illustrated on page 24.

left: **Astarte** (third to
second centuries BC);
Louvre, Paris

The statuette of Astarte has both Greek and Near Eastern characteristics. It
seems likely that the missing object she held in her extended right hand was
a pomegranate—frequently used by the Greeks as Aphrodite's symbol because
the way in which the fruit splits when it is ripe resembles the
female sex. On the other hand, the crescent in the figure's
hair recalls Astarte's role as a moon goddess. The broad hips
indicate that she continues to be regarded as a goddess not only
of love but also of fecundity.

When the Renaissance began the process of secularizing European culture,
it was natural that this image should reappear, as it does in resplendent form
in Botticelli's celebrated *Birth of Venus*, painted c. 1485 for the villa of Lorenzo
de' Medici at Castello. Painted for a member of the family that, *de facto*, ruled
supposedly Republican Florence, the picture represents not merely a delib-
erate return to antiquity but also a defiance of Church prohibitions against
the representation of nudity. Venus appears resplendent, but she is purely an
object for the male gaze, and the picture would probably have been kept in a
room, such as Lorenzo's private study, that women did not frequent.
The gesture of the figure, one hand covering her breasts, the other concealing
her sex, is derived from classical statues of the Venus Pudica—the Venus who has
suddenly become aware that she is being watched. However, the figure is much
less solid and fleshy than classical prototypes, and one can see the artist's searching
for ways to make her look ethereal and visionary—a phantom rather than some-
thing rooted in reality. The psychological strain involved for the artist can be gauged
from his sudden subsequent conversion to the doctrines of the fiercely puritan
Savonarola, who denounced paintings of this type as sinful "vanities" and commanded
that they should be burned. So we are perhaps fortunate that this particular painting
by Botticelli has survived, even if the subject and treatment are hardly
satisfactory in a feminist context.

Judy Chicago If the image of the goddess as love is one of diminished potency, her darker side needs to be acknowledged and analyzed. Her appearance as fearful destroyer is only one aspect of ancient conceptions of the goddess in whom life and death were joined. To the Western mind, however, despite the fact that this same conjoint identity is present in the figure of Coatilcue, the image—powerful as it may be—seems to conjure up negative definitions of the female as devourer. This might have a modern counterpart in the idea of the castrating woman, though it is by no means certain that this is what the Aztecs had in mind.

THE DARK SIDE OF THE GODDESS

The goddess in her more fearsome and destructive aspect occupies a larger place in the imagery of non-Western civilizations than it does in the West, where the concern has so often been to play down the power of the female. The Aztec earth goddess Coatilcue—the name means "Serpent Skirt" in Nahuatl—was a symbol of the earth as creator and destroyer, mother of both gods and mortals. In the best-known representation of her, her skirt is made of interwoven snakes, which here symbolize fertility; her fingers and toes are claws, to indicate that she feeds on corpses; and her breasts are deliberately portrayed as flabby, to indicate the myriads she has nourished. In addition to being an earth goddess she was the goddess of childbirth, but also, in another of her aspects, the deity of sexual impurity and wrong sexual behavior.

In the Hindu pantheon, Kali (the name in Sanskrit means simply "black," and the goddess is often represented as black in color) is the destructive, terrifying aspect of the supreme goddess Devi, who in her other aspects is peaceful and benevolent. Kali is shown with bared fangs and protruding tongue. She is garlanded with the heads of her victims, and her multiple arms hold attributes that symbolize her destructiveness—a sword, a severed hand, a severed head. Among other functions, she is the patron of assassins—the thugs, gangs of professional murderers who operated in India until the nineteenth century, made their offerings to her. Her best-known temple is the Kalighat, in Calcutta, the focus for a prolific output of folk paintings, like the one illustrated, which celebrate the goddess and her powers. Made rapidly to be sold as cheaply as possible, these paintings are produced by both men and women, who follow traditional designs that are passed down from one generation to the next.

Neither of these incarnations of goddesshood represents an acceptable ideal for contemporary women, but they are included here as a reminder that the image of the female as an all-powerful nurturer does incorporate within itself much darker forces. The hidden presence of these forces undoubtedly adds to the potency of the more familiar benevolent image. The inability of Western art to come fully to terms with the goddess in her destructive aspect is significant in itself.

left: *Coatilcue, Mother of the Lord of the Universe* (late fifteenth/early sixteenth century); National Museum of Anthropology, Mexico City

right: *Kali* (late nineteenth century); Victoria and Albert Museum, London

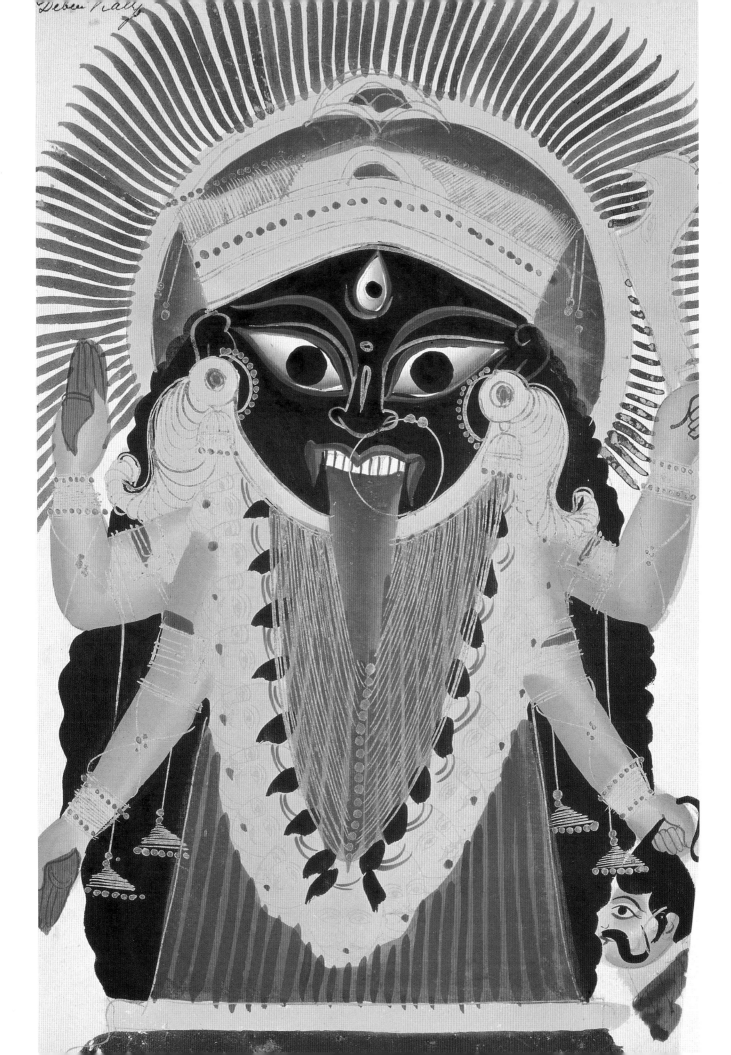

Challenging the masculine nature of God has been a primary goal of both feminist theology and feminist art. But pernicious as it has been to limit the gender of God, it has been equally demeaning to people of color, of either sex, to have God always defined as white. How marvelous, then, to see artists challenging this concept, expanding the definition of the divine to encompass a broader humanity through a creative reimaging of the figure of God.

CHALLENGING THE GREAT WHITE FATHER

One of the fascinating aspects of the revival of goddess images and the goddess cult in art has been the effort to adapt the image of female divinity to specific situations to do with race as well as gender. The African-American artist Romare Bearden (1911–88), in creating the goddess image *SHE-BA*, looks to African as well as European and modernist precedents. These images not only challenge the primacy of Western art, they challenge the Great White Father as head of the divine hierarchy.

This is not a new enterprise. The Virgin of Guadalupe, the protectress of Mexico, owes her origin as an image to the visions of a convert to Christianity named Juan Diego in December 1531—that is, only ten years after Hernán Cortés completed the conquest of the Aztec empire and began the process of turning its subjects into Christians. The cult flourished throughout the colonial period, giving rise to many representations of the Virgin as Diego had seen her, and in 1754 a papal bull made the Virgin of Guadalupe the official protectress of New Spain. But she did not remain in the hands of the Spanish.

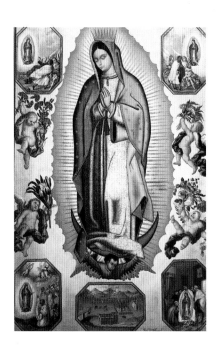

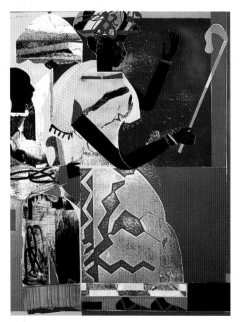

In 1810, Miguel de Hidalgo, who began the rebellion that led to Mexican independence, placed her image on his banner.

The Guadalupe Virgin achieved a position in Mexico that made her in many respects more powerful than Christ Himself or God the Father. It was she to whom most Mexicans appealed— and continue to appeal—in cases of accident or emergency, as is demonstrated by the small votive pictures placed in Mexican churches, where hers is the invariable protective image. This typical image by Juan de Villegas, conventionalized to conform to the apparition that Juan Diego described, is a variant of European representations of the Virgin which had already begun to be imported into Mexico, mostly in the form of prints from the great print shops of Antwerp, then part of the Spanish dominions. But there is also a very real difference: in this version the Mother of Christ is a mestiza—a woman of mixed race.

It is therefore no surprise to find the contemporary Chicana artist Yolanda M. Lopez (b. 1942) representing herself in the guise of the Guadalupe, or to find that this representation also incorporates aspects of the much more aggressive Aztec deity Coatilcue. Whereas the Virgin remains a passive figure, floating tranquilly in the heavens, borne on the crescent moon, Lopez strides confidently forward. In one hand she grasps a snake; the other holds a star-studded cloak whose folds billow around her as she moves. This is the goddess reinvented for the age of feminism.

above: **JUAN DE VILLEGAS**
The Virgin of Guadalupe (mid-sixteenth century); Museo de América, Madrid

above right: **ROMARE HOWARD BEARDEN**
SHE-BA (1970);
Wadsworth Atheneum, Hartford, Connecticut

main picture: **YOLANDA M. LOPEZ**
Portrait of the Artist as the Virgin of Guadalupe (1978)

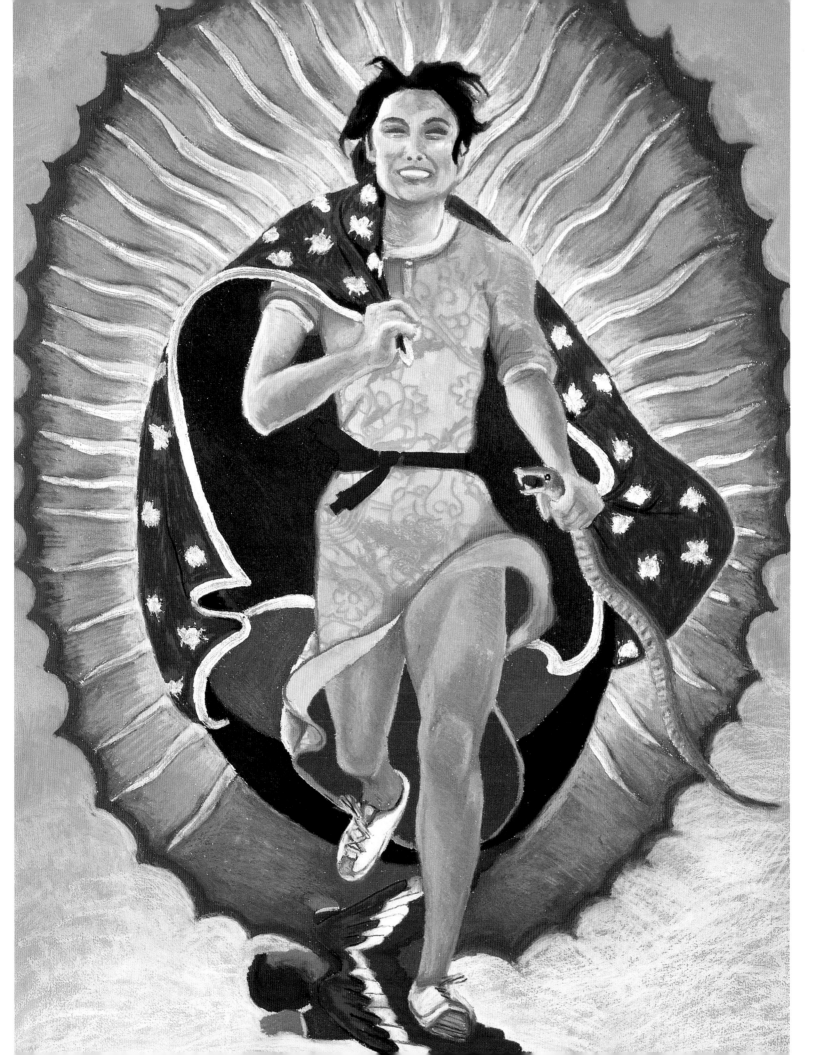

The Heroic

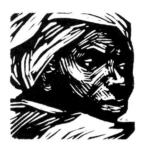

Gender is a social construct and . . . woman, like man, makes and defines history.

GERDA LERNER, 1993

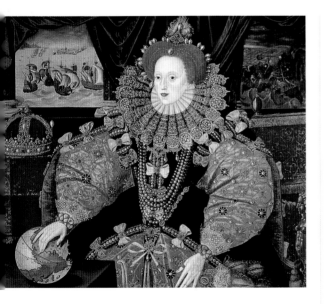

above: **MARCUS GHEERHARDTS THE YOUNGER**
Queen Elizabeth I (1588); Woburn Abbey, Bedford, U.K.

WOMEN IN CHARGE

Though women frequently appear in art playing allegorical roles, as incarnations of some abstract idea, there are remarkably few female heroes who emerge as distinct personalities in Western art. This is something that can also be said of Western culture in general—it reflects the tendency to relegate women to a passive role. Of those heroic images that do exist, many, not surprisingly, portray royal personages. The images presented here of the ancient Egyptian woman pharaoh Hatshepsut and of Queen Elizabeth I of England and Ireland speak eloquently of the special circumstances that surrounded these remarkable women's possession of power.

Hatshepsut (c. 1478–1452 BC) was a queen of Egypt, one of very few who ruled in her own right. Following Egyptian royal custom, she was married to her brother, Thutmose II. Brother–sister marriages were an Egyptian royal custom because the succession to the throne, at least in theory, passed through the female line. When her brother died, after a brief reign, Hatshepsut assumed the regency for Thutmose III, born of a minor royal concubine. After fulfilling this role for about seven years, she seized full control of the government, had herself crowned a pharaoh, and adopted

not only the royal Horus name—reserved for male rulers—but also male pharaonic regalia, including the false beard worn by kings. In every outward aspect, her official statues portray her as a man, yet there is always something subtly feminine about them, thanks to the delicacy of the features.

One of the most striking of Hatshepsut's portraits is the image which portrays her as a sphinx. The convention of showing the ruler of Egypt as a lion with a human head was long established in Hatshepsut's day. It went back as far as the Old Kingdom. The Great Sphinx at Giza, for example, is a portrait of King Khafre, the fourth king of the Fourth Dynasty (c. 2575–c. 2465 BC). In this case the queen's face peers out from the mane of an undoubtedly male beast. The effect is not really androgynous, despite the presence of the formal false beard. Hatshepsut's tranquil, confident face remains recognizably that of a woman.

From what we know, she had much to be confident about. She emphasized good administration and commercial expansion rather than war, and sent a major trading expedition to Punt, on the African coast at the southern end of the Red Sea. It is these qualities, not military triumphs, which are recorded in the reliefs which adorn her mortuary temple at Deir el-Bahri, one of the most elegant of all ancient Egyptian buildings.

Elizabeth I of England (r. 1558–1603) was an even more substantial figure, with an equally shrewd feeling for self-presentation. One of the things we know about her is that she maintained extremely strict control over her own image, insisting, for example, that her face always be shown without shadows. She began her reign in the knowledge that there was immense contemporary hostility toward female rulers. In the last year of her sister Mary's reign, the Scottish Calvinist preacher John Knox had proclaimed, in his book *The First Blast of the Trumpet Against the Monstrous Regiment of Women*, that "God has revealed to some in this age that it is more than a monster in nature that a woman should reign and bear empire above man." Mary had been Catholic, which was one very basic reason for enmity, and it was part of Elizabeth's defense against ingrained sexual prejudice that she herself was a Protestant. But she knew she had to create a fresh cultural model to justify the fact of female rule. She did so by turning herself into a kind of secular divinity, even daring to take on some of the characteristics her Catholic opponents allocated to the Virgin Mary. Her state portraits proclaim that she is a Virgin Queen, wedded only to her kingdom. Her semidivinity was emphasized by the dazzling richness of her dress.

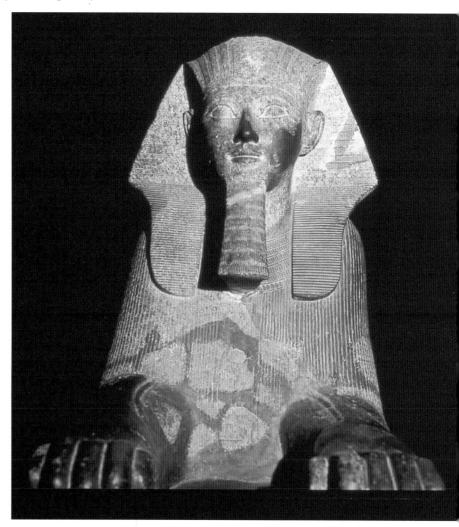

above: *Sphinx of Queen Hatshepsut* (c. 1478–1452 BC); Egyptian Museum, Cairo

The dictionary definition of a hero is "one who shows great courage." During my research for *The Dinner Party*, I discovered countless women whose actions qualified them as genuine heroes. Nevertheless, we are often more familiar with allegorical figures of women—like Liberty or Justice—than with knowledge about the courageous lives of real people.

Certainly, we know of many female rulers, who might qualify as heroes. But for me, such stature would be justified only if their reigns benefited the women of their era. In the case of Hatshepsut, this is difficult to establish because she lived so long ago. However, the reliefs in her famous mortuary temple at Deir el-Bahri show her to be interested in peaceful trade and exploration rather than war. Queen Elizabeth I was a contradictory figure, but she was extremely erudite, and through both example and support she continued the tradition of female scholarship which was advocated at the time by English humanists. In contrast, King James I, Elizabeth's successor, was especially hostile toward women, and their circumstances definitely worsened after the queen's death. By then, the intellectual sustenance the cloister provided for women like Walpurga had long since given way to a sequestered and limited convent life. The constriction of women's options that had been set in motion by the Renaissance was reinforced by the Reformation and firmly locked in place by the customs, the repressive attitudes, and the laws of the early nineteenth century.

SAINTHOOD AS EMPOWERMENT

During the Middle Ages, and also in the centuries that immediately followed, one of the few routes to genuine female empowerment was through religion—specifically through becoming a saint, though full recognition of sainthood could come only after the woman concerned was dead. Personages connected in a special way with sacred reality, saints were objects of veneration which had nothing specifically to do with their gender, and female saints were as much venerated as male ones. However, there were some limitations to this. Female sainthood was often strictly connected to the idea of the preservation of a woman's chastity. The most conspicuous apparent exception to this is St. Mary Magdalene, celebrated as a witness to the Crucifixion and the first person to see the resurrected Christ. Legend, not fully supported by the Gospels, made her a prostitute who repented of her sins and then spent the last 30 years of her life as an ascetic living in an alpine cavern. This aspect of the saint is represented in the famous statue by Donatello (1386–1466) which portrays her as an emaciated figure covered only by her long hair. The Spanish artist Luisa Roldán (c. 1656–c. 1704), the only woman ever to be named sculptor to the court of Spain, follows the same tradition in her *Death of Mary Magdalene*—implying that sainthood involves the deliberate sacrifice of all physical attractions.

A late medieval image of *St. Walpurga* (c. 710–779) presents a very different version of female empowerment, perhaps because it was made by women chiefly for

above: **LUISA ROLDÁN**
Death of Mary Magdalene (1697);
Hispanic Society of America,
New York

left: **DONATELLO**
Mary Magdalene (c. 1455); Museo
dell'Opera del Duomo, Florence

main picture: *St. Walpurga*
(fifteenth century); Bayerisches
National Museum, Munich

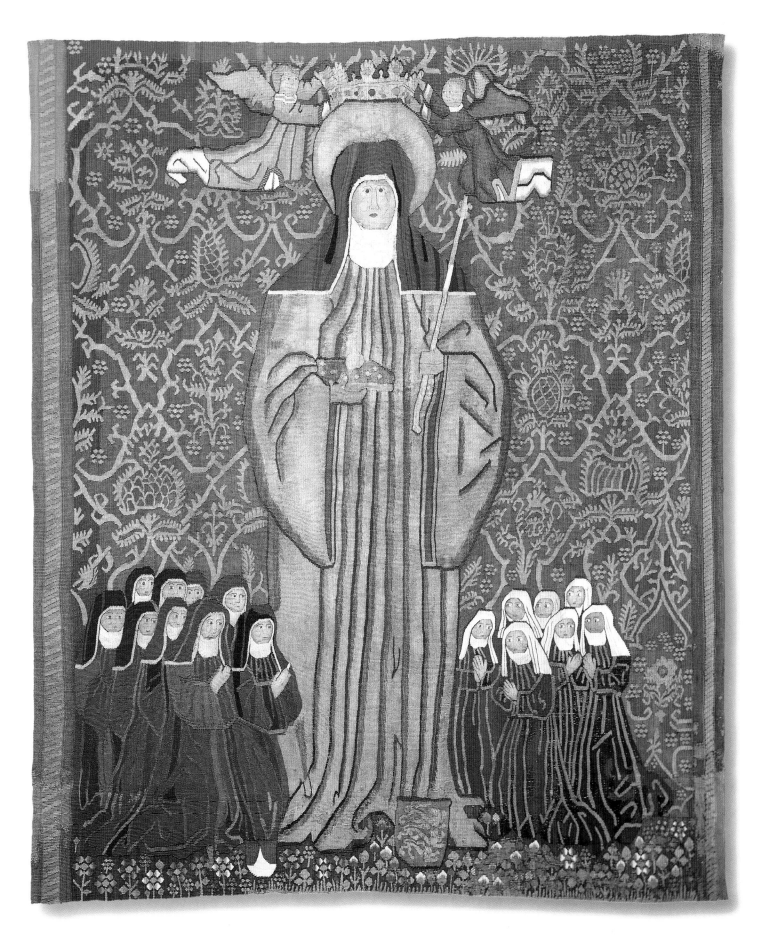

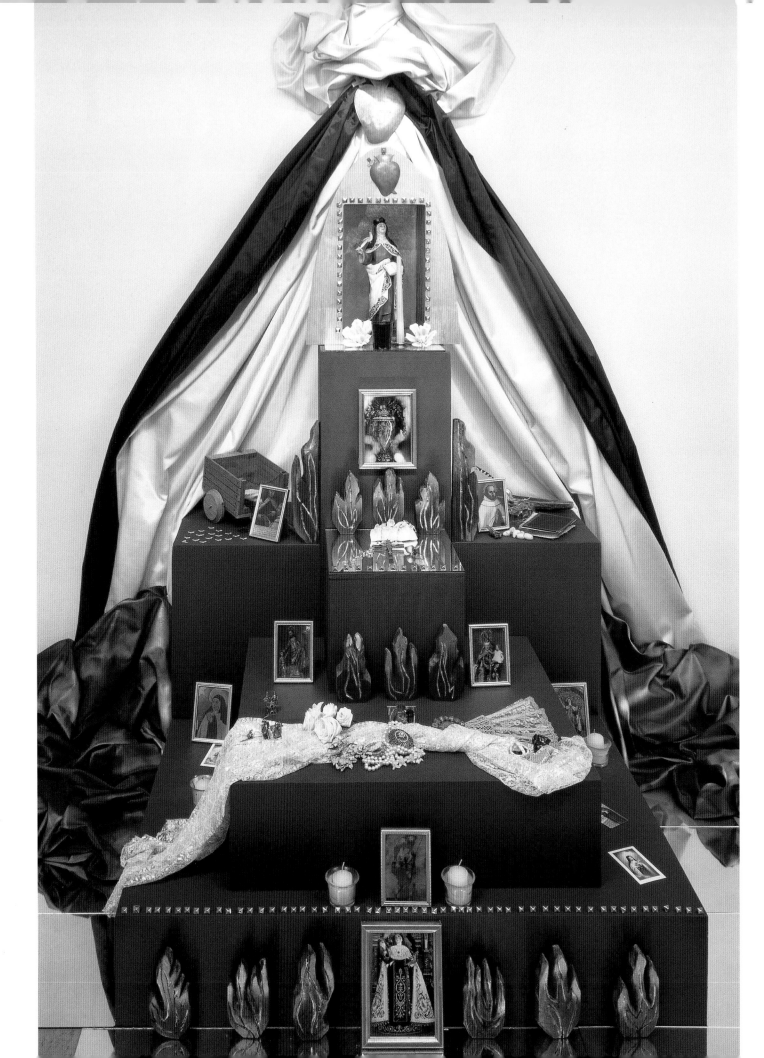

women. It even uses a typically "female" technique, embroidery. The saint is shown as a capable, dominant figure, totally unapologetic about her assumption of authority. This is in line with what we know about her life. Born in England, she was summoned by her brother St. Winebald to help him rule his newly founded monastery of Heidenheim in Germany. This institution contained both monks and nuns. After St. Winebald's death in 761, Walpurga ruled over the whole monastery.

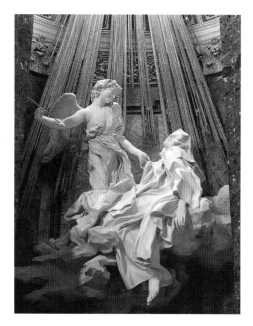

But her legend, too, like Mary Magdalene's, acquired an element of confusion. After her death St. Walpurga became identified with Waldborg, a German pre-Christian fertility goddess. On Walpurgis Night, the eve of her feast day, which falls on May 1, witches—in other words the servants of the old goddess-worshiping religion, later falsely portrayed as servants of the Devil—were believed to gather in the Harz Mountains. Even in nun's clothing, as she is portrayed here, St. Walpurga's image can be regarded as being yet another—wholly unexpected—example of a representation of the Great Mother figure.

Some of the most familiar images of female sainthood represent saints in ecstasy. Perhaps the best known is the altar by Gianlorenzo Bernini (1598–1680) in Santa Maria della Vittoria in Rome, which celebrates *St. Teresa of Ávila* (1515–82, canonized 1622). This sculpture follows the text of the saint's own autobiography, in which she describes how an angel pierced her heart with a fiery arrow of divine love. Both the description itself and Bernini's physical embodiment have strong sexual overtones—the saint, as he shows her, seems to be in the throes of orgasm. This emphasis on a female hero's helpless bondage to sexuality might perhaps be read as a way of denying her power. There is no hint here of the capable and persistent ecclesiastical reformer which we know St. Teresa to have been, and certainly none of the intense asceticism which in reality typified her character.

Nevertheless, as forthright celebration of the powers of named, individual women, Bernini's altar and other works of the same genre have had a liberating effect on a number of contemporary female artists looking for new ways of asserting the achievements of their gender. The work by Amelia Mesa-Bains illustrated here is a case in point. It celebrates St. Teresa not only as a heroic woman but also as an integral part of the Hispanic heritage—someone whom Hispanic women can still look up to as an example to follow.

Judy Chicago One of the few early paths to what is commonly thought of as a heroic life was through sainthood, achieved through self-sacrifice, piety, and passionate belief. But according to Teresa of Ávila (1515–82), one of the greatest mystic writers of all time, sainthood for women wasn't all that great: "The very thought that I am a woman is enough to make my wings droop." Nonetheless, in *The Way of Perfection*, she made the point that although convent life might be difficult, it was "better than being a wife."

In Bernini's gorgeous but sexualized image of this great woman, it is hard to recognize the valiant person who not only challenged the apostolic precept which forbade women to teach but also single-handedly reformed the Carmelite order, establishing 16 nunneries for women and 14 religious houses for men.

It was St. Teresa's achievements and her example that inspired contemporary artists such as Amelia Mesa-Bains to honor her, while claiming long-overdue recognition for her as a woman of Hispanic heritage.

above: **GIANLORENZO BERNINI**
The Ecstasy of St. Teresa of Ávila (1645–52);
Santa Maria della Vittoria, Rome

main picture: **AMELIA MESA-BAINS**
Renunciation and Denial: Altar for St. Teresa of Ávila (1984)

Judy Chicago While there are countless images of male warriors, comparable heroic representations of women are rare, which is one reason why there has been so much fascination with the mythology surrounding the Amazons. Whether they truly existed or are historical fabrications, these warrior women offer an alluring symbol of female power.

As for Joan of Arc, her story is so wrapped up with male political intrigue—in which she was both pawn and martyr—that her situation is somewhat ambiguous, as suggested by the two images that appear here. The miniature depicts a failed mission, while the Ingres painting deals with her success in achieving Charles VII's coronation.

Yet, to this viewer at least, the miniature is far more appealing, as it presents a picture of a woman who is decidedly in charge, whereas the Ingres—despite its visual beauty—suggests a heroine who is either exhausted by her mission or who is already on her way to a posthumous existence as a saint. In either of these cases, a heroic woman's actions have been ignored by the artist in favor of a pleasing and positive image.

above: *Joan of Arc Before Paris, 1429* (from *Les Vigiles de Charles VII*, mid-fifteenth century); Bibliothèque Nationale, Paris

right: *Wounded Amazon* (Roman copy of a bronze original by Cresilas, second half of the fifth century BC); Pergamon Museum, Berlin

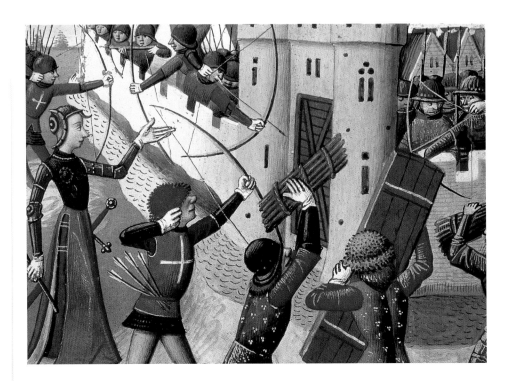

WARRIOR WOMEN

St. Teresa can be seen, and is indeed seen by believers, as a warrior for the Christian faith. Though in theory a paradoxical reversal of established gender roles, the idea of the warrior woman is in fact deeply rooted in Western culture. From the ancient Greek world came the legend of the Amazons, a tribe consisting of women who lived separately but mated with men of another people, keeping only the female children thus produced. These they brought up to be warriors like themselves. In order to facilitate their use of the bow, they amputated one breast. Combats between Amazons and Greeks were a favorite subject in Greek art, and in the mid-fifth century BC a famous statue of an Amazon was created by the sculptor Cresilas. This is thought to survive in a number of Roman copies.

It is significant that Cresilas's Amazon is portrayed as wounded—the wound, scarcely visible in the photograph, is under her raised arm and accounts for the weariness of her stance. This wound is symbolic of her loss of martial power after encountering those—presumably Greek and male—who had proved superior to her in battle.

The most famous "warrior woman" in Western history is undoubtedly Joan of Arc, born c. 1412, burnt at the stake in 1431, and finally canonized in 1920. In response to visions that came to her when she was living at Domrémy, a small village on the borders of Lorraine, Joan crossed France to the court of the future Charles VII at Chinon. There she inspired the dispirited French forces to raise the siege of the city of Orléans—then on the point of being captured by the English—and led the king to his belated coronation at Reims, thus **legitimizing a monarch whose claim seemed precarious.**

In one sense Joan fits a fairly common late medieval pattern—that of the individual who comes from nowhere but, claiming visionary inspiration, asserts the right to instruct and often to overrule secular power, thus leapfrogging, so to speak, all the gradations of the rigid social hierarchy of the period. Though both men and women took this path, it was of more importance to women, since it was one of the few ways in which members of the female sex could play a major role in the direction of affairs. The strategy was always high risk—the majority of these prophets and prophetesses were rapidly discredited, and then usually either imprisoned or executed. One of the few exceptions to this was Joan's near-contemporary St. Bridget of Sweden (c. 1303–73), a mystic and reformer who played a part in ending the exile of the papacy to Avignon, though this was not finally terminated until four years after her death. But Bridget's visions were not widely known until an account of them was published in 1492.

Though Joan in theory failed—her execution as a heretic was meant to put an end to her influence—her story became so closely entangled with the renascent prestige of the French monarchy that she remained for many years a nagging political and religious issue. Shortly after his triumphal entry into Rouen in 1450, which marked the decisive defeat of the invading English, Charles VII ordered an enquiry into her trial, which had been held there. Two years later, a fuller investigation, the so-called Trial of Rehabilitation, took place, and Joan, despite stout resistance from some of her surviving judges from the University of Paris, was officially exonerated. This exoneration was confirmed by Pope Calixtus III in 1456, and her condemnation for heresy was annulled. The medieval miniature illustrated here belongs to the first period of the revival of her reputation. It stresses her importance by making her larger than the other figures shown, but does not idealize her appearance. Though the miniature gives her such a commanding and active role, the incident it illustrates represents not one of Joan's successes but the first check in her career—her failure to take Paris in September 1429.

The painting of Joan by J. A. D. Ingres (1780–1867), painted in 1854, belongs to a very different historical and psychological climate. Its context is that of nostalgic Bourbon legitimism, after the overthrow in 1848 of the last Bourbon ruler of France, Louis Philippe, and his replacement by Napoleon III. Ingres's picture, which shows Joan at Charles VII's coronation in Reims cathedral, standing beside the altar carrying her banner, was intended to assert a mystical connection between the monarchy and divine right. Joan had now become a convenient emblem of this, whereas in the eighteenth century her legend had been cruelly satirized, notably in Voltaire's cynical mock-epic poem *La Pucelle* (1755). Ingres's picture also marks the beginning of something of more significance for the future—the French nineteenth-century nationalist upsurge which led to Joan's belated canonization following the French victory in World War I. Compared with the medieval miniature, the Joan shown here is passive. She does not act, she is content to play a purely symbolic role.

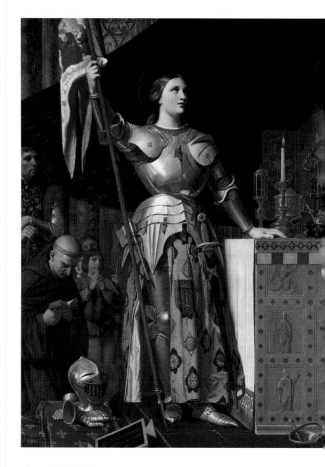

above: **J. A. D. INGRES**
Joan of Arc (1854); Louvre, Paris

One reason I wished to juxtapose these two images was to discuss the difference between an allegorical figure of a female hero—such as Delacroix's *Liberty Guiding the People*—and that of an actual heroic woman, particularly one depicted by a woman artist, like Catlett's marvelous woodcut of the antislavery campaigner Harriet Tubman.

Although the Delacroix is undoubtedly the more significant picture in art historical terms (due to its size, technique, and agreed-upon stature), the fact that its heroine is not an actual woman is irksome, especially in light of the leadership role women have played in many revolutions, not least the French Revolution.

In contrast to Delacroix, who denied women an authentic heroism in favor of using a woman as a symbol for a revolution which ultimately betrayed women, Catlett chose to represent a real woman who is powerful, strong, black, and determined.

This choice not only acknowledges the importance of Harriet Tubman but also challenges traditional images of women in general and black women in particular. As for the idea that her *Harriet* mimics the posture of Delacroix's *Liberty*, all I can say is, *give me a real woman any time.*

above: **EUGÈNE DELACROIX**

Liberty Guiding the People (1830); Louvre, Paris

main picture: **ELIZABETH CATLETT**

Harriet (1975);

Hampton University Museum, Virginia

ALLEGORY VERSUS REALITY

The complex history of the development and modification of Joan of Arc's posthumous reputation demonstrates how a historical figure can gradually assume allegorical and symbolic attributes, to the point where the real human personality almost vanishes beneath the weight of these accretions. Representations of women have also frequently acted as a vehicle for allegorical personification where no specific personality is involved. Some contemporary feminist theorists object violently to this practice. They see it as a means of depriving women of their true personalities and of reducing them yet again to the status of objects.

Nevertheless, some of these personifications have enjoyed a long life. A good example is *Liberty Guiding the People*, by Eugène Delacroix (1798–1863). Painted in 1830, the picture commemorates the July Revolution which had just overthrown the restored Bourbons of the senior line and installed in their place the more liberal Louis Philippe.

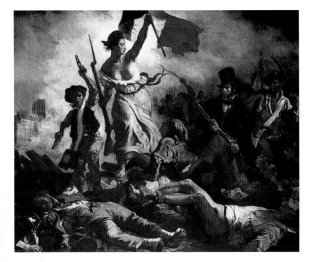

Liberty Guiding the People has been an enduring success which has long transcended the political circumstances that gave it birth. The courageous, free-spirited woman whom Delacroix shows mounting the barricades has provided a role model for women in real life and also a useful template for compositions by other artists. Elizabeth Catlett (b. 1919) clearly borrows from Delacroix in her powerful woodcut *Harriet*—an image by a black female artist celebrating Harriet Tubman (c. 1820–1913), perhaps the most prominent black woman in the movement for abolition of slavery in the United States. This borrowing is wonderfully appropriate, since Tubman did quite literally lead members of her race to freedom in the North—sometimes even threatening them with a revolver to force them to go forward. Her fellow abolitionist John Brown referred to her admiringly as "General Tubman."

The link between Catlett's composition and that of Delacroix raises a question often asked somewhat angrily by feminists—should one refer an image of this kind by a woman to a male source, since this (in their view) tends to diminish female achievement? The answer is that Catlett, like many other women artists, belongs to a broad artistic tradition which includes both males and females. To identify the apparent source of an image gives a better idea of how it works in its new context, but does not necessarily make it either less original or less powerful.

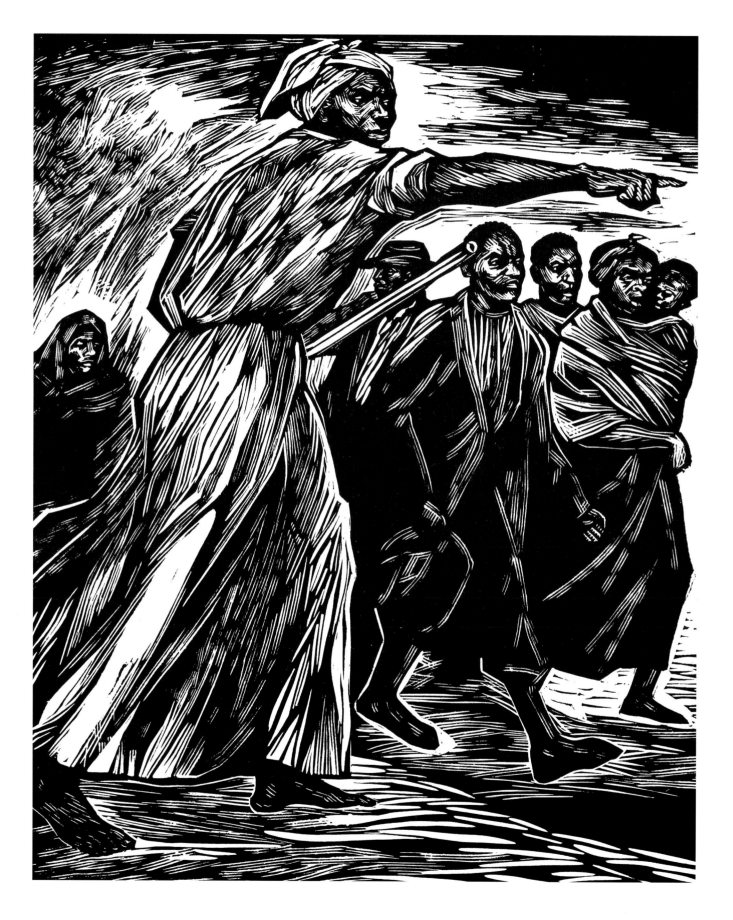

 Ever since the fifteenth century, when the writer Christine de Pisan attempted to construct a history of women in her *Book of the City of Ladies*, women have endeavored to place themselves within a historical tradition of their own, primarily through literature or art. Such efforts might best be understood as an effort to counter women's general excision from history.

One method of accomplishing this in visual art was through the creation of statuary honoring historical or biblical women with whom the artist identified. For example, in speaking of her sculpture of the biblical *Hagar* in 1875, Edmonia Lewis stated that she had a strong sympathy for all women who have struggled and suffered.

right: EDMONIA LEWIS
Hagar (1875);
National Museum of American Art,
Washington, D.C.

far right: HARRIET
GOODHUE HOSMER
Zenobia in Chains (1859);
Wadsworth Atheneum,
Hartford, Connecticut

TILTING THE SCALES

Catlett is one of a number of American women artists, both white and black, who have attempted to create appropriate images of historical and allegorical figures to symbolize their struggle for equality, in the area of race as well as gender. It would be nice to be able to say that the works that the pioneer members of this group produced are dazzling masterpieces, sudden manifestations of repressed genius, but this is not the case. Instead they tend to be worthy, honorable attempts to say something necessary and different, which are all to some extent frustrated by their adherence to the artistic conventions of their time.

Of the two sculptors whose work is illustrated here, Harriet Hosmer (1830–1908) is probably the best known. Her *Zenobia* was exhibited in the International Exhibition held in London in 1862. She was one of a group of American women sculptors—nicknamed "the white marmoreal" flock—who lived in Rome in the nineteenth century. Her choice of subject and her presentation of it both have things to tell us. Captive women had great appeal for the nineteenth-century audience. Another American sculptor who was living and working in Italy, Hiram Powers (1803–73), had previously scored a huge international success with his *Greek Slave*, shown at the Great Exhibition of 1851, also held in London. Both artists worked in marble, in the conventional academic style of their period, but there is nevertheless a great contrast between their two captive figures. Hosmer's is a historical personality—Zenobia, Queen of Palmyra (d. after AD 274), who led a revolt against the Roman Empire. She is fully clothed, whereas Powers's statue is nude and represents an anonymous victim of the Greek War of Independence, then still vivid in public memory.

Hosmer's sculpture, though never as notorious as that of Powers, did attract a good deal of public attention. Part of this fascination, however, was due to the claim made in the press, notably in the *Art Journal*, that Hosmer could not have made it herself, but must have relied almost entirely on assistants. Hosmer thought that the attack was prompted by her gender, and contemporary evidence shows that this was the case. In later life Hosmer was identified with the women's rights movement, but even earlier, with *Zenobia*, her choice of subject—a captive ruler—offered a comment on the condition of women in general.

Hagar, by the black, and also partly Native American, sculptor Edmonia Lewis (c. 1844–after 1911), who also lived and worked in Rome, carries a similar burden of comment, simply through the choice of subject. Hagar was Abraham's Egyptian concubine—harshly treated by his legitimate wife, Sarah—who fled into the desert and was succored there by an angel. Later she gave birth to Ishmael, who has become the type of the outcast. But, while the subject hints at rebellion, the style is once again tamely academic. Recent reactions to Lewis's sculpture indicate the difficulty of finding any kind of middle ground in dealing with work of this type. Too much emphasis on her racial background and her gender have the effect of trivializing her ambition, which was to be seen not as some kind of strange phenomenon but as a sculptor working on equal terms with the other sculptors who surrounded her. When Lewis talked about her own background she tended to stress her Native American ancestry rather than her African heritage, and she made a number of sculptures on Indian themes, most of which are now lost.

The Awakening of Ethiopia, by another black woman sculptor, Meta Vaux Warwick Fuller (1877–1968), who belonged to a somewhat younger generation, is more directly concerned with the theme of black liberation than Lewis's Hagar. A young African woman, wearing the headdress of an ancient Egyptian queen, is shown emerging from the wrappings of a mummy. The image reflects the desire to link contemporary African-American cultural endeavors with the prestigious past represented by pharaonic Egypt. Though Fuller was older than most of the male members of the Harlem Renaissance, this work in particular became emblematic of the resurgence of African-American art which took place in the 1920s and, despite its somewhat unadventurous style, retains strong symbolic value today.

For all their evident inadequacies, these sculptures can be regarded as genuine forerunners of the feminist art movement that arose in the United States in the 1970s. One major parallel is the concern with actual content. While the artists who created this movement raged at the oppression of women, making works which were cathartic because of their emotional violence, they also sought to celebrate women's achievements, long hidden by history. The culmination of this effort was the massive installation *The Dinner Party* created by Judy Chicago (b. 1939), the coauthor of this book. Presented in the form of a triple Eucharist, which singled out 39 famous women who had altered the course of human history—but also found space to mention numerous others—the work made a point of using skills that have been thought of as specifically female, such as stitchery and china painting, as an integral part of the installation.

Chicago, even more than predecessors such as Hosmer, ran into criticism for the ambitious nature of her enterprise. Many male viewers, and some feminists also, took offense at the nature of her imagery, which seemed to place

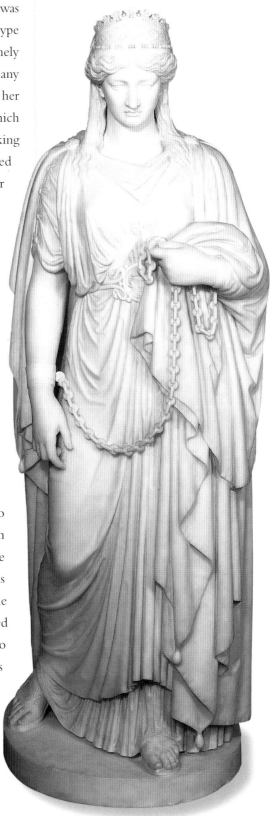

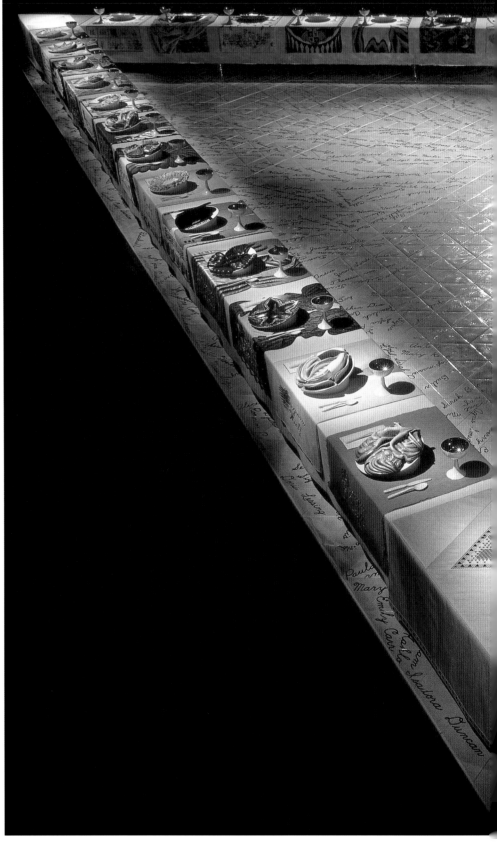

right: **JUDY CHICAGO**
The Dinner Party (1979)

the emphasis on the physical differences between men and women—the plates at her *Dinner Party* were inspired by the form of the vulva—rather than on the inequalities imposed by the social context. Chicago has always said that her primary aim was not to stress difference but to celebrate women's achievement in the face of all odds. *The Dinner Party* is now recognized as being both a key event in the history of the women's

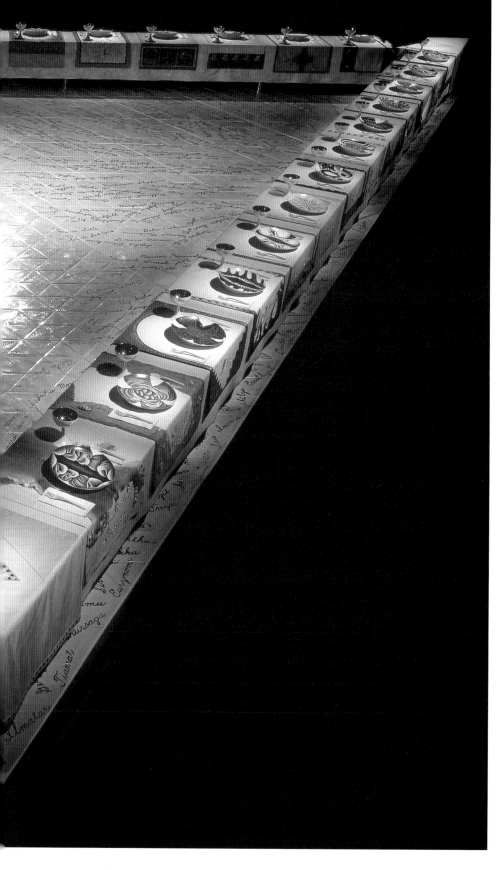

On page 42 I mentioned how Edmonia Lewis had spoken of her identification with struggling and oppressed women. This same feeling was one of my motivations in attempting to create a symbolic history of women with *The Dinner Party*. My dream was to create a work of art that would impact sufficiently on the culture to end the cycle of repetition so aptly described by Gerda Lerner in *The Creation of Feminist Consciousness* (1993) :

> *Men develop ideas and systems of explanation by absorbing past knowledge and critiquing and superseding it. Women, ignorant of their own history, did [do] not know what women before them had thought and taught. So generation after generation, they struggle[d] for insights others had already had before them ... resulting in ... the constant reinventing of the wheel.*

movement and also a defining moment in the history of American art. It also signaled the return to content, long in abeyance since the triumph of minimalist art in the late 1960s, and a new willingness to reconsider the role of the decorative. A number of male artists, such as the Los Angeles painter Lari Pittman (b. 1952), have acknowledged the influence it had on their work.

Judy Chicago There are a number of reasons why Artemisia Gentileschi became a heroine to my generation of women, including me. First, she was one of the first women to make a living from her art (an accomplishment that still eludes many of us). Second, in a period in which women artists were typically confined in their subject matter to diminutive still lifes or modest portraits, Artemisia worked in the grand tradition, turning out large narrative compositions.

But the most significant reason for her greatness is that she was one of the first women to twist mainstream art practice to include her own perspective as a woman, not only by focusing upon and honoring biblical heroines, but also by interceding in traditional narratives to present a female viewpoint.

To understand the crucial importance of this act, it is necessary to realize that women artists of her time had little choice but to work within the tradition of art history (if they were sufficiently fortunate to obtain the training to do so). This tradition was, of course, shaped by men.

Once included, women's options were few—they could assume a male perspective, or "male drag" as I described it in the introduction, or they could avoid the problem altogether by staying within the limited areas of art considered appropriate for women. Rarely did women take on the more challenging task of attempting to infiltrate the existing language of art with their own experience as women, which is what Artemisia did, particularly in the work which earned her a place as a feminist heroine, *Judith Slaying Holofernes*.

THE LEGEND OF JUDITH

If *Hagar* and *Zenobia* offered women artists a chance to comment on their own condition, and on the situation of women in general, the same might perhaps be said—and has recently sometimes been said with great emphasis—about the biblical legend of Judith and Holofernes. Further investigation of the cultural context for this story indicates a need to be careful. The book of Judith in the Apocrypha (it is included in the Roman canon, but not in the Hebrew or Protestant one) is a piece of patriotic fiction, which tells the story of how a virtuous Jewish woman saved her people from the army of the Assyrians. She does so by getting the enemy general, Holofernes, drunk, then cutting off his head. The many anachronisms included in the story make certain that it cannot be regarded as true history, but Judith attained wide popularity as the type of the independent heroine who acts on her own initiative. For the Florentines of the fifteenth century, for example, she was the symbol of the resistance of the Florentine Republic to papal and other attempts to dominate the city, and this is the significance

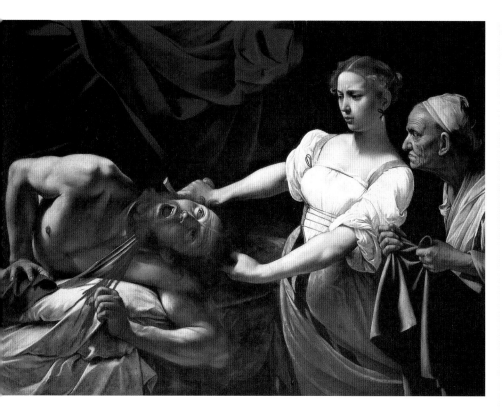

often attached to the celebrated statue of Judith made by Donatello, and placed outside the Palazzo Vecchio. Ironically, however, the statue was made for a non-Florentine patron and only later acquired by the Medici, who were largely responsible for removing the political liberties of the city.

The most celebrated representation of Judith, next to Donatello's version, is now the painting by Artemisia Gentileschi (1593–1652/53). Artemisia has attracted attention not only for her career as a successful woman painter, at a time when women painters were extremely rare, but also because she was raped by another painter, Agostino Tassi, whose pupil she was. The documents concerning this trial have been extensively published and have raised Artemisia to the position of feminist heroine. Her Judith has been seen as her own commentary on her ordeal—a perception reinforced by the fact that her father, Orazio Gentileschi (1562–1639), also a painter, used his daughter as the model for his own version of Judith.

This "personal" interpretation of Artemisia's painting has proven extremely popular in recent years for understandable reasons, but one inconvenient fact stands in its way. The painting by Caravaggio (1573–1610) of the same incident, in which Judith violently severs Holofernes's head, is quite clearly the inspiration for Artemisia's composition. Throughout her career Artemisia was influenced by Caravaggio's highly individual style. To some extent, we have to make a choice between a personal interpretation and a more purely art historical one. If Artemisia made this painting a vehicle for her own feelings, these were poured into a stylistic vessel which was not completely her own.

Accomplishing such a subversion of subject matter within the constraints of the framework of art history is something to be profoundly admired. To focus only on the formalist similarities between Artemisia's *Judith* and that of Caravaggio or other male artists is to privilege form over content. This is one of the methods by which male critics and historians—even friendly ones like Ted—maintain control over the evaluation of art, thereby devaluing women's art, whose radical nature—yes, even greatness—often lies in the subject matter or its attitude toward that subject matter.

above left: **CARAVAGGIO**
Judith and Holofernes (1598–99);
National Gallery of Antique Art, Rome

above right: **CINDY SHERMAN**
Untitled (1990)

left: **ARTEMISIA GENTILESCHI**
Judith and Holofernes (before 1621); Uffizi Gallery, Florence

One indication of the difficulties surrounding the interpretation of Artemisia's life and work is provided by the film *Artemisia* (1998). Though obviously inspired by feminist interest in the artist—and made by a woman director, Agnès Merlet—the film changes the story to turn Tassi into a sort of hero and Artemisia into a young woman who is in love with him. The fictional Artemisia therefore becomes a total betrayal of the historically established one, and the film undermines itself.

It is undoubtedly the popularity of the Judith story as a feminist text which encouraged the contemporary artist Cindy Sherman (b. 1954) to portray herself as Judith in one of her autobiographical paraphrases of the Old Masters. Amusing as this portrayal is, it is marked by the curious undercurrent of self-dislike which marks so much of Sherman's work. Far from being an active, positive figure, Sherman's Judith stands rather limply, making a *moue* of distaste, Holofernes's severed head dangling almost forgotten from her hand.

DIFFERING VISIONS OF HEROISM

The portrayal of female heroism in Western art has, until recently, despite the occasional intervention of female artists like Artemisia, been largely dominated by males. Despite the examples of women in action illustrated here, the main part of the tradition often gives these supposedly heroic figures a curiously passive role. A good example is in the portrayal by Jan van Eyck (c. 1390–1441) of *St. Barbara*, who sits passively beside the tower in which she was supposedly imprisoned by her tyrannical father. Nothing indicates her position as the patron of artillerymen and protector against thunderstorms. But then, she acquired these attributes only because her father was struck by lightning and reduced to ashes after personally executing her following her conversion to Christianity. St. Barbara's story sounds highly unlikely, and it is not surprising to learn that she was recently struck from the official calendar of saints, on the grounds that her very existence cannot be clearly established.

The contemporary artist Paula Rego (b. 1935) takes a very different approach in her portrayal of a clearly female angel. Waving a sword with a briskly confident air, this personage has all the boldness we attribute to Joan of Arc. Rego is famous for her sardonic sense of humor, and it is not surprising to find that this personage is presented in a slightly deflationary way. The artist seems to admire the militant stance of her creation, while finding her also very slightly ridiculous. Yet it is worth noting that Rego's angel has an ambiguous side. In her other hand she carries a sponge, one of the instruments of the Passion—the sponge was used by an attendant soldier to offer vinegar to Christ when he was hanging on the cross.

above: **JAN VAN EYCK**

St. Barbara (unfinished; early fifteenth century); Koninklijk Museum voor Schone Kunsten, Antwerp, Belgium

right: **PAULA REGO**

Angel (1998); Marlborough Fine Art Gallery, London

Maternity

If men had babies, there would be thousands of images of the crowning.

above: **KÄTHE KOLLWITZ**

Portraits of Misery III

(from *Simplicissimus;* 1903–11)

main picture: **ALICE NEEL**

Margaret Evans Pregnant (1978);

Robert Miller Gallery, New York

EXPECTING

One of the most basic of all female images is that of woman as mother, but the various phases of pregnancy and birth are unevenly represented in art. The more boldly physical the representation, the more male artists have tended to shy away from it. Several slightly conflicting reasons can be suggested for this—that women's experience was not considered important enough to be worth representation; that there was an element of secrecy attached to certain female bodily functions; that women in the throes of giving birth were considered ritually unclean. For whatever reason, representations of heavily pregnant women and, still more so, of women in the process of giving birth are unusual in Western culture. In the Middle Ages, the Virgin is occasionally shown as pregnant, pointing to her swollen belly. The most famous example of this is Piero della Francesca's *Madonna del Parto* in the chapel of the cemetery of Monterchi near Arezzo, painted in the 1460s. The representation is always idealized.

More recently, representations of pregnancy have been made by women artists as a way of stressing the central importance of women as life-givers and the guardians of the future of the human race. Käthe Kollwitz (1867–1945), with her deep concern for the struggles of the industrial working class—which she knew at first hand because

her husband was a doctor who ran a clinic for the urban poor in Berlin—makes a weary, pregnant working-class woman into a symbol of endurance, but she also implies that the woman is the victim of all the accumulated social evils of her time.

One of the most striking of all twentieth-century images of pregnant women is a portrait by the American artist Alice Neel (1900–84). Neel's career followed a pattern not uncommon in the case of gifted female artists—many years of neglect followed by a sudden burst of recognition when she reached old age. In her case, neglect was intensified by the fact that her painting remained stubbornly figurative throughout a period when abstraction had become the dominant mode in American art. A high proportion of her work is made up of portraits of friends, who are portrayed with an unflinching eye for character. Incapable of compromise and—despite her gift for friendship—a compulsive non-joiner of artistic groups or movements, Neel often took a mischievous delight in creating confrontational images. When, late in her career, she made a portrait of Andy Warhol, then a major celebrity whose interest in her work was partly responsible for the belated establishment of her reputation, Neel insisted on showing the terrible scars which were the result of the attack made on him in 1968 by Valerie Solanas. Warhol, with his taste for publicity, concurred, where any other sitter would probably have refused. At first sight, Neel's portrait of *Margaret Evans Pregnant* follows a similar pattern, but the confrontational element is softened by the artist's evident feeling of reverence for the new life which is so soon to begin.

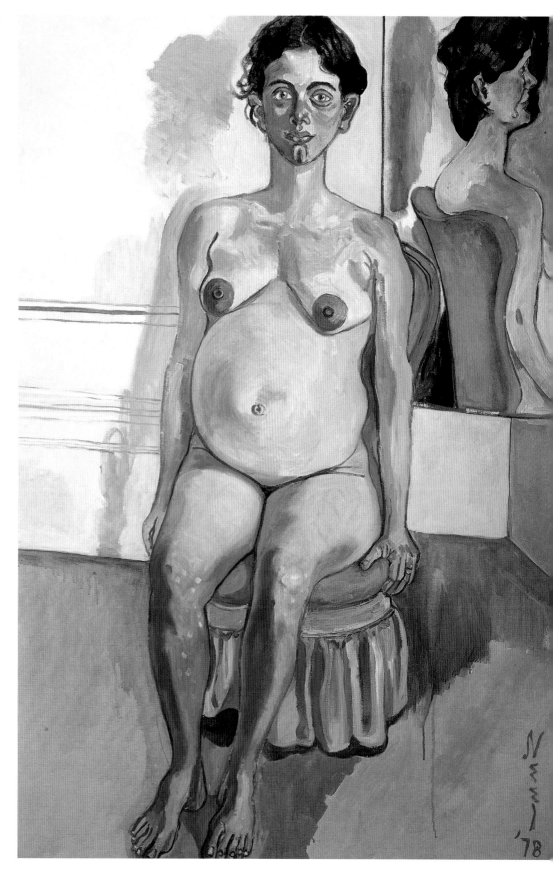

I, like many women artists of my generation, believed that maternity was antithetical to the creative life, primarily because of prevailing attitudes that one couldn't be a woman and an artist too; how then to be a mother and a painter? The idea that maternity and art don't go together has cropped up more than once in history, notably in a 1625 essay by Francis Bacon entitled "Of Marriage and the Single Life":

> He that hath wife and children hath given hostages to fortune; for they are the impediments to great enterprises ... Certainly the best works ... have proceeded from the unmarried or childless man.

FERTILITY / INFERTILITY

It is natural that representations of pregnant women or of women giving birth should concentrate on the notion of fertility. One can find other images as well. The Mexican photographer Marta Maria Perez Bravo (b. 1959) offers a disturbing self-portrait—she is shown threatening her own pregnant belly with a knife. The inscription implies that she does not wish to be reduced to the level of an animal.

Frida Kahlo (1907–54), unique in this as in so many other respects, made paintings about her own inability to give birth. Kahlo's failure to have children was intimately linked to her whole career as an artist. In 1925, still in her teens, Kahlo was involved in a serious bus accident. The injuries she sustained affected her health for the rest of her career and meant that she had to undergo numerous painful operations. It was during her long convalescence from this accident that she first started to paint. Largely self-taught, Kahlo based her style on Mexican folk paintings, notably on the retablos dedicated in churches, usually in thanksgiving for the dedicator's recovery from an illness or his or her escape from some other form of danger. Kahlo found in the naïve, very direct style of these paintings a vehicle for describing the vicissitudes of her own

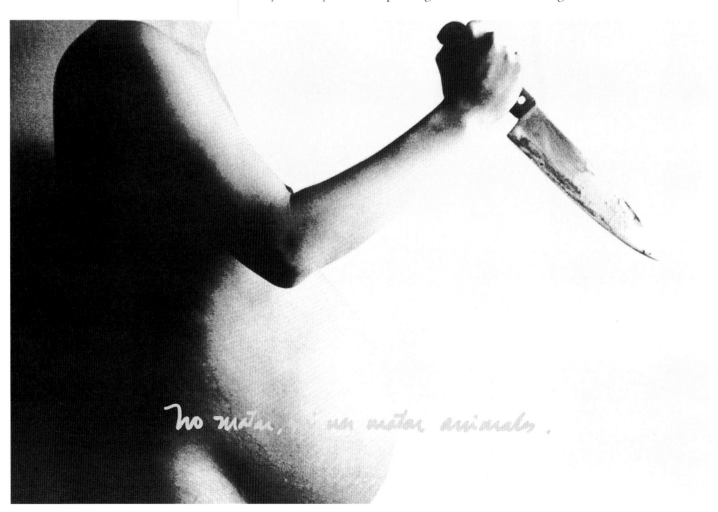

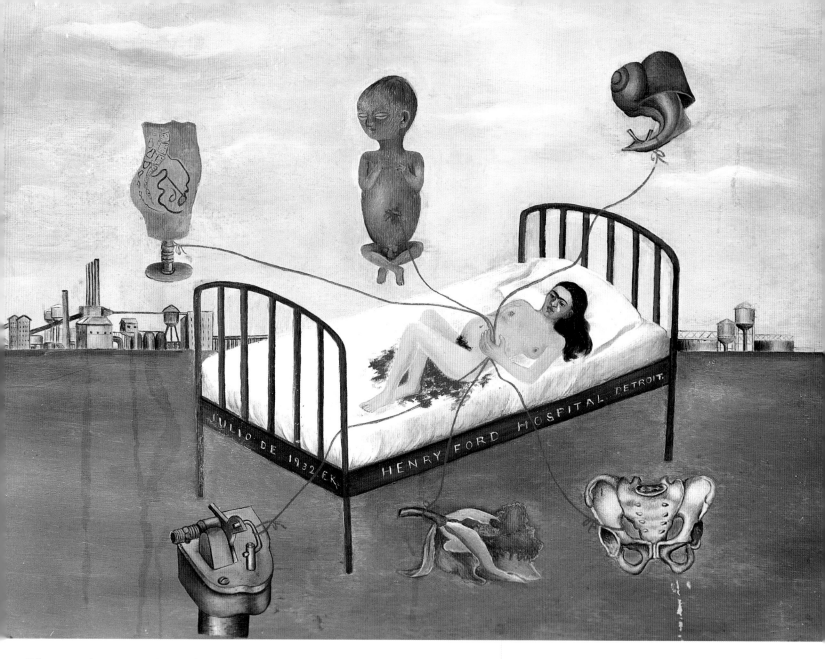

life. Major themes were her self-identification with Mexican culture and the Mexican people, her stormy marriage to the leading Mexican muralist Diego Rivera (1886–1957), and, linked to this, her own inability to carry a child to full term—one of the long-term consequences of her terrible accident. Kahlo's anguish over her miscarriages reflected a sense of incompleteness as a woman, which, in turn, was linked in her mind to Rivera's compulsive infidelity. A child would not only make her in her own eyes biologically complete but would also, she thought, make her husband less inclined to stray.

What is striking about Kahlo's art is its ability to deal with these especially painful and intimate concerns without the slightest circumlocution. No male artist of her time was able to speak about such matters. It is this ability to go straight to the point and to convey so clearly the extent of her suffering that has created her worldwide posthumous reputation. Diego Rivera, to his credit, always praised his wife's art, but even he might be astonished to see the extent to which her posthumous reputation has tended to surpass his own.

Nevertheless, many male creators were prodigious in their production of both art and progeny. But for a woman artist, a child usually brought with it increased responsibilities, less time to work, and a debilitating guilt when the intensity of work caused her to neglect her child or when child-rearing duties interfered with her creative life.

above: FRIDA KAHLO
Henry Ford Hospital or The Flying Bed (1932);
Fundación Dolores Olmedo Patino, Mexico City

left: MARTA MARIA PEREZ BRAVO
No Matar, Niver Matar Animales # 7 (Do Not Kill Animals nor See Them Be Killed) (1985–86);
Throckmorton Fine Art Gallery, New York

Judy Chicago The realization about the friction between maternity and artistic practice was brought home to me when, in the early 1980s, I undertook *The Birth Project*. Because there were then so few known contemporary images of birth, I based my early images upon personal testimonies, which, in addition to divulging the reality of the birth process, also attested to the many conflicts women experienced, particularly creative women.

THE MOMENT OF BIRTH

Images of women actually giving birth, though they do not commonly occur in Western culture, can be found in other contexts. Some of the most striking can be found in pre-Columbian art. The sculptures and ceramics showing women in the throes of delivering children are clearly linked to complex fertility cults. The Aztecs of Central Mexico, for example, inherited a large pantheon of fertility gods and goddesses from the tribes who preceded them on the plateau. They included a number of earth goddesses, often imperfectly differentiated from one another, who were concerned with the fecundity of both the soil and women. In this context it is not surprising to find a range of forthright birth images.

> *In almost all cultures, pregnancy, birth, and nursing are interpreted by both sexes as handicapping experiences; as a consequence women have been made to feel that by virtue of their biological functions they have been biologically, naturally, placed in an inferior position to men.* ASHLEY MONTAGU, 1952

In contrast, similar images are most often lacking in traditional Western art—the nearest Christian art gets to this theme is probably in representations of the birth of the Virgin, and in these the baby is already safely delivered and is being washed or wrapped in its swaddling bands by the mother's attendants.

Recently, perhaps because of the increasing tendency for fathers to be present at the births of their children, the image has become less taboo. The English painter Jonathan Waller (b. 1956), for example, has recently produced a long series of extremely realistic images showing women giving birth. Having produced them, he nevertheless encountered a good deal of difficulty in getting them exhibited. The continuing squeamishness of the contemporary audience when confronted with this range of imagery has something to tell us concerning modern society in general. We live in a world where images of the female nude are more and more freely distributed, and where the ban on representations of actual copulation is frequently disregarded. But the logical consequence of copulation, which is the creation of new life, is still a subject which museums tend not to exhibit and which some spectators find difficult to look at. The societies we call "primitive" are consistently franker in their representation of the whole sexual cycle. For them birth is an act whose sacredness cannot be denied, though they also frequently believe that the woman who is in the process of giving birth, or who has just given birth, is in some way ritually unclean. They also, to our eyes rather amusingly, in some cases evolve rituals where men take over the woman's pain.

left: ***The Goddess Tlazolteotl in the Act of Childbirth*** (fifteenth century); Dumbarton Oaks Collection, Washington, D.C.

main picture: **JONATHAN WALLER** ***Mother No. 27*** (1996)

Throughout the years of *The Birth Project* I was involved in what might best be described as hand-to-hand combat with the many obstacles to focused work faced by my needleworkers.

Personally, I had looked to the lives of earlier creative women like Virginia Woolf, Georgia O'Keeffe, and Anaïs Nin, all of whom had been childless and hence unencumbered, as Bacon suggested the creative person had to be. "One cannot have everything in life," I told myself, and felt fortunate that my own biological needs were entirely drowned out by an overpowering creative drive.

Not that I would argue that my path represents the best alternative, but until the model for achievement is no longer the unencumbered individual described by Bacon, women artists will face choices that are neither fair nor humane.

above: **JEAN FOUQUET**
Virgin and Child (mid-fifteenth century); Koninklijk Museum voor Schone Kunsten, Antwerp, Belgium

main picture: **PAULA MODERSOHN-BECKER**
Nursing Mother (date unknown); Kunsthalle, Bremen, Germany

AT THE BREAST

Representations of infants at the breast did enjoy an established place in Christian iconography, as a standard way of representing the Virgin and her Son. They were especially popular toward the end of the Middle Ages. One of the best-known examples is Jean Fouquet's *Virgin and Child*. Fouquet (c. 1420–c. 1481) executed the painting for the Chancellor of Charles VII of France, Étienne Chevallier. The other panel of what was originally a diptych, though the two halves are now separated, is a portrait of Chevallier himself, shown as the donor of the work. The Virgin is also a portrait, an unmistakable likeness of the beautiful Agnès Sorel, mistress of the then-aging king who had once been the patron of Joan of Arc. She is represented richly dressed, wearing a sumptuous crown over the shaven forehead fashionable at the time.

The signals that the image sends out are distinctly mixed. On the one hand it is a devotional image of a kind already familiar to its intended audience. On the other, it seems intent on emphasizing the erotic impact made by Agnès's beauty, and perhaps also on asserting her aspirations to quasiroyal status. Perhaps for these reasons the exposed breast has a somewhat voyeuristic effect.

A painting of the same subject, a mother breast-feeding her child, by the German painter Paula Modersohn-Becker (1876–1907), has much greater directness and simplicity of feeling. Her image of a mother feeding her child is painted strictly for its own sake, with no religious, cultural, or even social overtones, though critics have detected some similarities between Modersohn-Becker's work and that of her contemporary Käthe Kollwitz. Speaking of a similar scene, encountered somewhat earlier in her career, Modersohn-Becker noted in her diary:

> I sketched a young mother with her child at her breast, sitting in a smoky hut. If only I could someday paint what I felt then! A sweet woman, an image of charity. She was nursing her big, year-old bambino, when with defiant eyes her four-year-old daughter snatched for her breast until she was given it. And the woman gave her life and her youth and her power to the child in utter simplicity, unaware that she was a heroine.

Modersohn-Becker was herself to give her life for a child. She died of an embolism, shortly after giving birth to a daughter.

Few comparisons between Modersohn-Becker and other artists are really fruitful, however, since she was an artist of great originality who pursued an essentially solitary path. Prolonged periods of study in France, which brought her into contact with the work of the turn-of-the-century Nabis and that of Gauguin, taught her chiefly to see painting not as literal representation but as a reflection of the emotion that the act of looking aroused in her. In this, she was a forerunner of German expressionism, although not formally associated with it. Her early death deprived the twentieth century of what may well have been its greatest woman artist.

Images of birth date back to the earliest period of human existence. Some of the most ancient extant works of Western art are depictions of a female being whose swollen belly and bulbous breasts testify to a time when the portrayal of pregnancy symbolized fecundity and inspired reverence and hope, though pregnancy in art would not always signify such optimism. Much later, it was to become the premise for sorrow, shame, or self-sacrifice, as was the intention of medieval images of the pregnant Virgin.

During the Greco-Roman period, birth began to be represented as something the male could also do, as suggested by the myth of Zeus giving birth to Athena through his head. This inversion of reality is also present in the Genesis-inspired image by Michelangelo in the Sistine Chapel, where a male God gives birth to Adam, who in turn produces Eve from his rib.

It is only in the twentieth century that the reality of birth as experienced by women begins to enter Western iconography once again.

The labor of She Who carries and bears is
the first labor all over the world
the waters are breaking everywhere
everywhere the waters are breaking
the labor of She Who carries and bears
and raises and rears is the first labor
there is no other first labor.

JUDY GRAHN, "SHE WHO," 1978

main picture: **EMILY CARR**
Totem Mother, Kitwancool (1928–29);
Vancouver Art Gallery, Canada

MOTHER LOVE

The bond between a mother and her child has also been represented in a multitude of different ways that do not involve the image of an infant suckling at the breast. In the eighteenth century, Marguerite Gérard (1761–1837), sister-in-law of Jean-Honoré Fragonard (1732–1806), with whom she frequently collaborated, made it the pretext for painting a charming domestic scene. Gérard's work has recently been the subject of some controversy. Far from being perceived simply as a producer of slightly over-sweet domestic scenes—*The Child's First Steps* is a typical example—she has been seen as someone who implicitly criticizes the fetishization of domesticity. Her sweetness and preciosity of touch are recontextualized in this new interpretation as the products of a concealed critical and satirical impulse. Appreciation of Gérard's art quality has been hampered by the link between her work and that of a more celebrated male artist. Art historians spend more time looking for Fragonard's contribution than they do examining what Gérard herself had to say.

Very different facets of the same emotional nexus can be found in the work of two twentieth-century artists, the Canadian Emily Carr (1871–1945) and the Maori painter Robyn Kahukiwa (b. 1940). Carr's *Totem Mother, Kitwancool* is inspired by Northwest Coast Native American art—specifically by a totem-pole figure found in a remote tribal village. Carr broadened the figure and exaggerated the massiveness of the head to make a greater contrast with the small infant. She was not trying to make a record of something she had seen, but instead of this to create something that would radiate a feeling of omnipotent power.

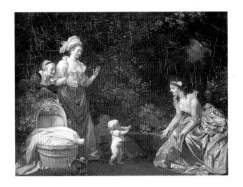

above: **MARGUERITE GÉRARD AND JEAN-HONORÉ FRAGONARD**
The Child's First Steps (1786–92);
Fogg Art Museum, Cambridge, Massachusetts

below: **ROBYN KAHUKIWA**
(left to right) *Papae / Threshold 1* (1997);
Papae / Threshold 2 (1997); *Whanau / Born* (1997)

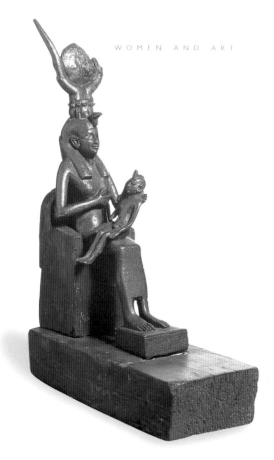

above: *Isis Suckling the Child Horus*
(c. 664–332 BC); Ashmolean Museum, Oxford, U.K.

main picture: **BERTHE MORISOT**
Le Berceau (1872); Musée d'Orsay, Paris

below: **BARBARA HEPWORTH**
Mother and Child (1934); Tate Gallery, London

Kahukiwa deals with material that is hers by direct inheritance, but tackles it in a new way. Of the paintings *Papae/Threshold 1 & 2* and *Whanau/Born*, the artist says:

They are about the actual time of birth and passing through the threshold into the world of light. The women refer to the carved ancestor figures of a [Maori] meeting house. They are shown in the squatting position taken by women in labor in traditional times. All three women are giving birth on papatuanuku, the Earth Mother, to symbolize the close relationship of the Maori with the land.

Because she is a woman, Kahukiwa is excluded from the traditional Maori way of making art, which is woodcarving. Like a number of other Maori women artists, she has therefore turned to oil painting—a European skill.

The mother-and-child theme is in fact subject to an almost infinite number of variations, and versions of it can be found throughout the history of European art. One of its roots is in the art of ancient Egypt, as can be seen from the elegant statuette of the goddess Isis and her infant son Horus illustrated here. This provides an obvious prototype for the seated Madonnas of the Middle Ages, the Renaissance, and still later periods. The potency of the image means that it can be stretched in any number of different directions, while still remaining immediately legible. There is a huge stylistic gulf, for example, between the mother and child by Berthe Morisot (1841–95)—a representation not only of maternal love but also of the bourgeois milieu in which French impressionism flourished—and the abstracted forms of the *Mother and Child*

sculpture by Barbara Hepworth (1903–75). But the message conveyed is very similar. In fact, we would not be able to construe the subject of the Hepworth as easily as we do if we did not have this long heritage of mother-and-child images available to support our reading of it.

The Christian religion endowed the image of the mother holding her infant with tragic overtones peculiar to itself. Standard Madonna compositions frequently include allusions to the Passion and the tragic fate that awaits the child who now rests in his mother's arms. These implications are more fully worked out in another standard Christian image, that of the Pietà, in which the dead body of Christ, newly taken down from the cross, is shown resting in his mother's lap.

The most famous version of the Pietà is undoubtedly the one created by Michelangelo (1475–1564) for St. Peter's in Rome. Working to commission for a French cardinal then living in Rome, Michelangelo took a poetic conception already rather awkwardly expressed in visual terms in northern Gothic art and tried to make it conform to the rational ideals of the Renaissance without losing any of its

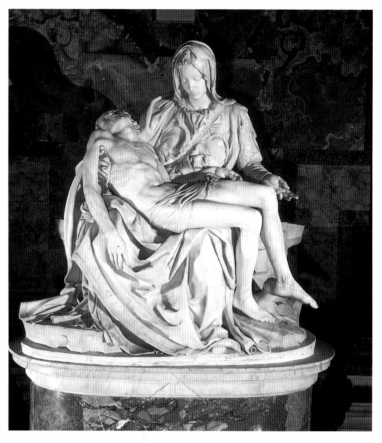

intrinsic emotional force. In order to do so he made many subtle adjustments. Few spectators notice, for example, that the Madonna, who has the face of a young girl, not a mature woman, is actually massive in proportion to the male body she holds in her lap. The mother and the force of love she represents thus triumph over the son's tragic fate, and an image of tragedy also becomes one of hope.

Like all great visual inventions, the formula Michelangelo evolved for the *Pietà* has enjoyed a long subsequent career. Traces of its influence can even reasonably be found in a recent powerful image created by the African-American photographer Renée Cox (b. 1958), though the figure of the mother is standing not seated, and though her child remains unequivocally a child. When Cox's photograph was shown as part of the 1996 *Sexual Politics* exhibition in Los Angeles, visitors to the show (as one of the attendants told me) immediately sensed the link with Michelangelo's sculpture, despite the wide historical and cultural gap.

Yo Mama is, despite some obvious parallels with the *Pietà*, primarily an image of an individual mother with an individual child. The mother's proud but slightly defensive stance and the child's expression suggest other possible meanings as well—for example, there may be a suggestion that we ought to remember the way in which slave mothers were often forcibly separated from their children. It is thus an extremely potent image for African-Americans.

Judy Chicago While working on *The Birth Project*, one question I was continually asked was how I, as a childless woman, could authentically represent the subject of birth. I always wondered if anyone had ever asked Michelangelo if he felt qualified to render the *Pietà*, given that he had never experienced the death—or the birth, for that matter—of a child. But then, perhaps this experiential lack helps to explain how he could have imagined for one moment that birth takes place by a male God reaching out his finger and creating a full-grown man.

above: **MICHELANGELO**
Pietà (1498–99); St. Peter's, Vatican City, Rome

main picture: **RENÉE COX**
Yo Mama (1993); Christine Rose Gallery, New York

Am I pushing or am I dying? . . .

I am pushing in the darkness, in utter

darkness. I am pushing until my eyes open

. . . and the pain makes me cry out.

A long animal howl.

ANAÏS NIN, 1948

CREATING LIFE

As one of the most fundamental of all human processes, birth itself has no need of any particular religious framework to give it an aura of the sacred. This expresses itself in many forms—very seriously in the Neolithic figure of a seated goddess in the act of giving birth found at Çatal Hüyük, near modern Konya in Turkey, during a series of excavations in the early 1960s; and ironically in the modern environmental sculpture *Hon*, created in 1965 by Niki de Saint-Phalle (b. 1930) for an exhibition at Moderna Museet in Stockholm. The Çatal Hüyük figure has been described by some authorities as being one of the earliest pieces of firm evidence for an organized system of religious belief. Radiocarbon testing places it between 6500 and 5800 BC.

far left: JUDY CHICAGO
Birth Tear/Tear, from *The Birth Project* (1982)

left: NIKI DE SAINT-PHALLE
Hon (1963)

below: *Mother Goddess Giving Birth Between Lions or Leopards* (c. 6500–5800 BC);
Hittite Museum, Ankara, Turkey

Hon was an 85-ft.- (26-m-) long reclining female figure which contained various compartments or rooms. The artist's conceit was that the public entered the sculpture via her vagina—thus reentering the womb—and exited by the same route—thus symbolically acknowledging her as their mother. Inside the sculpture were various rooms—one, directly within her breasts, contained a milk-bar. *Hon* was both a nice joke and, simply because of her scale and assertiveness, a clear declaration of new female power in the arts. It is not surprising that the figure has been coopted as a feminist emblem, though it was not originally intended that it should perform this function.

The most extensive artistic exploration of the artistic and spiritual significance of birth is Judy Chicago's *The Birth Project*, which dates from 1980 to 1985. *Birth Tear/Tear*, illustrated, is a statement not about the mystery of birth but about its violence—what it does to the female body. It can be compared to the more literal representation of the same trauma by Jonathan Waller (see page 55). Chicago chose a generically "gentle," feminine way of representing this violent act—silk embroidery on top of her own line drawing made on silk. Yet the nature of the materials is contradicted by the swirling lines of force, reminiscent of the work of Edvard Munch (1863–1944).

The controversy which has raged over Monica Sjoo's image *God Giving Birth* is an example of the double standard that is still alive and well in the art world. Whereas male artists indulge in and are rewarded for all manner of outrageous aesthetic acts—from masturbating under the floorboards of a gallery to urinating on a canvas and calling it art—women artists are continually castigated for daring to challenge the sacred cows.

However, the most destructive consequence of this double standard is that it deems male art practice great, while denigrating and erasing its female counterpart. Thus young women never see the rich aesthetic tradition of art created by women, a richness that is only hinted at in this chapter.

main picture: **MONICA SJOO**
God Giving Birth (1968);
Museum Anna Nordlander, Skellefteå, Sweden

above: **JUDY CHICAGO**
Godmother (1983)

SACRED BIRTH

Over the last couple of decades, some contemporary feminist artists have begun to propose the idea of birth as a sacred act, and of woman as life-giver. This is the basis of a new religion that is intended by its founders to challenge what are believed to be the prevalent patriarchal assumptions of traditional Christianity. One of the most powerful images associated with this emergent philosophy is the painting *God Giving Birth* by Monica Sjoo (b. 1938). This representation of a human-form female deity in the process of giving birth looks back to some of the Neolithic Anatolian and pre-Columbian representations of female divinities already cited—see *Coatilcue, Mother of the Lord of the Universe* on page 28, or *Mother Goddess Giving Birth Between Lions or Leopards* on page 64. The artist has said that it was inspired by the home birth of her second son in 1961, an event which she describes as her first mystical experience of the divine power of the Great Mother.

While it is impossible to establish whether a viable system of religious belief can in fact be created from these elements—such as scattered personal epiphanies, sheer force of will, and ingrained dislike for long-established Christian and Western traditions—the effort itself nevertheless illustrates the need felt by many contemporary women for an alternative spiritual perspective to the prevailing climate. This theme—which was also addressed in the first chapter—is one in which the fullest respect is accorded to the role of women as repositories of their own traditions, and as possessors of the unique means of nurturing and maintaining human life on this planet. Sjoo unequivocally considers herself a shaman—a term derived from Northern Asian spiritual communities, meaning a person regarded as having access to the world of good and evil spirits—and views her work as an artist as a form of shamanistic activity. *God Giving Birth*, which is a very early example of confrontational feminism in art, elicited extreme reactions when it was first exhibited in *Five Women Artists: Images of Womanpower* at the Swiss Cottage Library in London in 1973. At one stage the artist was threatened with prosecution for blasphemy and obscenity.

During the course of the Swiss Cottage exhibition, a well-attended public meeting was held at the Library. According to one of those present this soon degenerated, first into "vindictive abuse, uproar, and screaming," then finally into total chaos when a man in attendance pulled off his shirt and dramatically declared: "I may have a man's body, but I have a woman's soul." Yet, as John A. Walker concludes in his recent book *Art and Outrage* (1999):

> *Despite the crudity and amateurism of much of the art on display, the Swiss Cottage exhibition was a bold initiative which succeeded in its aim of demonstrating the power of women when they band together in pursuit of their emancipation. It also raised issues that were to be keenly debated in the years to come; it empowered many of the women who saw it and served to educate some male viewers.*

Daily Life

As a woman, I have no country,

As a woman, I want no country,

As a woman, the world is my country.

VIRGINIA WOOLF, "THREE GUINEAS," 1938

Judy Chicago Originally, this chapter was to have been focused only upon work, but the concept of work is limited by a gender framework. Work is usually construed to mean work for pay, but given that much of women's work in the world is unpaid, does this mean that what they do isn't working?

As it turned out there was a wide range of material depicting women's daily life, much of it unfamiliar, primarily because the images that are most often reproduced tend to emphasize female passivity rather than activity.

WOMEN AND THEIR WORLD

Western art offers innumerable images of women, and a great many of these show them engaged in everyday occupations of various sorts—the business of daily life. This chapter offers only a very small selection from this vast mass of visual information, though we have tried to select certain groupings that make particular points concerning women's relationships to a number of major human occupations. The concern has been to show them active rather than passive—passivity being the posture of too many of the standard images of women. The first group is concerned with women tilling the soil.

An image of a woman nurturing plants and tending the soil often carries strong symbolic overtones. This is the case with the brilliantly decorative *Spring Gardening—The Tale* by the early Russian modernist Natalia Goncharova (1881–1962). Goncharova belonged to a group of early twentieth-century Russian modernists who were strongly influenced by Russian folk art. In this case the impact made on the artist by *lubok*, or Russian folk prints, is clearly evident. These prints were sold cheaply by itinerant peddlers and were used as decoration in peasant homes. Goncharova's interest in them, shared by her fellow modernists, was inspired not only by their bold, simple, highly

decorative designs but also by the wave of cultural nationalism which swept intellectual circles in Russia in the years immediately before World War I. The harsh climate of Russia makes the coming of spring an especially dramatic natural event, and in this painting Goncharova both celebrates it and personifies it in female guise.

The barefooted female figures who appear in Goncharova's picture have another, more general ancestry in addition to the *lubok* prints just mentioned. They are descendants of the female peasants who appear regularly in European art from the Middle Ages onward, often, to begin with, in calendar miniatures representing the passage of the seasons included in books of hours. The artist seems to have intended these women to be personifications of Mother Earth herself—fecundity in human shape.

Within this genre male artists have created some of their most sympathetic portrayals of women. But no one has yet compared depictions of women at work (both paid and unpaid) by men with those by women artists, so at present we cannot adequately assess the differences between them.

above: **NATALIA GONCHAROVA**
Spring Gardening—The Tale (c. 1900);
Tate Gallery, London

right: **OSCAR BJÖRK**

Feeding the Cows (1890);

National Museum, Stockholm

bottom right: *Women Harvesting*

(detail from book illumination; end of the twelfth century);

Rheinisches Landesmuseum, Bonn

below: **JEAN-FRANÇOIS MILLET**

The Gleaners (1857); Musée d'Orsay, Paris

WORKING THE FIELDS

One of the nineteenth-century painters most concerned with agricultural labor as a basic metaphor for the whole of human existence was the French realist Jean-François Millet (1814–75). Millet spent his youth working on the land and was therefore intimately acquainted with the conditions that he depicted. He began to paint peasant subjects in the 1850s, and by the late 1860s had established a substantial artistic reputation, which eventually became fully international, American collectors being especially enthusiastic about his work.

Millet's appeal to bourgeois collectors was due in part to the impact of the Industrial Revolution, which increasingly tended to separate people from their roots in the land. In France, however, this revolution took place much more slowly than it did in, for example, Britain or the United States, and substantial parts of the old way of life remained unaltered. Millet, having experienced the harsh life of the French peasantry

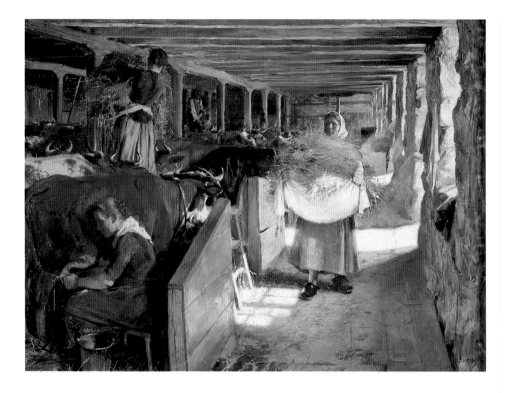

Judy Chicago From the earliest times, the survival of human societies depended upon the annual harvest, and people lived in harmony with the cycles of nature. Traditionally, women worked in partnership with men or by themselves on the planting, cultivating, and harvesting of food. As indicated in Ted's text, the Industrial Revolution drastically altered the relationship between human beings and nature, for both women and men.

The late eighteenth and early nineteenth centuries brought the cult of nature and a celebration of what amounted to a dying way of life. But long before this, women had been specifically associated with nature, as poetically described by Susan Griffin in the prologue to *Woman and Nature* (1978):

> *He says that woman speaks with nature.*
> *That she hears voices from under the earth.*
> *That wind blows in her ears and trees*
> *whisper to her. That the dead sing through*
> *her mouth and the cries of infants are clear*
> *to her. But for him this dialogue is over.*
> *He says he is not part of this world, that he*
> *was set on this world as a stranger. He sets*
> *himself apart from woman and nature.*

at first hand, was under no illusions about the degree of material deprivation suffered by the men and women who formed so large a part of his subject matter. There had in fact been a severe agricultural depression in France during his own youth, prompting food shortages and price rises, which played a large part in the overthrow of the regime of Louis Philippe in 1848. Memories of this episode fueled his later peasant scenes. But Millet also saw his peasants not just as individuals, but also as symbolic entities. His *Gleaners* are women determined not to waste anything the soil can offer—they work in collaboration with nature to make the most of her gifts. The painting stresses the idea that there is an age-old association between women and nature—a view that many contemporary women now reject.

The traditional nature of women's work in the fields is emphasized if Millet's painting and the German medieval book illumination *Women Harvesting*, shown here, are compared. A similarly timeless spirit radiates from the painting *Feeding the Cows* by the Swedish Salon realist Oscar Björk (1860-1929).

One further point is worth noting. In both the medieval illumination and the painting by Björk, we see women undertaking work which puts them on precisely equal terms with men. In the agricultural sphere, gender roles which had been established through the ages—where they did exist—often had to bow to the demands of sheer necessity. Tasks were performed by whichever hands were available to do them. This is not, however, the case with Millet's *Gleaners*, since the backbreaking job of following behind the harvest, gathering up the last ears of grain, was one traditionally reserved for women and children.

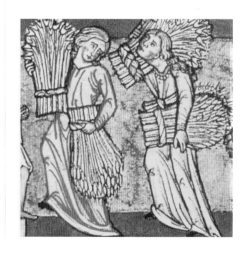

Judy Chicago Women have been associated with the textile arts since the earliest historical times. Various ancient myths and legends attribute the invention of spinning and weaving to female deities, who were thought to have taught these skills to women and sanctified their work.

In Egypt and Greece, textile production was usually in the hands of slaves, both male and female. However, goddesses continued to be associated with the fiber arts, as symbolized by the image of the Egyptian goddess Neith, who is usually depicted with a spindle on her head.

top: *A Woman Spinning and a Servant with a Fan* (700–600 BC); Louvre, Paris

right: **BERNHARD KEIL** *The Lacemaker* (late seventeenth century); Ashmolean Museum, Oxford, U.K.

SPINDLE AND NEEDLE

In contrast to agriculture, the textile arts have always been strongly associated with the female gender—a custom which expresses itself in traditional phraseology, such as "the distaff side," used to distinguish the female from the male members of a family. The association of spinning and weaving with women is very old—the relief from Susa illustrated on the left, dating from 700–600 BC, is one of a large number of such images which have come down to us from ancient civilizations. Textile arts play a prominent role in ancient literature as well—for example, there is the story of Penelope, Odysseus's wife, unpicking every night what she had woven during the day in order to fend off her unwanted suitors.

Nevertheless, one thing that the history of craft, followed by the history of industry, brings home to us is that the textile arts are neither an economic nor a social unity. When weaving became a quasi-industrial process, rather than a purely domestic one— as it did in the Low Countries during the later Middle Ages—the looms were taken over by men because working at the loom then became an occupation for the chief breadwinner in a family, stereotyped as male rather than female. In 1302 it was an army made up largely of the weavers of Flanders that routed an invading French army at the Battle of the Golden Spurs, just outside Courtrai.

Later, when the looms were mechanized by the Industrial Revolution, employers were able to force down the price of labor by using unskilled women, unprotected by any guild organization, in place of skilled men with labor guilds to defend them.

The illustrations we have chosen here show women making or working with textiles, but tell very different stories, economically and socially. *The Lacemaker* by Bernhard Keil (1624–87) shows a woman exercising a traditional, very intricate skill not as an amateur but as a professional who earns her living by what she does. She is surrounded by other women and is evidently the doyenne of the group. Women of this sort, even in the seventeenth century, when the picture was painted, were able to gain an independent livelihood, though not always a good one. The weariness of the lacemaker's expression hints at the drudgery to which she has had to become accustomed.

Lydia at a Tapestry Frame by Mary Cassatt (1844–1926) shows the artist's sister doing needlepoint—by this time

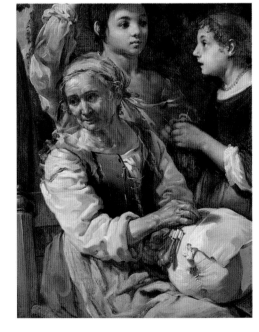

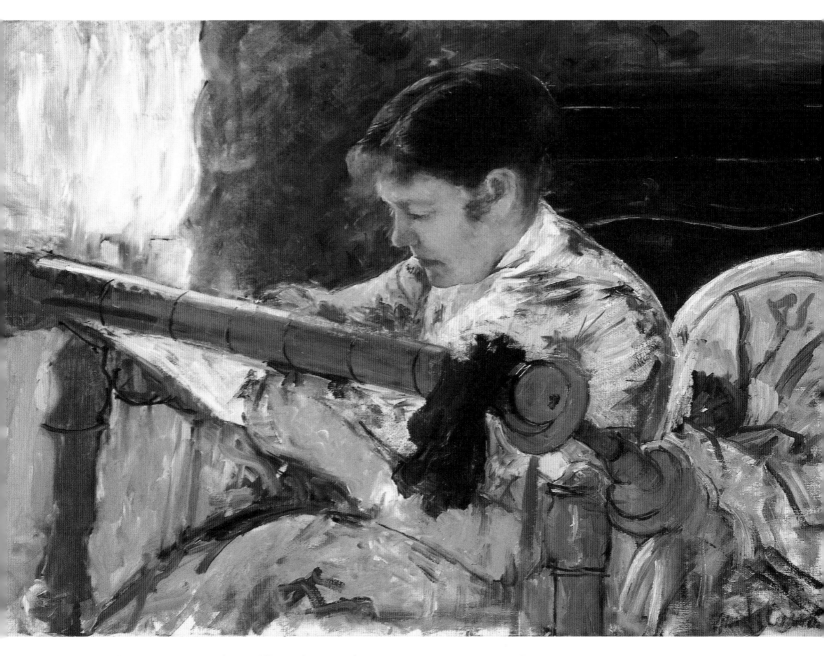

a well-regarded leisure occupation for middle- and upper-class women. Cassatt came from a wealthy American family that settled in France, and it was her family's money which allowed her to participate in the then-radical impressionist movement, since she did not have to make a living from her art. If her artistic attitudes were progressive, the subjects Cassatt represented—taken directly from her surroundings—are a reflection of her family's social position. Even in her day, skill with the needle was something that was expected of upper-class women. Cassatt's sister Lydia clearly takes her embroidery seriously, as we can tell from her expression and posture, but she does not have to do this intricate work in order to make a living, and in this she differs radically from Keil's tired lacemaker.

In the beginning, there was the Earth Goddess…and she wove the whole world as a big mantle…The world is actually a huge coat, which is spread over an enormous world tree…The sum of it is reality.

MIRCEA ELIADE, *THE TWO AND THE ONE* (1965).

above: **MARY CASSATT**
Lydia at a Tapestry Frame (c. 1881);
Flint Institute of Arts, Michigan

During the Middle Ages, when religious houses were the centers of culture throughout Europe, needlework was a major art industry. Both nuns and royal women produced narrative hangings (such as the Bayeux Tapestry) and ecclesiastical vestments, which were often quite ornate.

The Renaissance brought an end to the long tradition of women's prominence in the textile arts, not only because textile production moved into secular workshops, but also because of the development of a naturalistic art style which required a type of training that was unavailable to women.

Moreover, the notion developed that women were incapable of infusing a design with life. As a result, although women continued to produce elaborate needlework for the home, men took over needlework design. An example of this is William Morris's needlework designs, which were usually executed by his daughter May.

The Industrial Revolution brought the invention of the spinning jenny, which in America quickly led to long hours for the women who were employed in factories. With the development of the department store, their more privileged sisters could shop till they dropped.

above right: **JAMES TISSOT**
The Shop Assistant (1883–85);
Art Gallery of Ontario, Toronto

main picture: **FLORINE STETTHEIMER**
Spring Sale at Bendel's (1921);
Philadelphia Museum of Art

SHOP TILL YOU DROP

The lighter side of the daily life of women has also been a subject for art—often in images made by women painters, who seem more than capable of laughing at female foibles. The birth of the department store in the second half of the nineteenth century offered an entirely new theme to artists, though they were at first slow to tackle it. The first true specimen of this type of emporium, the Bon Marché in Paris, was created in something like its present form as early as 1865 and was radically revamped in 1876 with a new building designed by Gustave Eiffel, who went on to design the Eiffel Tower in 1889. In the late nineteenth century, the challenge of depicting these additions to the urban environment fell first to writers, notably to Émile Zola, whose

novel anatomizing a department store, *Au Bonheur des Dames* (*Ladies' Delight*), was published in 1883.

In art the theme was gleefully, if belatedly, taken up by a self-taught woman painter, the American Florine Stettheimer (1871–1944), who saw shopping as a form of therapy—something that, at least momentarily, lifts women's spirits by offering them a new form of self-realization through the pursuit and possession of material goods. Stettheimer's attitude, in *Spring Sale at Bendel's*, is lightheartedly mocking. Her women appear to have been seized by euphoria—they pose and prance as if they have forgotten where they are. James Tissot (1836–1902), in his painting *The Shop Assistant*, looks at shopping from a rather different point of view. The assistant, tall and elegant like all the women in Tissot's paintings, seems self-possessed and in control of her situation, but she is in fact someone who lives on the margins of society. At the time that Tissot's picture was painted the shop assistant was an innovative figure. She represented a new form of employment for women, but one full of ambiguities—dressed to resemble the elegant customers she served, this employee was nevertheless eternally their inferior. However, working in an upmarket shop, like working in an office, did at this period begin to offer a middle- or upper-class woman the possibility of making an independent living, though it also exposed her to social risks which many contemporaries thought were unacceptable. Because of her situation she was also open to unwelcome approaches by men.

Judy Chicage As has been well documented, women's relationship to the arts has been extremely problematic, in part because of the difficulty in obtaining training. Moreover, as Virginia Woolf commented in *A Room of One's Own* (1929), a woman must have money and a space of her own in order to write, an observation which applies equally to music and visual art. Such resources were difficult to come by for all but women of means, at least until women were legally entitled to manage what monies they were able to earn, which did not happen until the nineteenth century.

Literature was the first of the creative fields to be penetrated by women, perhaps because only the publisher stood between the writer and her audience. If that publisher was sympathetic, a woman's voice might be heard; if the audience proved receptive, she would, in all likelihood, have further opportunities.

In music, however, the situation was far more difficult. Although women have a rich musical tradition dating back to ancient times, their music centered on the voice, which the Church viewed as lascivious, causing it to insist that the female voice be thoroughly suppressed in favor of the sounds made by castrated males. Even after the reappearance of professional female singers during the Renaissance, the continued use of *castrati* limited women's chances for professional musical work.

MAKING MUSIC

Women's history as entertainers is as long established as their connection with the textile arts. One of the most famous scenes left to us by ancient Egyptian art is the tomb painting from an Eighteenth Dynasty official called Nakht, showing a group of female musicians playing at a feast. It seems fairly certain from the context that they were paid professionals who earned a living wage from the practice of their art at such events.

Depictions of women enjoying the arts of dancing and music can have an entirely different significance, however. Images of this sort are potent emblems of human rejoicing. In the *Golden Haggadah*, above, Moses' sister Miriam and her companions as depicted are celebrating, with music and dancing, the Jewish escape from the pursuing Egyptian army—walking dry-shod across the Red Sea, according to tradition. The Book of Exodus (15:20) describes how "Miriam the prophetess, the sister of Aaron, took a timbrel in her hand; and all the women went out after her with timbrels and with dances." Jewish women later celebrated the young David's victory over the Philistines in the same fashion:

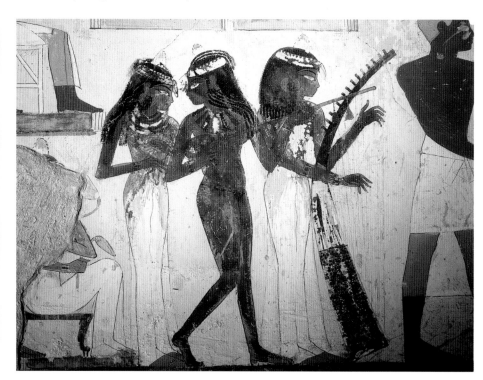

right: *A Group of Musicians* (Eighteenth Dynasty, c. 1567–1320 BC); Tomb of Nakht, Luxor, Egypt

And it came to pass as they came, when David was returned from the slaughter of the Philistine,
that the women came out of all cities of Israel, singing and dancing, to meet king Saul, with
tabrets, with joy, and with instruments of music. (1 SAMUEL 18:6).

top left: *Miriam Dancing* (1320);
British Library, London

above: **FRANCISCO MASRIERA**
A Melody of Schubert (1896);
Museu Nacional d'Art de Catalunya, Barcelona, Spain

In the nineteenth century, the ability to play an instrument was considered, as it had
been for some centuries, one of the necessary accomplishments of a gentlewoman.
This is the message of *A Melody of Schubert* by Francisco Masriera, which shows a
group of upper-class young women making and enjoying music together. Soon after
the picture was painted, the invention of the wireless—following hard on the heels
of the gramophone—would revolutionize attitudes toward music in the home. Though
Edison invented the gramophone in 1877, it did not become widely available until
1894, and the wireless did not become a common feature in the home until the 1920s.
Masriera's painting allegorizes, as many paintings had done previously, the musical
party as the image of a peaceful, well-ordered community in which women could
actively cultivate the arts. The development of modern industrial society in Europe
was already in the process of invalidating this concept when the picture was painted.

Judy Chicago Within the sanctuary of domestic life—be it home or cloister—women were often musically active; in fact, amateur musical proficiency was often seen as a requisite skill for women of the middle and upper classes. However, for women whose aspirations were more public and major, for example composing or conducting, numerous obstacles existed, not the least of which was the obliteration or obscuring of their work.

In this regard, I am reminded of something that took place in 1987 in conjunction with *The Dinner Party* exhibition in Germany. A year prior to the show at the Frankfurt Kunsthalle, a group of women organized the "Festival of One Thousand Women" at the local and splendidly refurbished opera house. Hundreds of women from all over Europe attended, festively costumed as the women at *The Dinner Party* table and on the "Heritage Floor" (the porcelain floor which supports the table and features the gilded names of 999 women of achievement).

For this—uncostumed—participant, the highlight of the day was when a female conductor, dressed as the nineteenth-century composer Fanny Mendelssohn, led an all-woman orchestra in a performance of an exquisite piece of hers that had never before been publicly performed.

PEN AND PAINTBRUSH

A similar significance attaches to images showing women participating in other creative arts. The beautiful portrait of a young woman holding a stylus—from Pompeii, buried by the eruption of Vesuvius in AD 79—captures the moment of thought before the actual act of writing. We do not know, however, what she was about to write—an ordinary letter, perhaps, or possibly something ambitiously creative, like a poem. It may be that the picture was intended as an idealized portrait of the Greek poet Sappho (c. 610–580 BC), the most celebrated female writer of antiquity. Alternatively, it may be a likeness of an inhabitant of the city prior to its destruction. In this case, the fact that the subject chose to have herself portrayed in the act of writing is still significant, since it implies that this is a prestigious act and puts unmistakable emphasis on the importance of female literacy.

Painted many centuries later, the meticulous depiction by Alice Barber Stephens (1858–1932) of *The Women's Life Class* at the Pennsylvania Academy of the Fine Arts is also a work with multiple resonances. It commemorates the struggle women endured to receive a fully professional training in the arts, and the way in which the need to study from the nude—the foundation of the academic curriculum prevailing from the sixteenth through the nineteenth centuries—came into conflict with established social mores, reinforced in the United States by the residual influence of puritanism. The nude life class was one of the last citadels of artistic gender segregation remaining at the end of the nineteenth century.

Yet even given her artistic achievements, Stephens was to discover later in her career that her own liberation was not complete. She was subsequently to demand, in conversation with a woman who was one of her former students, "If I do clever work, why not let it go at that? Can't they judge me as an artist, not a woman?"

This plaint has been made many times over the centuries by women artists, and it continues to be heard today. Women's art is still frequently defined in terms of gender; men's art usually escapes this kind of categorization. This differential ensures that men's and women's art is still not treated equally.

As for visual art, one of the major hurdles for women was the prohibition of study from the nude, which renders the Stephens picture of the female art class particularly poignant to me. Less than a century after it was painted, I would be drawing from the figure at the Art Institute of Chicago, entirely unaware of the long struggle that had taken place so that I had the right not only to be there but also to take this right for granted.

above: **ALICE BARBER STEPHENS**
The Women's Life Class (c. 1879);
The Pennsylvania Academy of the Fine Arts, Philadelphia

left: *Woman Holding a Stylus* (AD 55–79);
National Archaeological Museum, Naples, Italy

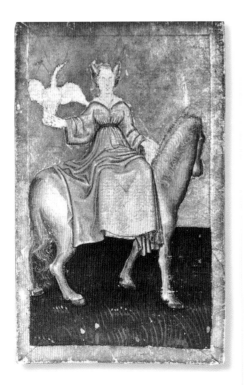

Historically, women's participation in physical activities was confined to dancing and horseback riding, sometimes in conjunction with hunting, as suggested by the medieval scene above. However, the convention that women could not ride astride but must sit sidesaddle tended to limit the mobility of all but the boldest.

In the nineteenth century, women began playing croquet, lawn tennis, and golf, as well as taking up archery. But it was not until the advent of public education that women's sports really got under way, gaining great impetus from the enormous popularity of bicycle riding at the turn of the century.

above: KONRAD WITZ

Mounted Lady with Heron (c. 1440–45);
Kunsthistorisches Museum, Vienna

right: MARY CASSATT

A Woman and Child in a Carriage (1879);
Philadelphia Museum of Art

WOMEN ON THE MOVE

Some of the most subtly significant depictions of women in art take as their subject women traveling or in movement. Throughout the centuries women have traditionally been less free to travel than men—less free to move around the world, and usually not free to do so independently. A few medieval illuminations showing women hunting on horseback imply the relief some of them felt when certain restrictions on rapid movement were occasionally lifted. Yet they were still forced to ride sidesaddle, which meant that they were physically less secure. The best excuse for real travel was usually to go on a pilgrimage—Chaucer's *Canterbury Tales* gives a good idea of how enjoyable some women found them. We also read, in medieval sources, of women who made much longer and more arduous journeys than the one undertaken by Chaucer's pilgrims—journeys to as far away as Jerusalem, for instance.

In the Middle Ages and later, women who made long journeys sometimes adopted male dress—Joan of Arc, for example, when she traveled from Vaucouleurs, on the eastern fringes of France, to Chinon to see King Charles VII. This practice was frowned on by the Church and resonant with unwanted implications.

Two paintings from the nineteenth century help to extend our understanding of this theme. One is now well known—Mary Cassatt's *Woman and Child in a Carriage*. The woman is almost certainly her sister Lydia, who in many of her paintings serves as Cassatt's alter ego. The intent expression on her face as she drives her light dogcart is very striking, as is the social hierarchy expressed by the close conjunction and the arrangement of the three figures—Lydia herself, the child seated beside her, and, seated facing backward, the young groom who will leap down to the street to take the reins

above: JEAN BÉRAUD

The Cycling Hut in the Bois de Boulogne (c. 1900);
Musée de l'Île de France, Sceaux, France

when the carriage comes to a halt. Not many years previously it would have been the groom who drove, while the upper-class woman and child were content to sit passively in the back of their conveyance.

The other painting, by Jean Béraud (1849–1935), celebrates the popular bicycling craze of the late nineteenth and early twentieth centuries. First introduced in France during the 1860s as the velocipede, the bicycle took on a degree of totally unexpected social significance as its mechanics were improved. It provided a reliable, cheap, and easy means of transportation, as well as a form of exercise in which both men and women could participate. At the same time, because the standard bicycle (as opposed to the tandem) carried only one person, riding a bicycle strongly suggested physical independence. It also led to modifications in dress. It was possible to ride a horse in a long skirt by sitting sidesaddle, but with a bicycle such a posture was impossible. The "rational dress"—usually bloomers—adopted by women for bicycle riding was widely mocked but equally widely accepted. Béraud's picture, showing a crowd of bloomer-clad young women enjoying an outing, is mildly satirical in intent, but nevertheless rich in implications concerning the new roles that the women of this period were beginning to forge. Inventions often change society in ways unforeseen by their originators, and the bicycle is a good example of this fact. Created as a convenient form of transportation, it had a wholly unexpected impact on relations between the sexes.

However, sports remain a key cultural location for male dominance, which helps to explain the fierce struggle that has marked women's efforts to gain equity in athletics. This is reflected in the controversy surrounding female participation in the Olympic Games, which were closed to women until the early twentieth century. In 1997, Laurie Feinstein, body-builder and curator of an exhibition on female hypermuscularity, wrote:

> The muscular woman disturbs the common, even uncommon, constructs and actualities regarding women, beauty, art and power … Instead of vapidity, one is faced with a vigorous being and a potential "threat."

Judy Chicago Throughout the Middle Ages, the convent was a place of refuge for many women fleeing the vicissitudes of war and social unrest. This was particularly true for upper-class women, who sometimes escaped to the cloister to avoid losing their property rights through marriage. Within its walls, women were sometimes able to conduct all manner of religious observance, away from the prying eyes of the male superiors. Moreover, for many royal ladies, living in a not-too-strict religious house—even without benefit of full vows—was an acceptable alternative to the rigors of married life.

Christianity's introduction into the Americas produced a rather sordid tale, often involving the forcible conversion of native peoples, the suppression of their traditions, and untold suffering. Despite efforts to Westernize all the indigenous peoples, Native Americans were able to reassert their tribal identities, revivify their local traditions, and, in some instances, achieve an amalgam between their own religious practices and Christian rites, as is evident in the charming painting by Pablita Velarde at right.

THE SPIRITUAL LIFE

In the Greek and Roman worlds women enjoyed what may now seem a surprising degree of religious liberty, and the cult of the Great Mother and related goddesses ensured that there were many rites reserved exclusively for female participants. One reason for pagan resistance to Christianity, even after it had established itself as the official religion of the state, may have been the exclusion of females from its most central ceremony, the consecration of the Eucharist, which could be performed only by a man. The carved ivory diptych leaf illustrated here, showing a priestess sacrificing at a pagan altar, was commissioned by a leading anti-Christian statesman and polemicist of the late imperial epoch, Quintus Aurelius Symmachus (c. 345–c. 402), who, despite his religious stance, attained high office under several of the immediate successors of Constantine. The complete diptych commemorated his appointment to the consulship in the year 391. The scene showing a priestess carried a polemical message.

The special nature of women's spirituality, given the female role as life-giver, was nevertheless recognized throughout the Christian centuries, and entering a convent was often, paradoxically, the way in which a woman could achieve a small measure

above: *Priestess and Attendant*
(one leaf of the Symmachus diptych, AD late fourth century);
Victoria and Albert Museum, London

right: **PABLITA VELARDE**
Santa Cruz Women Before the Altar (1933);
Museum of Indian Arts and Culture, Santa Fe, New Mexico

above: *Poor Clares at Service*
(illuminated psalter, c. 1400); British Library, London

of independence and attempt to conduct life on her own terms in a way that simply would not have been possible in the domestic sphere of her time. *Poor Clares at Service* offers a glimpse of the attractions of convent life, which provided not only a physical refuge against the storms and dangers of the world outside but also a place where women were free to examine their own natures, and were actively encouraged to do so. This late medieval image of nuns attending a service stresses both a sense of community (the women are assembled for a common purpose) and of equality (they are all dressed in nuns' habits); but it also stresses the fact that each woman is engaged in personal meditation.

Women of minority communities have often found in religion and religious ceremonies an opportunity for bonding which was not readily available to them elsewhere, as suggested by the painting *Santa Clara Women Before the Altar* by Pablita Velarde (b. 1918). The image also demonstrates the synthesis between Native American and Christian religious practice that has evolved in many Indian pueblos.

Judy Chicago There is a saying that those who have the least to say about human events often suffer the gravest of consequences, which is particularly apt in terms of women's relationship to war. Despite the fact that, historically, wars have impacted dramatically and usually negatively upon women's lives, female experience is almost wholly absent from the iconography of war imagery, which has focused primarily on the heroic exploits of men.

I am therefore delighted at this Goya depiction of a woman who—far from being victimized—has taken up arms in defense of her town. And the Gross-Bettelheim reminds us that, in addition to keeping the home fires burning while the men were off fighting in World Wars I and II, women also helped to build the bombs.

WOMEN AND WAR

Seldom the makers of war, women are usually among war's chief sufferers. Yet there have also been occasions when wartime conditions have had a liberating effect. Goya (1746–1828), in his print *Que Valor!*, from the *Disasters of War* series, commemorates the "Maid of Zaragoza," a heroine of the bloody French siege of Zaragoza in 1808–9. It is, however, almost the only print in the series in which a woman is shown playing an active role. Though Zaragoza was eventually lost, news of the heroine's exploits traveled throughout Spain and helped to stiffen resistance to the invading Napoleonic armies. Mostly, however, Goya presents women as the passive victims of French brutality.

More, perhaps, than any war which preceded it, World War I helped to bring about a permanent change in women's status and also in their attitude toward themselves. The print *Home Front* by Jolan Gross-Bettelheim illustrates one reason for this—women were encouraged to take over many jobs, such as working in munitions factories, which previously would have been done by men. Inevitably, when peace returned, perceptions as to what women could and could not do, and indeed perceptions concerning their whole position in society, were radically changed. It was the experience of wartime that ultimately clinched the success of the women's suffrage movement in both Britain and the United States. In Britain, women received the right to vote in February 1918, before the conclusion of the war. In the United States, since each individual state had to ratify the measure, and the legislative process therefore took much longer, women had to wait until August 1920.

right: **FRANCISCO GOYA**

Que Valor! (etching from *The Disasters of War,* 1810–15); Prado, Madrid

main picture: **JOLAN GROSS-BETTELHEIM**

Home Front (1943); Library of Congress, Washington, D.C.

Asking for It?

Women are a colonized people. Our history, values and . . . culture(s) have been taken from us . . . manifest most arrestingly in the seizure of our basic and most precious "land," our own bodies.

ROBIN MORGAN, 1992

SEDUCTION

A good deal of Western art—and it must be remembered that this art is preponderantly by men—has concerned itself with the idea of woman not merely as victim of random forces of violence but also as someone who, in one fashion or another, invites her own fate. Not surprisingly, contemporary women often find it difficult even to look at these images, much less to consider in detail what they have to tell the spectator both by means of the text that is immediately apparent on the surface, and through half-concealed subtexts implied by the pictorial narrative.

The first and mildest of the various formulations available is the seduction scene. *On the Brink* by Alfred Elmore (1815–81) offers a classic Victorian version of this. A young woman at a ball is being importuned by a would-be seducer and is clearly on the verge of allowing herself to be persuaded by his blandishments. The picture is an accomplished example of the narrative painting of its time, in the

sense that it encapsulates not only the moral crisis which is its announced subject but also what has led up to the situation. At the same time it offers clear signals as to the most probable outcome. Since, unsurprisingly, its codings are not necessarily as clear to a present-day audience as they would have been to Elmore's contemporaries, there is some excuse for spelling them out.

From the point of view of prevalent nineteenth-century morality, the young woman who is the chief figure within the tableau has already to some extent compromised herself by allowing her suppliant to converse with her in an out-of-the-way corner at a large social gathering. If they are observed together, she will have already seriously tarnished her good reputation—and so her apparent willingness to take this considerable risk indicates that she may also be ready to take a step which may be truly fatal to it. Her agonized expression indicates that she has some realization of the consequences of an irregular relationship, but also signals her almost certain loss of control and capitulation to the psychological pressure she is now being subjected to by her suitor.

One of the interesting things about the painting itself is the fact that the focus is entirely on the female protagonist, rather than on any relationship with the would-be seducer, whose figure is deliberately left in shadow. The drama is not one between two people but between two halves of a divided nature, and we are left in small doubt as to which half is the stronger. The subtext, therefore, is that the man is effectively guiltless and that it is the female protagonist who must take responsibility for her own probable ruin. The moral perspective of the work places the blame fully on the woman and lets the real culprit off the hook.

The Rejected Offer by Judith Leyster (1609–60), however, is totally different. Here the man appears to be insisting on something—and the coin he holds in his palm indicates that his proposition is an immoral and probably sexual one—while the female subject steadfastly ignores him and continues with her sewing. Yet within her social milieu she is clearly not free simply to shake off the hand he has placed on her shoulder, although her whole posture indicates that she is humiliated by what is going on. One implication of the scene is that the woman is socially inferior to the man and that this gives him a certain power over her. Leyster's picture belongs to a substantial class of Dutch seventeenth-century genre scenes in which women receive approaches of this sort from men. In those painted by male artists, their response almost invariably indicates that they are willing to be bought. Very often, an older woman acts as procuress, selling the services of a younger one. In the equally frequent "Merry Company" scenes, the women are shown as tipsy—the implication being that in this state they lose all sexual inhibitions.

Judy Chicago A Vindication of the Rights of Woman (1792) by Mary Wollstonecraft ushered in a body of literature by women which presented their own views of their circumstances.

Such is the blessed effect of civilization that the most respectable women are the most oppressed ... Would men but generously snap our chains, and be content with rational fellowship instead of slavish obedience, they would find us ... better citizens ... who would then love them with true affection, because we should ... respect ourselves.

In art, however, any comparable stance was more subtly presented, as in this Leyster, which—when juxtaposed with the Elmore—gives an opportunity to compare male and female views of the same subject.

top: **ALFRED ELMORE**
On the Brink (c. 1865);
Fitzwilliam Museum, Cambridge, U.K.

left: **JUDITH LEYSTER**
The Rejected Offer (1631); Mauritshuis, The Hague

It seems important to examine several images in the next few chapters in relation to some of the arguments about women that have raged over recent centuries. Art might be said to be the visual symbology of social attitudes, even when the artists do not consciously realize or acknowledge that they are enacting larger societal views. Instead they operate on the assumption that their art represents an individual perspective.

This is particularly true for male artists' images of women, which are rarely discussed in terms of larger philosophical ideas or social attitudes toward the female. For example, the images by Greuze and Hunt can be better understood in relation to the nineteenth-century cult of the "lady," an imprisoning concept of womanhood against which women were soon to revolt, inspired in part by the century-old writings of Mary Wollstonecraft.

THE "FALLEN WOMAN"

Generally speaking, male painters and their audiences, in the eighteenth and nineteenth centuries, had a prurient fascination with women who were not only "fallen"— as the women in the Dutch scenes of sexual bargaining may be considered to be—but were also repenting their "sins." Many paintings portray subjects who, for all their regrets, will never be quite able to make amends for their failure to obey society's sexual code. *The Broken Mirror* by Jean-Baptiste Greuze (1725–1805) is a typical work by this master of feigned innocence and enticing female disarray. The young woman sitting at her dressing table is ostensibly weeping because of a small domestic disaster, a broken mirror. It is nevertheless made clear—chiefly through the excessive nature of the subject's own emotion—that what she is really weeping for is the recent, irremediable loss of her virginity. The smashed mirror serves as the emblem of a brutally ruptured hymen. Virginity played a prominent part in the sexual double standard of the time. A man was entitled to take it if he could. If he did so by fraud, little blame was attached to him. A woman who lost her virginity before marriage, certainly if she was a member of the middle or upper classes, was forever spoiled for the marriage market.

The Awakening Conscience, by the leading Pre-Raphaelite William Holman Hunt (1827–1910), is another melodramatic delineation of a crisis that comes too late to save the woman who experiences it. A kept woman has been listening to her lover play the piano. By chance he alights on a melody which recalls the sweetness and purity of the life she has left in order to live with him. She is immediately agonized, but he is not able to comprehend her distress. Hunt, a stern puritan in his private life, ostensibly condemns the male participant in this little drama—it is he, after all, who is frivolous and unfeeling. But the emotional focus remains with the woman. Is she now going to continue with her indubitably immoral way of life? If she does not, how is she to live? Her reputation is irretrievably spoiled—no respectable home will receive her; no respectable man will marry her. She is the one who has no way out, and the painter contemplates her dilemma with a sort of repressed sadism. With each of these works one feels a conflict of intention. The artist, while ostensibly sympathizing with the plight of his female subjects, in fact enjoys their suffering, and expects the audience to do so as well.

above right: **WILLIAM HOLMAN HUNT**
The Awakening Conscience (1853);
Tate Gallery, London

main picture: **JEAN-BAPTISTE GREUZE**
The Broken Mirror (1773); Wallace Collection, London

Judy Chicago In 1755, in *A Discourse on Political Economy*, Jean-Jacques Rousseau had presented quite a different view from Wollstonecraft's (which was one reason she penned her famous book):

> In the family, it is clear, for several reasons that lie in its very nature, that the father ought to command.

This echoed the popular sentiment that women must submit to their husbands, and should sacrifice both their own needs and their identities in the process.

It is instructive to see images of female martyrdom and self-sacrifice in the larger context of such expectations of women, expectations that confined many women to a life of circumscribed possibilities.

Images of self-sacrifice in the form of martyrdom seldom appeared in ancient or classical art, because people who were condemned to death for their beliefs rarely gave their lives voluntarily, but had their fate decided by others. Thus they are best described as victims, in Iphigenia's case, one murdered by her own father.

main picture: *The Sacrifice of Iphigenia* (c. AD 30); National Archaeological Museum, Naples, Italy

right: **Paul Delaroche**
The Execution of Lady Jane Grey (1834); National Gallery, London

SACRIFICIAL LAMBS

The nineteenth century also had a taste for paintings in which completely and undoubtedly innocent women appear as victims. These seem to have aroused all the latent sadism of the contemporary bourgeois audience, who empathized with the agony of the victim, while at the same time relishing it, as they relished, for instance, the death of Little Nell in Dickens's novel *The Old Curiosity Shop* (1840–41). An example is *The Execution of Lady Jane Grey* by the French academic painter Paul Delaroche (1797–1859). Jane Grey was titular queen of England for nine days in 1553, as the candidate of the extreme Protestant faction that wished to block the accession of the Catholic Mary I after the death of her brother Edward VI. Her sad fate after Mary's accession provided a ready-made subject for an artist like Delaroche, who wanted to tug at his spectators' heartstrings while flattering their supposed historical erudition.

The female "sacrificial lamb" is not a purely Victorian invention. Classical mythology, followed by classical drama, had already provided an archetype in the story of the innocent Iphigenia, sacrificed by her father, Agamemnon, en route to Troy, in order to appease the goddess Artemis. Euripedes made the episode the subject of his tragedy *Iphigenia at Aulis*, and it seems likely that this text is the literary source for the fresco of the subject that was discovered at Pompeii. Compared with Delaroche's melodramatic composition, the Pompeiian fresco seems exceedingly tame. The focus is on the whole event—the painting does not dwell on the plight of the victim exclusively but instead endeavors to tell the story.

Judy Chicago It was with Christianity that the notion of martyrdom came to the fore and began regularly to be represented in art. Women were extremely active in the early days of Christianity, and so they too became martyrs and were depicted as such.

This imagery eventually came to intersect with Reformation and Victorian ideas that women were to be self-sacrificing in life as well as religion, an expectation that is still felt today. Many young women tell me about the dissension they feel between their own aspirations and the presumptions of family, friends, and lovers, made more acute by the widely accepted fiction that women are now entirely free to do whatever they wish.

MARTYRDOM

The work by the American realist artist Melissa Weinman shown here raises the issue of the importance and meaning of context in acute form. How would the contemporary spectator—in particular the contemporary female spectator—react if under the impression that this was the work of a man rather than a woman? In such circumstances the entire meaning might seem to shift. As a male creation would the image seem gloating, thanks to its intense realism? Would a female spectator be able to believe that a man could empathize sufficiently with what is depicted to justify the making of the work? The preferred version of the female sacrificial lamb has usually been not some historical or mythological personage but a Christian saint. The sufferings of virgin martyrs like St. Catherine and St. Agatha were frequently depicted for church

use. St. Agatha, an early Christian martyr born in either Palermo or Catania, supposedly resisted the sexual advances of the Roman prefect sent by the Emperor Decius (r. AD 249–251) to govern Sicily. Decius was the instigator of one of the first organized state persecutions of the Christian religion. For resisting the prefect, Agatha was punished by having her breasts cut off and was afterward burned at the stake.

This lurid and historically distant tale, with its leitmotif of sexual violence, was—perhaps unsurprisingly—greatly to the taste of artists and patrons alike. Agatha was shown not merely in the throes of her ordeal, as she is in this sketch by Giovanni Battista Tiepolo (1696–1770), but also bust-length, bearing her severed breasts on a plate.

Though Agatha is now generally thought to be an apocryphal figure, with no greater historical basis than St. Barbara, her legend has retained its hold on Western artists' imaginations to a great and perhaps surprising extent. Melissa Weinman's *St. Agatha's Grief* seems to equate the saint's physical ordeal with that of contemporary women who have lost breasts to cancer. As such, it is a powerful reminder of the psychological as well as physical effects of the disease.

right: **GIOVANNI BATTISTA TIEPOLO**
The Martyrdom of St. Agatha (c. 1734);
Courtauld Gallery, London

main picture: **MELISSA WEINMAN**
St. Agatha's Grief (1996)

Judy Chicago Although I don't like to admit it, I am of the generation that was told, "In case of rape, relax and enjoy it." Since then, attitudes toward rape have certainly changed, in large part due to feminist literature and activism. However, in terms of art, for a long time the issue of rape was entirely avoided. A case in point was a performance work I did on this subject in Los Angeles in 1971 with several other artists, including the (subsequently) well-known performance artist Suzanne Lacy. In preparation for the piece, entitled *Ablutions*, I spent many hours taping the testimony of rape victims, which I then edited down to a 90-minute audiotape. This played throughout what was a rather gritty

RAPE

The same questions apply, though in different form, to pictures depicting the act of rape. Some of these are by the greatest masters of Western painting. Are we simply to pass over or ignore their violent subject matter because of what is judged to be their sheer pictorial quality? Can we, alternatively, make them acceptable by returning them to their original cultural context and trying to see them as the artist's contemporaries would have seen them? If the verdict is that they are now entirely unacceptable, what are we to do about them? Should we demand that they be placed in museum storerooms forthwith, permanently out of sight of a corruptible public? Even in that case, could we really successfully excise them from our collective consciousness? Should all reproductions of such works be banned in future? Should we rip them out of the books where they already appear?

A case in point is *The Rape of the Daughters of Leucippus* by Peter Paul Rubens (1577–1640). The subject is a mythological episode—the women shown, princesses, daughters of the king of Argos, are being carried off by a pair of divine beings, the Dioscuri. In another guise, the Dioscuri were Castor and Pollux, savior gods who rescued shipwrecked sailors. What the painting shows is an abduction rather than an

actual rape, though it also gives Rubens the opportunity to offer the spectator a very ample view of nude female flesh. If we try to put the composition in its own context, we note that abduction, in primitive societies, was often a prelude to marriage. Many tribal marriage rites feature the ritual abduction of the bride by the groom and his close relatives. The myth Rubens illustrates seems to refer to customs of this kind. The unobtrusive presence of Eros, the god of love, at the left-hand edge of the composition hints at a happy outcome.

Rubens's painting is a rhythmic pattern of contrasting diagonals. It is this compositional sophistication which appears to have fascinated Pablo Picasso (1881–1973), who obviously based his own *Rape of the Sabines* on Rubens's design, paraphrasing the earlier master as he also paraphrased famous compositions by Velázquez, Manet, and Delacroix. The paraphrase emphasizes the brutality of the abduction. There is now only one horse, not two; one rider, not two; one naked woman, not two. The woman twists violently backward, her face an

agonized mask, her enormous hands flung skyward. One of the horse's hooves drives toward the center of her body like a phallus. The pinheaded rider threatens her with a sword, in another phallic gesture. The horse grins evilly. The fact that the horse's mask is so much more prominent and expressive than the rider's face, which, in addition to being small, is almost expressionless, serves to stress the animal nature of the scene. The beast becomes an emanation of the horseman's desires. Though the picture is, with its monochrome color scheme and violent distortions, much less realistic than its prototype, it does not seem like the work of a man who much likes women. One recalls that two of Picasso's consorts, Marie-Thérèse Walter and Jacqueline Roque, committed suicide, and also that Françoise Gilot, in her book of memoirs *Life with Picasso*, describes his assaults on her, one with a burning cigarette.

performance—one of the earliest works reflecting a female perspective on what has been a traditional subject of male art.

The work—which included imagery involving raw meat, blood, milk, eggs, and bound female bodies—was presented to a packed audience and stunned silence. Rarely, in all the ensuing years, has anything been said—or written—about this piece, as if by ignoring it, the discomfort aroused by a truthful exploration of this subject would go away. The painful testimony on the tapes made the well-meaning advice alluded to earlier altogether grotesque.

Thanks in large part to the efforts of female art historians, the problematic subject of rape in art has been introduced into the art dialogue, though not yet at the level of discourse which seems appropriate for such a significant subject, especially given the way in which images of rape—particularly those reproduced in the mass media—continue to impact upon many ordinary women's consciousness.

I once heard a story about a graduate art history class during the late 1970s, when feminist awareness was just beginning to develop among female art practitioners. The professor was discussing a Rubens painting which featured abduction and implied rape. His focus, however, was upon the brushwork, which he was rhapsodically praising.

left: **PABLO PICASSO**
Rape of the Sabines (1962);
Museum of Fine Arts, Boston, Massachusetts

far left: **SIR PETER PAUL RUBENS**
The Rape of the Daughters of Leucippus (c. 1618);
Alte Pinakothek, Munich

Judy Chicago Quietly, one female student murmured to another, "But isn't that a rape?", a question which quickly started circulating around the room at an increasingly audible level until one of the students burst out: "Isn't that a rape?", followed by her outraged cry: "If that's a rape, how can you sit there, discussing the brushstrokes?"

In terms of my earlier comments about the relationship of images to, for example, philosophy, the brutality of the Picasso might almost lead one to suggest that the artist may have been a student of Nietzsche, who is known to have recommended that, when one goes to women, one must not forget the whip.

Certainly it seems important to acknowledge that one reason this art is so troublesome is that the subject matter is presented in what might best be described as beautiful packaging, which I suppose helps to explain how the aforementioned professor could be seduced into ignoring the content in favor of the brushwork.

However, it seems critical to discuss the fact that several of these works occupy an exalted position in the canon of Western art. One issue raised by work such as the Rubens or the Picasso is: what is to be done about it? In light of the—implicit or explicit—violence against women contained in these images, should they be viewed as the great art which they are currently considered to be, especially since there is an absence of work by women which

Tarquin and Lucretia—painted by Titian (c. 1487–1576) toward the end of his career, when he was at the height of his powers as a colorist—offers an unambiguously graphic image of a woman who is being sexually assaulted by a man. Tarquin is clothed, but the position of his knee and his raised dagger (both a threat in itself and a symbolic substitute for a penis) leave not the slightest doubt about the nature of the subject. The question once again is, how is the work—in a larger sense—meant to be read?

We know from anecdotal evidence—from the raunchy satirical poet Pietro Aretino, who was the painter's crony—that Titian's studio was not a place where young women could expect to be treated with much respect. But would Titian's contemporaries simply and straightforwardly have taken pleasure in the painting's display of male power and sexual energy and female vulnerability? Its context, for them, would have been the familiar story of Lucretia, the virtuous wife who, after being raped by the son of the then king of Rome, demanded an oath of vengeance from her husband and her father before committing suicide. As a result of this oath, there was a rebellion that drove the Tarquins from Rome and led to the foundation of the Roman Republic. Lucretia was frequently cited, both in classical and postclassical times, as the type of the unflinchingly virtuous heroine. A female spectator who does not know this—and even perhaps one who does—is nevertheless likely to be made both angry and uncomfortable by the nature of the image. Another masterpiece that should be forever condemned to the storeroom?

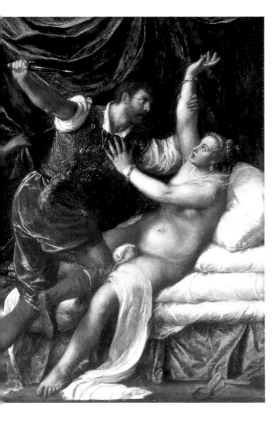

A rather different case is presented by a work by a far lesser painter, Christian van Cowenburgh (1604–67). His *Rape of the Negress* shows, in unflinching detail, a profoundly unpleasant scene. A naked black woman is being assailed by two white men. She bellows her distress as one of her assailants, nude, pulls her onto his lap. Another, with a cloth wrapped around his waist, points at her mockingly. A third male spectator, fully dressed, flings up his hands in protest.

Though the scene is unpleasant, is the painter in this case entirely unsympathetic to the victim's plight? She is shown as coarse and animal, and in this sense the picture can be construed as racist. But her distress is also powerfully conveyed. The white rapists are not glamorized in any way. The painter goes out of his way to emphasize the lack of feeling of the mocker on the left. This is a picture that essentially condemns the act of rape, rather than condoning it. Yet does this make us want to look at it?

It is only when we reach Goya's visual description of French atrocities in Spain— and Spanish resistance to them—in his etchings from the *Disasters of War* series that we find visual descriptions of rape which are close to twentieth-century attitudes. *No Quieren* (*They Do Not Want It*) is a brilliant journalistic snapshot of French soldiers attempting to rape Spanish women, who in turn prepare to resist them savagely and— it seems from what we are shown—successfully. As a French soldier lecherously embraces a young woman, who struggles in his grip, another, older woman rushes forward, dagger raised, to stab the assailant in the back. It seems significant that this defendant is another female. The print, perhaps because of its closeness to real events— things Goya had been told of at first hand even if he had not actually witnessed them himself—is so vivid that it burns itself into the mind. It also transcends its subject matter in a way that the van Cowenburgh does not.

presents an opposing view? And if the answer is in the affirmative, where is the line between symbolic and real violence against women? Also, what does the acceptance of symbolic violence—as represented by, for example, the iconic status of Picasso's work—convey to young women? And what does it do to men's self-image to see rapists cast as demigods?

above left: **TITIAN**
Tarquin and Lucretia (c. 1571);
Fitzwilliam Museum, Cambridge, U.K.

above right: **FRANCISCO GOYA**
No Quieren (etching from *The Disasters of War*, 1810–15);
Prado, Madrid

far left: **CHRISTIAN VAN COWENBURGH**
The Rape of the Negress (1632);
Musée des Beaux-Arts, Strasbourg, France

WOMEN FIGHT BACK

In the 1970s feminist consciousness began to focus on rape as the most extreme example of men's power over women. Probably the first feminist artwork to tackle the subject was a performance staged in Los Angeles on 13 December 1977 by Leslie Labowitz and Suzanne Lacy. Inspired by the activists of WAVAW (Women Against Violence Against Women), it was entitled *In Mourning and In Rage* and was a response to a string of sex murders—the Hillside Strangler case—then occupying the attention of the Los Angeles press. The performance, itself designed for media consumption, was directed more at press and television treatment of this series of crimes—which created a climate of hysteria that put enormous pressure on women—than at the criminal events themselves. It was also intended to be a demonstration of female solidarity and strength in the face of such pressure.

Since then, women artists have used various strategies in tackling this difficult subject. *New Bedford Rape* by Sue Coe (b. 1951) is a reaction to a notorious rape in New Bedford, Massachusetts, when a young woman was repeatedly raped on a bar pool table while habitués of the bar looked on. Coe has a powerful gift for drawing, and her image can be compared in a general sense to similar political and protest images made in the nineteenth century—for example, *La Rue Transnonain* (1834) by Honoré Daumier (1808–79), which commemorates, with similar indignation, a working-class family massacred by the French police.

Two things are worth pointing out—first, that no woman could have tackled Coe's subject matter in Daumier's day. Second, that Coe's considerable talents as a social and political polemicist have never found the kinds of outlets which Daumier was given, even at a time when censorship was in general much more repressive than it is now.

Judy Chicago It was not until the latter half of the twentieth century that women artists began to fight back in terms of creating an iconography of protest. In writing about *In Mourning and In Rage* (above) some time after the piece, Suzanne Lacy commented:

> The artist can use her understanding of the power of images to communicate information, emotion, and/or ideology. She may, additionally, provide us with a critique of popular culture and its images, or of current or past social situations. Sometimes her work can inspire her audience toward action . . . or the artwork might function best as a model for other artists . . . to play an active role in the politics of social change.

above: **SUZANNE LACY and LESLIE LABOWITZ**
In Mourning and In Rage (1977)

right: **NICOLE EISENMAN**
Amazon Composition (1992);
Shoshana Wayne Gallery, Santa Monica

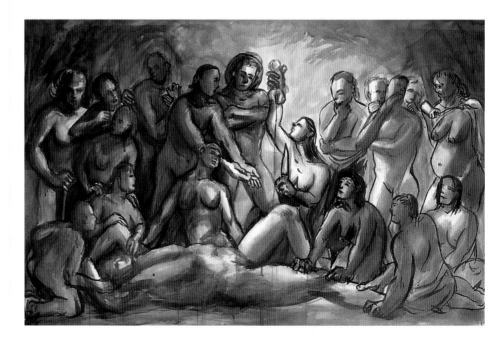

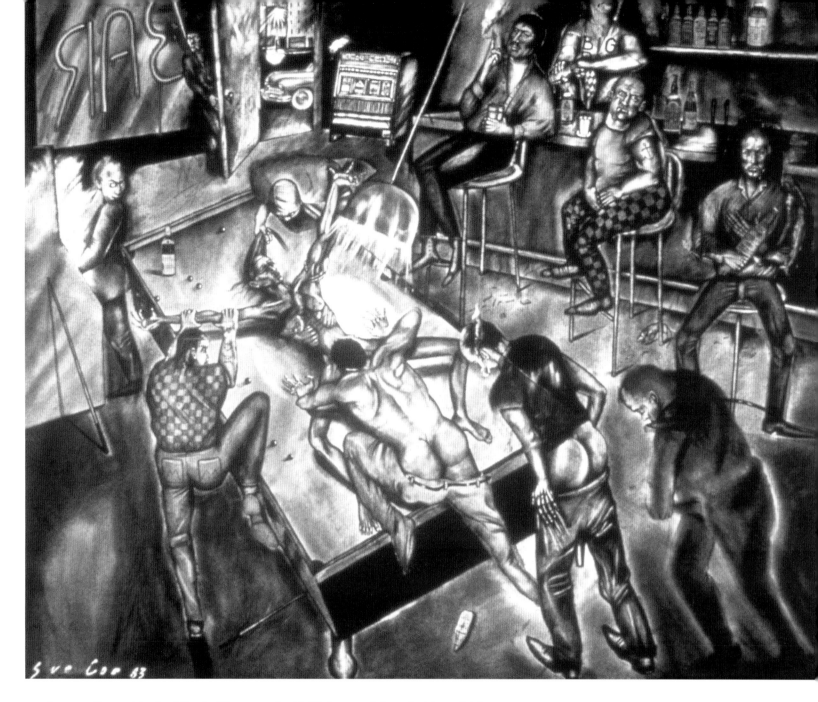

above: **SUE COE**

New Bedford Rape (1983); Galerie St. Etienne, New York

Amazon Composition by Nicole Eisenman (b. 1963) is a work by a lesbian which seems to express a generalized scorn directed toward members of the male gender. While this castration scene would certainly have been an unthinkable subject for a female artist at any earlier epoch, it does nevertheless have at least one historical parallel—a mid-sixteenth-century print after Francesco Primaticcio (1504/5–70) showing a satyr being castrated by a nymph.

A more important issue, however, is the ambiguity of Eisenman's image, which is emphasized by the above comparison. If Eisenman's drawing expresses the will to female independence (which is how it is read in a feminist context), does it have the same meaning when it is taken out of that context? Or is it then simply a rather creepy pornographic joke, like Primaticcio's design? In fact, is one entitled to ask much the same questions about this work as those one now feels compelled to ask about Rubens's *Rape of the Daughters of Leucippus*? There are no easy answers.

Casting Couch and Brothel

It is said that woman is sensual, she wallows in immanence;

but she has first been shut up in it.

SIMONE DE BEAUVOIR, 1949

THE CASTING COUCH

The reclining female nude since the Renaissance—one of the central images in Western painting—raises the question of the male gaze in more acute form than perhaps any other artistic stereotype. The woman is almost invariably shown as completely passive, an object for contemplation. From its beginning the type heralded a new sexual candor, in the sense that it was an open acknowledgment not only of male desire but also of the right of males to express that desire. A woman's part in this, or what a woman's feelings might be when looking at such images of members of her own gender, were never discussed until recently.

The artist most usually credited with popularizing the image of the reclining female nude is Giorgione (c. 1477–1510), the short-lived genius who changed the direction of Venetian art. His *Venus Resting* is generally thought to have been left unfinished—the landscape background was added by Titian. Giorgione's Venus was originally accompanied by a cupid, which has been painted out subsequently because it was so badly damaged as to be almost effaced. The isolation and apparent remoteness of the figure is therefore not necessarily what the artist himself intended. The cupid, gazing at Venus, would have acted as a mediator between the goddess and the spectator. In its present condition, the figure has regularly been interpreted as "remote" and "idealized." Is this really the case? The fact that Venus is sleeping, therefore unaware of the watcher outside the frame, renders her more vulnerable. She cannot object to the fact that she is being looked at or respond in any other way. The transaction, with its strong sexual component, is therefore entirely one-sided—the message is that woman exists to be the passive object of the male libido.

Another famous reclining female nude, *The Rokeby Venus*, painted by Diego Velázquez (1599–1660) during his second visit to Italy, offers a totally different version of the pose. Venus lies with her back to the spectator, gazing at herself in a mirror that is presented to her by Cupid. The erotic emphasis put on her buttocks has a long history in Western art—it stems from the Hellenistic *Venus Kallipygos*, which is known in a number of Roman copies—but the pose seems to have had particular appeal in the seventeenth and eighteenth centuries, perhaps because it was read as a statement about female vulnerability. Certainly in the case of Velázquez's version, Venus is presented as too narcissistically absorbed in her own reflection to be aware that she is being gazed at by others.

In terms of the history of Spanish art, *The Rokeby Venus* is a revolutionary picture. Religious control of Spanish society had ensured, up till then, that the female nude was not a permissible subject for artists, even though the Spanish royal collections contained many such nudes by non-Spanish painters. The austere Philip II, for example, bought voluptuous examples from Titian. It is no accident that Velázquez's painting was produced not in Spain itself but in Italy, and we can imagine the sense of liberation the artist may have felt as he tackled this hitherto forbidden theme. Yet the result was a work which many women of the present day can read only as oppressive. The question, once again, is that of how we fit such works into our contemporary cultural framework. Can we simultaneously acknowledge their importance in the history of art, and condemn them for their subject matter? If we do condemn them, how can that be expressed in a practical form? Should we remove them from art books on the grounds that at least half the students will find them difficult to deal with?

Judy Chicago I am certain that it will come as no surprise to my readers that I hate these images—particularly the Velázquez—even if they are considered masterpieces. And it does not help me to know that in the Giorgione the cupid has been effaced, and that its presence might have "acted as a mediator between the goddess and the spectator." For I am forced to ask: which spectator? Not this one.

Even a recent interpretation of this supine Venus suggesting that she is masturbating does not make me feel better. If she is engaged in an act of self-pleasure, from the somnolent look on her face, the only person sufficiently awake to be aroused would be the male viewer.

As for *The Rokeby Venus*, I accept that in the context of Western art it must be seen as representing a major breakthrough.

above: **GIORGIONE**
Venus Resting (c. 1508–10);
Gemäldegalerie, Dresden, Germany

far left **DIEGO VELÁZQUEZ**
The Rokeby Venus (c. 1648–51);
National Gallery, London

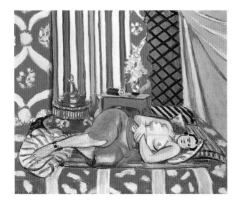

Judy Chicago In terms of these images, the question again must be: for whom are they intended? Not for the woman whose backside is being presented to who knows how many voracious eyes, and probably not for any conscious viewer in the twentieth century who has been privy to recent discussions about the male gaze.

As Mary Devereaux put it in her essay "Oppressive Texts, Resisting Readers, and the Gendered Spectator" (from *Feminism and Tradition in Aesthetics*, 1995):

> *The male gaze involves more than simply looking; it carries with it the threat of action and possession. This power to act and possess is not reciprocal. Women can receive and return a gaze, but they cannot act upon it.*

ODALISQUES ON THE COUCH

When it was first popularized in art, the female nude was usually presented as a goddess, or else as some other mythological being, such as a nymph. This enabled artists to distance the image from the spectator so that, while the nude was apparently sexually available, it did not become sexually threatening.

Sometime before this, however, painters had found a different way of presenting naked females as representatives of "the other"—that is, beings who could be the object of thoughts and emotions which would be unacceptable outside the realm of fantasy. This new formulation was the image of the odalisque—the beautiful inhabitant of an Oriental harem, who exists only for the pleasure of her master. The word "odalisque" is a French corruption of the Turkish term for a concubine, and the type was initially popularized by the fashion for all things Oriental that arose in Europe at the beginning of the nineteenth century. Probably the most celebrated odalisque in art is *La Grande Odalisque* by J. A. D. Ingres, first exhibited at the Paris Salon of 1819.

The painting was not immediately popular—contemporary critics attacked it for its anatomical distortions. The figure does indeed have several vertebrae too many. By modifying his subject in this way, Ingres was giving free rein to his own subjectivity—he endows the figure with an exaggerated sinuosity, which emphasizes its eroticism.

The odalisque as a subject was inherited by Henri Matisse (1869–1954), via Ingres's rival Delacroix. Matisse had fallen under the influence of Islamic art on an early visit to Morocco in 1912, and after he moved permanently to the south of France in 1917, odalisques in various settings became a prominent part of his subject matter. They suited him for several reasons. He had increasingly come to think that modern art was too anxious to challenge its audience, that a good painting ought to offer the spectator a feeling of comfort and repose, "like a good armchair." For him the odalisque was a symbol of hedonistic pleasure. It also suited him that Oriental settings and props

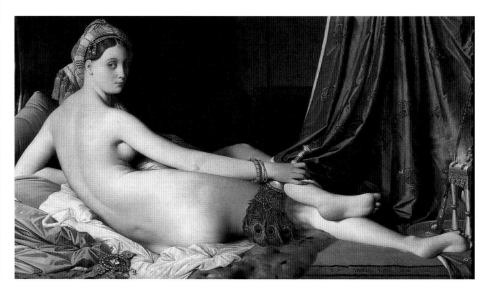

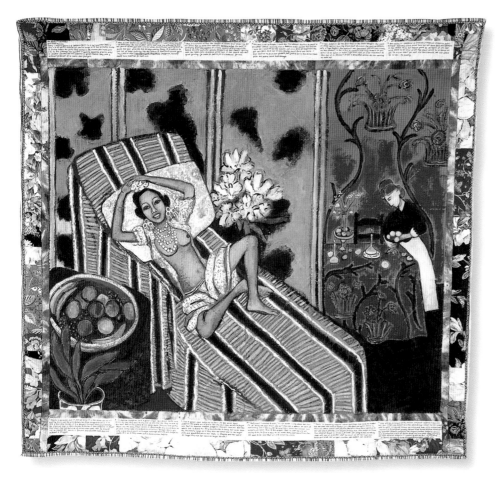

As much as I admire my coauthor and appreciate his efforts to look at some of these classics of Western art with a critical eye, I must point out slippages in his text now and again. For example, when he describes without comment Matisse's statement that his intention was to offer the spectators of his paintings "a feeling of comfort and repose, 'like a good armchair',", I again feel obliged to ask: which spectators? As a female spectator, I find myself between a rock and a hard place in relation to such pictures, uncomfortable looking at the female model—for she is definitely not producing a sense of comfort for me— and unable to identify with her, because a vehicle is not what I wish to be.

offered a way of depersonalizing the model—in effect, removing her individuality. Married to a forceful wife, who had given him considerable help in the difficult early years of his career, Matisse separated himself from her when he went to live on the Riviera, and thence forward, though certainly not celibate, seems to have been wary of all emotional entanglements. The odalisque paintings seem to sum up the detachment which lies at the core of Matisse's later art—they transform living women into passive objects of contemplation.

Jo Baker's Birthday by Faith Ringgold (b. 1930) is a sardonic commentary on male artists' attitudes toward the reclining nude, those of Matisse in particular. She takes as her subject not some anonymous inhabitant of the harem but the exuberant Josephine Baker (1907–75). The black singer and dancer became the symbol of African-American culture in Europe, as well as the long-time idol of the French music-hall public, remembered vividly for her performances at the Folies Bergère, where she danced seminude, wearing only a skirt made of bananas. But Ringgold's choice of Baker as her theme can be read in more than one way. Baker has been condemned by some African-Americans for reinforcing stereotypical white views about black women—in particular that they are mindless, purely sexual children of nature. Does Ringgold's work analyze the stereotype, or simply reinforce it?

top left: **HENRI MATISSE**
Odalisque with Grey Trousers (c. 1927);
Musée de l'Orangerie, Paris

bottom left: **J. A. D. INGRES**
La Grande Odalisque (1814); Louvre, Paris

above: **FAITH RINGGOLD**
Jo Baker's Birthday (1993);
Saint Louis Art Museum, Missouri

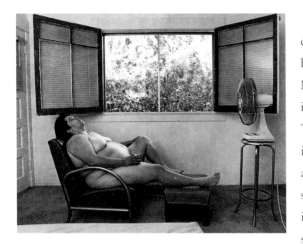

As the critic Laura Cottingham pointed out in her essay "Eating from the *Dinner Party* Plates" (from *Sexual Politics*, 1996):

> Lesbian and its colloquial synonym, "dyke," are seldom spoken or heard as purely descriptive enunciations; rather both words are routinely inflected with threat, fear, uncertainty, taboo, marginality, exoticism, pornographic implications, apology, and confusion.

If this is true at the end of the twentieth century, as Cottingham suggests, how much more piercing must such attitudes have been at the time Romaine Brooks lived and painted? And how much nerve did it take for this artist openly to acknowledge the sexual longings of a woman for a woman, as she has done in *Les Azalées Blanches*?

main picture: **Eva Gonzalès**
Morning Awakening (1876);
Kunsthalle, Bremen, Germany

above: **Laura Aguilar**
In Sandy's Room (Self-Portrait) (1991)

right: **Romaine Brooks**
Les Azalées Blanches (1910);
National Museum of American Art, Washington, D.C.

Other women artists, in addition to Ringgold, have tried their hand at depicting reclining women in varying states of undress, simply because this has become one of the central themes of Western art. *Morning Awakening*, by Manet's only pupil, the short-lived Eva Gonzalès (1849–83), tackles the subject in quite a different spirit from that of the male painters illustrated in this chapter. The picture shows an attractive young woman who has just awakened, clearly in her own bed. There is no nudity—her body is concealed by the covers—and the focus is on her face and in particular on the fleeting expression of someone just roused from sleep. There is no erotic subtext, simply a feeling of intimacy between artist and sitter, a complete mutual understanding. It is not surprising to learn that the subject was Jeanne Gonzalès, the artist's sister. This is an example of the way the standard subject is transformed by a shift in viewpoint.

Les Azalées Blanches (or *Le Filet Noir*) by Romaine Brooks (1874–1970) does, on the other hand, signal an intention to rival similar studies of the female nude by males. To understand this it is once again necessary to place the work in its context. Brooks, a Paris-domiciled American, belonged to a circle of accomplished and artistic women who were either lesbian or bisexual. The gaze she turns on her model is therefore likely to have been a close equivalent of the gaze directed toward similarly reclining nude females by members of the opposite sex. Laura Aguilar (b. 1959), a contemporary American photographer, uses the camera to subvert the entire category. *In Sandy's Room* is a matter-of-fact representation of a far from perfect body—that of the photographer herself. Through its absolute and unflinching directness the image questions the validity of the glamorized versions of the same subject offered throughout the ages by other artists. Part of the point is that the artist is an "out" lesbian. Within her essay on recent lesbian art in relation to feminism, published in *Sexual Politics* (1996), Laura Cottingham comments sharply:

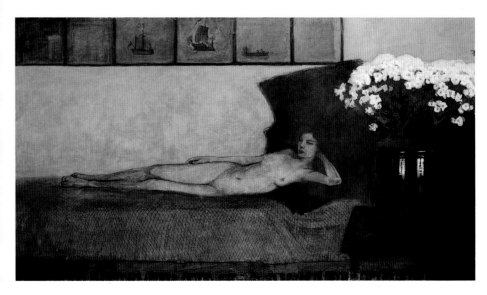

Although one museum curator tried to convince me that this is an image of blissful self-contentment, my experience of lesbian existence doesn't allow me to accept such an interpretation. This is an image of diminished expectations.

This remark has a strange resonance if we think of it in conjunction with the whole tradition of the reclining female nude as it descends to us from Giorgione. Diminished expectations in what respect? Through not being the object of the male gaze, or perhaps because of a lack of physical attractiveness? These two images by lesbians also raise in a more general sense the difficulties women artists continue to have in dealing with such a well-established tradition. A lot of questions come to mind. For example, do certain established formulae used in Western art for portraying the nude female form resonate differently if a woman uses them? Or if a lesbian uses them? Can we in fact immediately detect the difference between an image of a nude female produced by a man and an equivalent image produced by a woman, even if we are at that point ignorant of the gender of the painter? Or of her sexual orientation?

However, as much as I admire Brooks, I am forced to ask: what does it mean when a woman artist reinforces traditional—and negative—images of the female? For this painting might be described as a lesbian version of the traditional figure of the *femme fatale*. As to the Gonzalès, although it is a beautiful image, it is nevertheless a portrait of a rather listless woman on a couch.

Judy Chicago In my description of Artemisia Gentileschi as feminist heroine (see pages 46–47), I discuss the challenges faced by women artists confronting the iconographic traditions of art history. This problem is especially troublesome in relation to the female nude. "Am I the artist or the model?" one wonders, "the gazer or the gazee?"

The act of taking up the paintbrush answers this question, at least for the moment, for the paintbrush does not know the sex of the one who guides it.

THE BROTHEL

The idea of the "casting couch"—woman offering herself for voyeuristic inspection and delectation—relates to the depiction of the brothel, a place where sexual services are for sale. Brothels are extremely ancient institutions. In the ancient Middle East, sacred prostitution was widely practiced, and prostitutes—both female and male—were attached to temples, most often to those of Astarte, the goddess of fertility (see page 27). While Christianity in theory rejected prostitution, it nevertheless flourished throughout the Middle Ages, and the properties where brothels were situated were, perhaps surprisingly, often owned by the Church.

In the Middle Ages and later, the local brothel was often also a steam bath—its function as a bathhouse offered useful, if extremely transparent, camouflage. This is why brothels were sometimes referred to colloquially as "the stews"—the term has a derogatory double meaning, since a woman's vagina could also be referred to as her "stewpot." The fragment of a much larger wall painting by Albrecht Altdorfer (c. 1480–1538), from the Kaiserbad at Regensburg, seems to commemorate this double role.

For many centuries, brothels were not simply places where men went to have sex. They institutionalized the double standard of morality followed by men of the middle and upper classes by providing an alternative place for men to socialize, relax, and even, sometimes, to do business, all out of sight of their women folk. At the end of the nineteenth century, when Toulouse-Lautrec among many others frequented them, the legally recognized and regulated brothels of Paris were famous for the great splendor of their decor and architecture.

In late nineteenth-century France, the prostitute, whether working in a brothel or acting independently, occupied an especially prominent place in the public imagination, figuring both in literature and in art. Among the major literary works inspired by prostitution are Émile Zola's novel *Nana* (1880) and Guy de Maupassant's short story "Boule de Suif" (1880) and his novella *La Maison Tellier* (1881). *Nana*, from the massive Rougon-Macquart series, describes the rise and fall of a young actress who becomes a courtesan. Zola's friend Manet painted a striking imaginary portrait of the heroine of the book. She is shown *en déshabille*, standing before her mirror, while a middle-aged protector looks on. Just as Cupid serves as the intermediary figure in many portrayals of the nude reclining Venus, so this secondary actor is used by Manet to place what he presumes to be the true nature of the (male) spectator's interest.

above: **ALBRECHT ALTDORFER**

Couple (c. 1530); Historisches Museum, Regensburg, Germany

main picture: **ÉDOUARD MANET**

Nana (1877); Kunsthalle, Hamburg, Germany

Judy Chicago But other queries quickly appear, even if they do not make themselves known to the conscious mind. What to paint? And how to paint it? If one wishes to become part of art history, a method of accomplishing this is to take up the subjects deemed significant. Many women artists have done this without taking into account that, as women, they might have a different perspective. But for those women artists—like myself—who do not wish to see male experience continue to be privileged over its female equivalent, the question of where to be as an artist in relation to a tradition that has been shaped by men becomes crucial. However, as mentioned earlier, until recently there were few choices for women artists other than the strategy of subverting traditional subject matter, pioneered by Artemisia Gentileschi.

I recently went to see a Mary Cassatt retrospective. The catalogue pointed out that impressionism, which embraced her *oeuvre*, also caused it to remain partially undisclosed. It is interesting to note that Cassatt rarely painted completely naked women. Thus it is in approaching the subject of the female nude that the problem of point of view becomes particularly troublesome, because this tradition looms so large in the canon of Western art.

main picture: **VITTORE CARPACCIO**
Two Venetian Courtesans (c. 1490–1500);
Museo Correr, Venice

near right: **FRANCISCO GOYA**
Ruega por Ella (from the *Los Caprichos* series) (1799)

far right: **EDGAR DEGAS**
The Madam's Birthday (1878–79); Musée Picasso, Paris

Manet is always an ambiguous artist, and consequently his version of *Nana*, like the more famous painting *Olympia*, has been subjected to a variety of different readings. Some commentators see both pictures as exploitative; others, like myself, disagree, and perceive irony directed at standard masculine attitudes, mingled with sympathy for the position of women.

Irony is unmistakably present in Goya's cutting depictions of prostitutes and prostitution. One of his most forthright statements on the subject is an etching from the *Los Caprichos* series. Entitled *Ruega por Ella* (She Prays for Her), it shows a young prostitute being prepared by her family for the rigors of her profession. The full text that accompanies the image reads:

> *And she did well to do so . . . that God may give her luck, keep her from harm, money lenders and cops . . . make her skillful and careful, wide-awake and ready as her sainted mother.*

In other words, Goya sees prostitution as a family business, handed down from mother to daughter; but he also feels sympathy, as he usually does, for those who, in order to make a living, must place themselves outside the boundaries of respectable society.

One aspect of prostitution that has always fascinated male artists is its hidden side—the secret life of the brothel which is concealed from the client. One reason may have been that men knew that paying for sex was always an incomplete transaction—they might hire and use a female body, but the real person remained inaccessible. This is the theme of *Two Venetian Courtesans* by Vittore Carpaccio (c. 1460–1525/26). Venice was already famous for the number and variety of its prostitutes in the late fifteenth century, and was to continue to be so until the fall of the Venetian Republic in 1797. In Carpaccio's time one of their distinguishing marks was their yellow hair, a color obtained by soaking it in urine, then bleaching it in the sun. Carpaccio's courtesans are rather morosely engaged in this process of beautification.

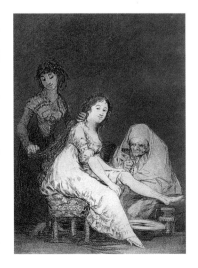

The Madam's Birthday, a monotype by Edgar Degas (1834–1917), was used by the enterprising dealer Ambroise Vollard (1865–1939) as an illustration for an edition of Maupassant's *La Maison Tellier*, although it is not certain that Degas originally conceived the painting in relation to this text. It does, nevertheless, form part of a long series of such monotypes concerned with brothel life—most of them dealing with its secretive or private aspect. The celebration shown is for women only.

Pictures concerning prostitution are as bothersome for me as those of female nudes. I remember seeing Toulouse-Lautrec's brothel paintings when I was young. I averted my eyes from the portraits of the women and concentrated on Toulouse-Lautrec's use of reds to move the viewer's eyes around the picture plane.

The problem of identification confronted me then. I have always likened myself to male artists rather than to their female models—which has confused not only me but also many men of my acquaintance who were surprised to meet a woman who expected to be treated as an equal, both in the bedroom and in the studio.

When I was in my thirties, some female friends and I visited some of the clubs in San Francisco that featured nude female dancers. Never having been in such an environment, I thought it might be instructive to try to understand something about both the dancers and their mostly male clientele.

I can distinctly recall my feelings of revulsion and pity on witnessing one of the dancers gyrating in front of a customer, with her ponderous breasts hanging over him. The look on his face was a seeming mixture of an almost childlike need and an adult lust. I found myself pitying him for having to pay a stranger for a substitute intimacy better found with a mother or a real partner. "Why would any man want such an empty transaction as this one appears to me?", I wondered, a question I cannot help but ask when confronted with the world of the brothel as depicted in art.

Judy Chicago And how can women do it? Even having posed this question, I must confess to some discomfort with the image by Isis Rodriguez. Even though I applaud her audacity, at the same time I find myself shrinking back from the overt anger in the painting. Her rage is no greater than that expressed in the Georg Grosz, though the object of the emotion is far different and, in the case of the Rodriguez, seemingly more appropriate.

ENOUGH IS ENOUGH

The Degas monotype (on page 108) was acquired by Picasso and now forms part of the collection of the Musée Picasso in Paris. As a young man, Picasso also concerned himself with brothels and prostitution; the paintings of the Blue Period (1901–04) often express this theme. Picasso's most explosive version of the subject, however, is the celebrated *Demoiselles d'Avignon*, painted in 1907, which announced the birth of cubism. The painting did not in fact acquire its title from Picasso himself but from one of his poet friends—either André Salmon or Max Jacob. It is a jesting reference to a particularly low-class brothel in the Calle d'Avignon in Barcelona, which the impoverished young artist used to frequent. The suggested title was a swipe at what seemed like the extreme ugliness of the female figures who populated the work.

Though the *Demoiselles d'Avignon* has complex sources, among them African sculpture and the series of paintings of bathers by Cézanne, there seems no doubt that it was from the first intended to depict a group of prostitutes. Originally the composition also included the figure of a young sailor carrying a skull—their client and victim. The painting expresses mingled feelings of horror and fascination. The artist condemns what he depicts but is nevertheless in thrall to it.

The same thing can be said about the drawings featuring prostitutes which the German artist Georg Grosz (1893–1959) made in the bitter aftermath of World War I. *Beauty, I Praise Thee* is a typical example. Grosz sets out to condemn the whole society of the Weimar Republic —its profiteers, its smug bourgeoisie, its sottish drinkers, lechers, and plotting militarists. Again and again, however, he reverts to the subject of commercial sex, and his condemnation of those who sell it is as savage as his verdicts on those who buy it. Though they are members of a victimized underclass, these women seem to fill him with a special horror. We may guess that the animus they arouse stems from something within himself, a hatred of women and, even more than that, a fear of the sexual feelings they excite.

Not surprisingly, depictions of prostitutes and prostitution by women artists are nonexistent even today. The closest thing we have been able to find in the course of our researches for this book are the exuberant comic strip-style drawings by the young

above: **PABLO PICASSO**
Les Demoiselles d'Avignon (1907);
Museum of Modern Art, New York

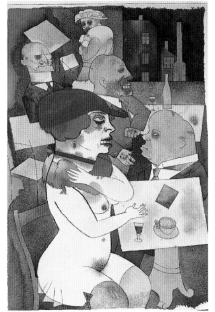

above right: **GEORG GROSZ**
Beauty, I Praise Thee (1919);
Museum of Modern Art, New York

As Simone de Beauvoir pointed out in her classic feminist work, *The Second Sex* (1949), men evidence incredible duplicity in relation to prostitution, regarding the women who live off their bodies as perverted and debauched, rather than applying that description to the males who use them. However, to express such anger openly toward men in one's art was something of a taboo to women artists of my era, or at least it was to me.

So while being able to celebrate the freedom of younger women artists like Isis Rodriguez, at the same time I have to be honest with myself and my readers and acknowledge the discomfort that this image causes me—a statement which indicates my own limitations rather more than it reflects on the art itself.

Californian artist Isis Rodriguez (b. 1964). Rodriguez spent seven years working as a nude dancer in San Francisco clubs. Her drawings are full of humor, but they have a serious message. As Rodriguez says in the *Womanfesto* she wrote in 1998:

> *Whoreism is on the rise right now. It is being glamorized by Hollywood through movies like* Pretty Woman, Indecent Proposal, Strip Tease, *and* Showgirls . . . *In the realm of politics and the law, many politicians now want to legalize prostitution. Legalizing is great for the pimps, the madams, the johns, the military, and the IRS, because they will have more control and make more money. In academic circles we now have people who claim that the whore was symbolic of women's freedom and empowerment. (They have the nerve to tell us that prostitution should be legal because it's the world's oldest profession and we can't escape it. We have to tolerate it.)*

There does not really seem to be much one can add to that.

above: **ISIS RODRIGUEZ**
No More (1996)

I Paint Therefore I Am

Self-portraits are not innocent reflections of what artists see when they look in the mirror. They are part of the language painters use to make a point . . .

FRANCES BORZELLO, 1998

above: **GUDA**

Self-Portrait in an Initial D (twelfth century);

Stadtbibliothek, Frankfurt, Germany

I AM AN ARTIST

The self-portrait plays a crucial role in the story of women's art from the sixteenth century onward. Before this time, self-portraits of any kind were rare. Among male artists they first begin to appear with some frequency toward the end of the previous century, though stone-carvers did sometimes include images of themselves in inconspicuous places in medieval cathedrals. Paintings like Dürer's *Self-Portrait* of 1498, in which he shows himself as a handsome, fashionable, and aristocratic young man, mark the birth of modern self-consciousness. The few self-portraits of women that have come down to us from the Middles Ages are almost invariably small details from manuscripts made in convent *scriptoria*. The *Self-Portrait of Guda in an Initial D*, illustrated here, serves as a kind of signature to her work but is not a major feature of the whole.

On the other hand, the *Self-Portrait* by Catharina van Hemessen (1528–after 1565), though small in scale, is definitely intended as a public statement, as the inscription makes plain—"*I Catharina van Hemessen painted myself, aged 20.*" The emphasis placed on the artist's personal responsibility for the work is noticeable and springs from more than one cause. Not only is van Hemessen, like Dürer before her, expressing a new and more complex sense of the self, she is also attempting to counter the feeling of surprise that a contemporary would have felt on encountering the work and learning its authorship. All sixteenth-, seventeenth-, and even eighteenth-century sources—chiefly collections of artists' biographies, like Giorgio Vasari's *Lives of the Artists* (1550; second, enlarged edition, 1568) and the rather similar collection of lives of northern artists published by Joachim von Sandrart in 1675—stress the fact that professional women artists were the exception to the general rule. The attitude was that it was not merely surprising that a woman should paint well, but that she should be able to paint at all. Female writers were better received.

There was also a further nuance. If a woman was a success as an artist, especially north of the Alps, it was usually as a specialist in some form of still life. Her accomplishment as a still life painter was, for example, the foundation for the considerable European reputation of Rachel Ruysch (1664–1750). By painting a self-portrait, a woman artist was making a claim to be considered a serious painter of the figure. Women were thought to be debarred from figure painting because they could not, with propriety, study from the nude—almost invariably male—model, and studies of this kind were the foundation required for all "higher" branches of artistic activity. In the standard hierarchy of artistic genres, still life and landscape ranked well below portraiture and still further below what was called history painting—the complex religious and narrative scenes upon which major artists founded their reputations. Here a thorough mastery of the figure was essential. Furthermore, women were generally considered incapable of the sheer physical energy required to produce great fresco cycles and very large canvases.

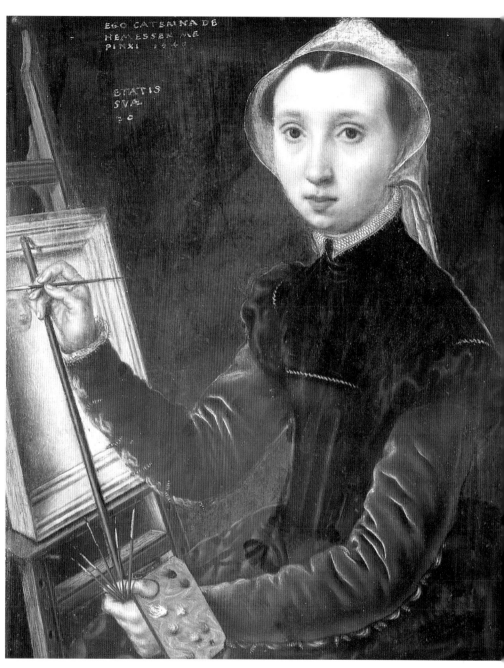

above: **CATHARINA VAN HEMESSEN**
Self-Portrait (1548);
Öffentliche Kunstsammlung, Basel, Switzerland

AM I AN ARTIST OR A LADY?

Female painters faced social problems as well as purely artistic ones. In the highly stratified society of the time, all professional artists occupied a somewhat uneasy position. On the one hand they were artisans, because they worked with their hands. On the other, they aspired to be honored members of the educated, intellectual class. Many anecdotes about celebrated male artists are designed to stress an element of social mobility, of exemption from the rules that governed perceptions of rank and status. One of the best known of these is the story of the emperor Charles V stooping to pick up Titian's brush.

Essentially a female artist could either elect to be a gentlewoman who painted, with the restrictions which this implied in terms of both daily conduct and long-term social mobility, or she could resign herself to being thought of as a not quite respectable outsider. A gentlewoman artist had access to a particular sort of patronage—she could become a favorite with the female members of a court or aristocratic circle. But this limited the scope of her art. This seems to have been the choice made by the gifted mannerist portraitist Sofonisba Anguissola (c. 1532–1625). Her self-portrait, one of several she painted, is signed on the book she holds. The book emphasizes her claim to be a learned and accomplished woman, as does another self-portrait, which shows her playing the clavichord. As the feminist art historian Frances Borzello points out in *Seeing Ourselves: Women's Self-Portraits* (1998), the self-portrait displaying musical talent is one which women made their own, and its origins lie in sixteenth-century ideas concerning the necessary accomplishments of a gentlewoman.

In the north—and particularly in seventeenth-century Holland, where tightly exclusive aristocratic groups were lacking and painters produced for the market rather than waiting for commissions—a different attitude was possible. The body language of Judith Leyster's fine self-portrait is extremely expressive. Using a more decorous version of a pose also used by her Haarlem rival Frans Hals (1581/85–1666) for portraits of self-confident males, she shows herself leaning casually back against her chair, in an attitude which is eloquent of her disregard for any kind of formality. She seems as if she is about to speak, and her gaze has a direct candor that shows she is meeting the viewer on her own terms—those of equality.

One of the very few female artists of this early period who managed to escape almost entirely from social dilemmas was the Bolognese Lavinia Fontana (1552–1614). Her stature was such that she was elected a member of the Academy of St. Luke in Rome. Even so, one of the things we learn about her was that her contemporaries especially admired the way in which she painted clothes and jewelry—something which points to a certain residual sexism in their attitudes.

Judy Chicago Many years ago, I searched the museums of Europe looking for examples of art by women. As silly as it may seem today, now that feminist scholarship has illuminated a tradition of female self-portraiture, those images were a lifeline to me. I was thrilled by my discoveries of (to me) unknown paintings—primarily self-portraits—by artists like Lavinia Fontana, Rosalba Carriera, and Marie-Louise-Élisabeth Vigée-Lebrun, which spoke to me across the centuries, affirming that one could be a woman and an artist, too.

above: **SOFONISBA ANGUISSOLA**
Self-Portrait (1554); Kunsthistorisches Museum, Vienna

main picture: **JUDITH LEYSTER**
Self-Portrait (1635);
National Gallery of Art, Washington, D.C.

Judy Chicago Writing recently about women's self-portraiture in the *Encyclopedia of Comparative Iconography*, art historian Fredrika Jacobs states:

> Over the centuries, women have chosen to depict themselves in ways that are not necessarily in agreement with their portrayals by male artists ... During the medieval and early Renaissance periods, self-portraits by women artists most often took the forms of a "visual signature" ... As women began to assume a more visible place in the arts during the sixteenth century, their self-portraits took a more formal and conventional form. Initially, these ... emphasized the social status of the artist as a "lady" ... but the reticence of women artists to assert their professional activities was short-lived.

According to Jacobs, it was Sofonisba Anguisciola whose work first asserted an authoritative female gaze, a precedent upon which other women built in order to "portray themselves in a manner that proclaims their mastery" and allowed them to explore "the conflicting roles imposed on them by society."

> For centuries women artists have portrayed themselves with originality, charm, and magnificence, and they continue to do so today.

FRANCES BORZELLO, IN *SEEING OURSELVES: WOMEN'S SELF-PORTRAITS* (1998)

WE ARE PROFESSIONALS

The eighteenth century saw a marked increase in the respect paid to women artists. When the Royal Academy of Arts was founded in England in 1768, two women were included among its founding members: Angelica Kauffmann (1741–1807) and Mary Moser (1744–1819). This tradition was not maintained subsequently, and there was a long gap before women were once again elected to membership. The next woman to enjoy full status as a Royal Academician was Laura Knight, elected in 1936.

Angelica Kauffmann came to enjoy a Europe-wide reputation for her neoclassical compositions. She eventually went to work in Rome, and when she died there, after a long and productive career, she was given what amounted to a state funeral.

Kauffmann was one of several female artists who enjoyed major international reputations at this time, flourishing especially as portraitists. Another was the Venetian Rosalba Carriera (1675–1757), whose path to fame was interestingly unorthodox. She learned the trade of lacemaking from her mother, and when the trade in lace declined, began painting portrait miniatures for snuffboxes. This in turn led to her making portraits in pastels. Carriera's success was rapid—in comparison with her predecessors she seems to have met with remarkably little resistance. She became a member of the Roman Academy of St. Luke at the age of 25, despite her lack of professional training. In 1720 she went to Paris, where she made a portrait of the young Louis XV and was elected a member of the Académie Royale. Ten years later she went to Vienna, where Emperor Charles VI became her patron and the Empress took lessons from her.

Marie-Louise-Élisabeth Vigée-Lebrun (1755–1842) was another immensely successful artist of the period. After studying with Jean-Baptiste Greuze and Joseph Vernet, she made her initial success as the preferred portraitist of Marie Antoinette.

Loyal to the Bourbons, she went into exile following the French Revolution in 1789, and for the next 12 years traveled throughout Europe, visiting Rome, Naples, Vienna, St. Petersburg, and Moscow. She returned to Paris in 1801, but soon left again, going to London and Switzerland before definitively returning to France in 1810. At this point she retired from painting. Her entertaining *Reminiscences* (1835–37) give a lively account of her widespread travels and the artistic triumphs she enjoyed everywhere that she visited.

These memoirs also give a good idea of Vigée-Lebrun's considerable acumen in managing her career. One of the foundations of her success, as she herself points out, was that she invented a new, informal way of dressing and behaving, which she duly recorded in the female portraits that form by far the greatest part of her output. Her own self-portraits were not merely proofs of her very considerable skill but also subtle advertisements for the reshaping of fashion and manners in the direction of simplicity which she helped to initiate.

When we compare Carriera's self-portraits to those of Vigée-Lebrun, we see an interesting difference. Carriera's self-portraits are far more penetrating than the general run of her work and seem to be essentially private meditations on her own personality. Vigée-Lebrun's are carefully calculated professional statements and, for all their charm and technical brilliance, do not attempt to go far beneath the surface. We know that when she arrived in a new city she usually displayed one of these self-portraits as a means of attracting commissions.

The two artists do have something in common, however—they were the beneficiaries of a movement in European culture that increasingly made women the recognized arbiters of taste and fashion. This was to be checked by the social and political upheavals of the Revolutionary and Napoleonic epochs, and women artists were unable to build on the gains they had made. Napoleonic art involved the glorification of the emperor and his victories, and women artists had little to offer there.

above: **MARIE-LOUISE-ÉLISABETH VIGÉE-LEBRUN**
Self-Portrait (1791); Uffizi Gallery, Florence

far left: **ROSALBA CARRIERA**
Self-Portrait as Winter (1731);
Gemäldegalerie, Alte Meister, Germany

left: **ANGELICA KAUFFMANN**
Self-Portrait (1787); Uffizi Gallery, Florence

LOOKING AT MYSELF

Real, in-depth self-examination on the part of women artists in general seems to coincide with the birth of modernism. There is one striking exception to this—the intense likeness of herself painted by Marie Bashkirtseff (1860–84), now better known for her *Diary*, which produced a sensation when it was published posthumously in 1887, after her tragically early death from tuberculosis. Her self-portrait is relatively conservative in style. It shows no trace of the impact made by the contemporary impressionist movement—her passionate admiration went instead to the realist Jules Bastien-Lepage (1848–84)—but is technically subtle and full of feeling. The fact that Bashkirtseff is remembered as a major contributor to literature, while her painting is nearly forgotten, is a reminder that women have consistently found it easier to achieve success as writers than they have as artists.

Women painters are more likely to be overshadowed by male relatives than female ones. For a long time this was the case with the British painter Gwen John (1876–1939), whose reputation was far outstripped by that of her flamboyant painter brother

Augustus (1878–1961). Gwen, as reclusive as her brother was outgoing, is now generally recognized as the finer artist of the two—something her brother generously predicted. Her searching self-portrait is almost as conservative technically as that by Marie Bashkirtseff. Its utter directness and simplicity are what make it seem modern—its overriding concern is with psychological truth.

Not surprisingly, Paula Modersohn-Becker's self-portraits are among the finest produced by any twentieth-century artist. The long series which she produced during her brief career illustrate, perhaps more vividly than the works of any other woman artist, the search for the self—the true self—which has been one of the principal and enduring themes of women's art in the course of the last hundred years.

Judy Chicago To appreciate fully the achievements represented by women's self-portraits, this work must be placed within the context of social attitudes toward women artists. For example, in his 1851 essay titled "Of Women," Schopenhauer quotes Rousseau, who, in "Lettre à d'Alembert," stated that:

> *"Women have, in general, no love for any art; they have no proper knowledge of any; and they have no genius."*

Schopenhauer expands upon this argument to proclaim:

> *The whole sex have never managed to produce a single achievement in the fine arts that is really great, genuine, and original; or given to the world any work of permanent value in any sphere. This is most strikingly shown in regard to painting...*

Let me share my own experience at college in the early 1960s, in a class in the intellectual history of Europe. At the first session, the professor—a respected historian—said that at the last meeting of the class he would discuss women's contributions. I waited eagerly all semester, only to have him stride into the final session and state curtly: "Women's contributions—they made none."

main picture: **MARIE BASHKIRTSEFF**
Self-Portrait with Jabot and Palette (c. 1880);
Musée des Beaux-Arts, Nice, France

above left: **GWEN JOHN**
Self-Portrait (1902); Tate Gallery, London

above right: **PAULA MODERSOHN-BECKER**
Self-Portrait (1906–07); Gemeentemuseum, The Hague

Although my professor's comment about the paucity of female contributions was not specific to art, its sweeping nature seemed to condemn my entire sex to a netherworld of insignificance. It is difficult to judge the feelings of my artistic predecessors in the face of such certainty as to the inadequate nature—and efforts—of all members of the female gender. I can only say that a deep gratitude is due those women artists who had the courage to reach for their paintbrushes with a firm resolve to combat such abiding prejudice the only way they could, by creating a revealing visual legacy of self-representation which might be viewed as an early form of oppositional art.

above: **KÄTHE KOLLWITZ**
Self-Portrait (date unknown);
Orlando Museum of Art, Florida

main picture: **HELENE SCHJERFBECK**
Self-Portrait: An Old Woman Painter (1945);
Central Art Archives, Helsinki

above right: **ELISABETH FRINK**
Self-Portrait (1987)

GETTING OLDER

Women artists who make self-portraits have to deal with the process of aging—more traumatic in their case than that of men, since society puts such a premium on youth and beauty in females. Perhaps the most intent observer of the inevitable toll taken by the passing years was the Finnish artist Helene Schjerfbeck (1862–1946), who would surely be better known had she not come from a small nation with a difficult language, combined with the fact that almost the whole of her work has remained in Finland. Schjerfbeck's primary subject is her own face. She unflinchingly records the changes in her appearance in a long series of images, all in the same format. In her last and most moving self-portraits she seems ghostlike, flesh gradually becoming transparent, fading, and flinching away from the material world.

Equally candid in this respect is Käthe Kollwitz, whose later likenesses of herself are

not only a record of the aging process but also of the terrible toll taken by both personal and political events, including the death of a son in World War I, the slow demise of the interwar Weimar Republic, and the rise of Nazism. Kollwitz unflinchingly records her own despair, but at the same time indicates the strength of character which will overcome this and enable her to go on creating art.

The British sculptor Elisabeth Frink (1930–93) made very few portrait busts of any kind and always said that she was not interested in portraying women. She made an exception to this when she was asked, by me, to make a likeness of herself for an exhibition of self-portraits by contemporary British artists. The resulting bust makes a particular feature of her mass of curly white hair, one of the most striking elements of her appearance.

Frink did not live to be as old as either Schjerfbeck or Kollwitz, but this bust is nevertheless a strikingly honest record of her demeanor and appearance just before she was struck down by a fatal illness, and shows a woman completely at ease with her own character, and with the changes that time has inevitably made in her appearance. To look at this bust is to be brought into the presence of the woman herself. The directness of her gaze in the work is especially arresting and the whole image reflects her animated personality.

Judy Chicago Until I read the book on female self-portraiture by Frances Borzello cited by Ted at the beginning of this chapter (see pages 115–116), I had never seen this painting by Laura Knight. Given my earlier comments about women's confusion in terms of identity, I was struck by the perfect way in which this picture seemed to express this dilemma.

However, when one studies the image, one is struck by several odd notes. Although the clothed figure—a representation of the artist—holds a paintbrush in her hand, there is neither paint nor palette in evidence. I suppose it is possible to paint such a large picture without getting any paint stains on one's smock, but who wears a hat, at least such a hat, when painting?

Borzello suggests that we are looking at two pictures of nudes, "encouraging the viewer to judge how well Knight's work is progressing." But maybe that is a real model in the background and the painting on which the artist is working is in the foreground of the picture plane. Perhaps the artist is not actually at work but, rather, studying nude paintings in a museum. Her clothes could actually be taken for street attire and the dual naked figures might be interpreted as two painted images. And yet this is not quite right either.

All in all, I would suggest that the ambiguous nature of the imagery only reinforces the cogent question being posed: am I to be the artist, or the artist's model? Am I to create my own forms of representation, or mimic a history that is not mine?

AM I THE ARTIST, OR THE MODEL?

One dilemma that consistently faced women who were attempting the self-portrait genre was the lack of a clear psychological division between the gazer, or painter, and the object of that gaze. The centuries-old presumption was that the artist, the person who looks, takes the active part, and that the model, the person who is looked at, is purely passive. A man making a self-portrait finds it relatively easy to deal with this division by making the picture also the portrait of a particular role. Both Dürer— who once painted himself in the guise of Christ—and Rembrandt, particularly in his earlier self-portraits, offer striking examples of this. Women run the risk of seeming affected and insincere if they attempt this course of action. One example of an artist tackling this issue directly is the fine likeness of herself by the British artist Laura Knight (1877–1970). She is shown, fully clothed, looking at a nude female model, who is being reproduced on her canvas. Frances Borzello remarks that in this picture Knight "... lays out for the viewer the change in the lives of women artists. Before the twentieth century, credibility and propriety forbade the inclusion of the naked model of either sex in a work by a woman artist."

The implication is that the active masculine role has been transferred intact to her, by virtue of her confidence in her own creativity. It is worth considering, however, how much more revolutionary the picture would seem if the nude model was male, thus exactly mirroring the situation frequently depicted in paintings made by men. In 1913, when the painting was produced, such a conjunction would still have been unthinkable. Knight, though a fine painter, was in most respects an artistic conservative—a fact confirmed by her election to the Royal Academy at a time when that institution was regarded as a ferocious opponent of everything modern.

Laura Knight's *Self-Portrait* therefore actually represents what is only a kind of half-way house. She has indeed seized the initiative, but is still confined by the generally accepted social boundaries of her gender. The argument she was involved in was never to be concluded during her lifetime, since she also belonged to pretty much the last generation of artists who studied art according to the old academic system. Working from a live model is no longer essential for any young artist, and even if an artist does choose painting—rather than alternatives such as performance, video, or the making of environments—as her normal method of production, the study of the nude is unlikely to play a large part in what she does.

This fact is one of the things which ought to warn us against making too many direct comparisons between the situation of the woman artist in the closing years of the twentieth century, and her situation in the Western artistic tradition up to and including its first two decades. So long as the academic system flourished, women remained at a disadvantage in the visual arts. It was almost as if many elements in that system had been deliberately constructed to exclude them.

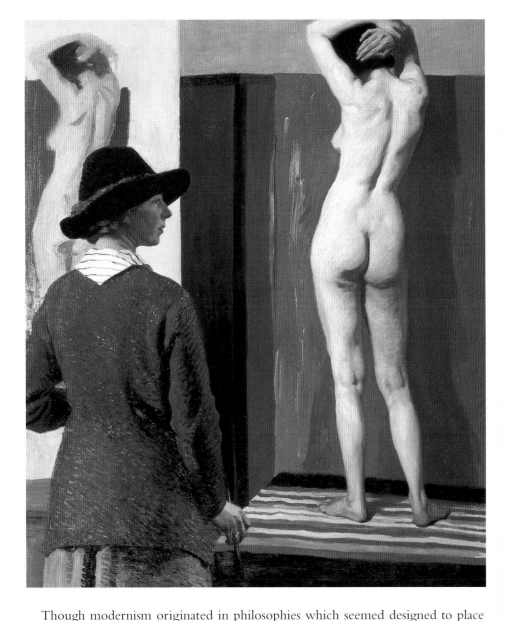

I found myself saying to myself—I can't live where I want to—I can't do what I want to—I can't even say what I want to . . . I decided I was a very stupid fool not to at least paint as I wanted to . . . as that seemed to be the only thing . . . that didn't concern anybody.

GEORGIA O'KEEFFE

main picture: LAURA KNIGHT
Self-Portrait (1913);
National Portrait Gallery, London

Though modernism originated in philosophies which seemed designed to place women at a disadvantage, it also broke the mold of thinking about how art should be made. Furthermore, it came up with new ideas about how the visual arts should function in society. Because the situation was in flux, women were offered opportunities which had previously been out of reach. Since the 1960s, in particular, we have witnessed an increasing pluralism of styles, and a proliferation of different ways of making art. Feminism made it difficult to confine women to the restricted role which they were forced to play in the art world when Laura Knight was a young woman. Her complex *Self-Portrait* represents not a door into the actual future, but a glimpse of an alternative art-making future which never came to pass. Whatever their disagreements, the modern movement and feminist art are historically linked. However, Laura Knight was never a modernist, and whether she was a feminist is unclear.

I AM WHAT I AM

The contemporary insistence on psychological openness has led to a number of startling nude self-portraits. A pioneer in this respect was Suzanne Valadon (1865–1938). Her *Self-Portrait with Bare Breasts* (1931) records the effects of age on the beautiful body opposite. The illegitimate daughter of a laundress, Valadon initially made her living as a circus acrobat. She then became an artist's model, posing for a number of celebrated artists, among them Renoir, Toulouse-Lautrec, and Pierre Puvis de Chavannes. It was this experience which inspired her to make art on her own account. Perhaps the first and most important person to encourage her was Degas, who, despite his carefully cultivated reputation for misogyny, was readier than most of his contemporaries to offer recognition to gifted women artists. He also encouraged Mary Cassatt, saying of her work, "There is someone who thinks as I do."

One consistent feature of Valadon's work is its boldness of color and line—some critics might say its consistent harshness. In this respect she is the very opposite of her younger contemporary Marie Laurençin (1883–1956), whose painting won rapid recognition because it could so easily be categorized as "typically feminine," with its blurred forms and pastel hues. Valadon's mature work, which dates from comparatively late in her career—she only really flourished after 1909, when she ended the marriage to a prosperous businessman which had cushioned her materially for some years—always looks like an exercise in compulsive truth-telling. While the high quality of her work has been widely recognized, it is perhaps less valued than it should be because of this. Another compulsive truth-teller, Alice Neel, retained a mischievous desire to shock well into old age, when her artistic importance was at long last being recognized. Her *Nude Self-Portrait*, painted only four years before her death in 1984, combines,

above: **KATHERINE DOYLE**
Self-Portrait (No Shame) (1992)

right: **ALICE NEEL**
Nude Self-Portrait (1980);
National Portrait Gallery, London

far right: **GILLIAN MELLING**
Me and My Baby (1992);
Nicholas Treadwell Gallery, London

main picture: **SUZANNE VALADON**
Self-Portrait (1917); Musée d'Art Moderne, Paris

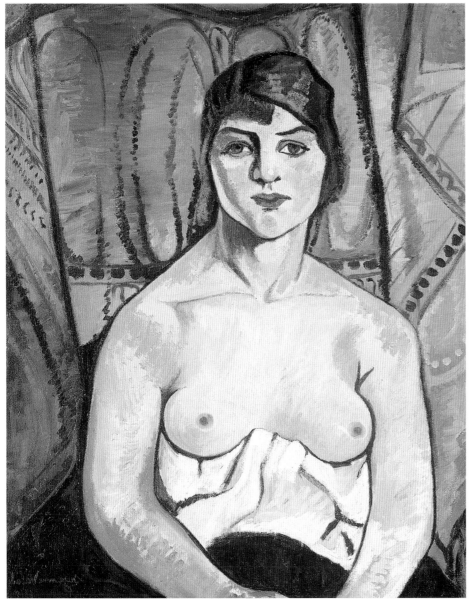

I sometimes see men walking around publicly bare-chested, often with fleshy stomachs hanging over their trousers. It always amazes me to witness their seeming sense of comfort with their bodies, because I—like many women—agonize over every pound of extra weight. Even when I am at my leanest, I find it difficult to expose my body openly, particularly as I grow older.

Thus I feel awe at the courage of these artists, who stripped bare in front of their mirrors to confront and depict the reality of female flesh—in youth, pregnancy, maturity, and old age.

tongue-in-cheek, apparently warring elements. The pose and expression of the artist—matronly rather than aggressive—suggest that an elderly woman in a state of total nudity is the most natural thing the spectator could encounter. But the fact of nudity nevertheless retains its power to unsettle us.

Younger artists, such as Katherine Doyle (b. 1952) and Gillian Melling (b. 1956), have also made use of nudity as a way of signaling their complete honesty. Melling's portrait of herself in a state of advanced pregnancy, *Me and My Baby,* has other meanings as well. In a general sense, it signals the artist's feeling that the process of making a painting is, for a woman, akin to the process of giving birth. In a more strictly personal one, it celebrates the fact that giving birth to three children ended Melling's earlier anorexia.

Body as Battleground

The reconceptualization of the female body from a symbol of sexual and spiritual power to an object under the control of men . . . gradually led women themselves to image their bodies from a male perspective.

RIANE EISLER, 1995

The struggle over the nature of female identity and the representation of the female body can be traced back to the thirteenth century, when the Church first consolidated its thinking about women. The *Summa Theologica*, a multivolume work written by Thomas Aquinas between 1266 and 1272, reflected official attitudes and held sway for many centuries.

FEMALE FLESH

The female body, clothed and, more especially, unclothed, has now become a cultural battleground, as is apparent from earlier chapters of this book. People are, however, not always aware of the issues raised by a number of quite celebrated twentieth-century artworks—some of which, indeed, enjoy iconic status in most textbooks on the subject. Examples are paintings of women by Willem de Kooning (1904–97)—one of the most universally lauded achievements of mid-twentieth-century art. De Kooning began the series with *Woman I* in 1950 and continued it throughout the first half of the decade. Following the basic principles of the abstract expressionist movement to which the artist belonged, the paintings, in addition to being representations of naked women, are equally naked revelations of the artist's psyche—a deliberately

uncensored exposure of his deepest fears and desires. They also reveal something which is at first sight surprising—this supposedly liberated individual, living in a society which was probably the freest of its kind at that moment in history, seems to have entertained a deep fear and horror of female flesh. These paintings are the equivalents of Indian images of Kali, the goddess of terror and destruction, but with no counterbalancing element. The worshiper of Kali always knew that she was only one aspect of a goddess who was just as ready to manifest herself in beneficent guise.

Aspects of de Kooning's own life history may help to explain the savage intensity of these images. He was raised by an extremely dominating mother, and his poor relationship with her seems to have played a major role in his decision to emigrate to the United States. He remained out of touch with her for many years, only resuming contact when he was able to return to his native Holland as a celebrity—that is, when he could feel, at long last, that she no longer had any power over him. Even when he resumed contact, their relationship remained cool.

But there is a public aspect to the series as well as a private one. De Kooning was already a well-established artist when the paintings were first exhibited. His reputation had been established by bold abstract works done in the late 1940s. His return to figuration raised his reputation to new heights. Both modern art critics and ordinary members of the public found something cathartic about them—they gave concrete, visible expression to feelings the artist apparently shared with many other members of his own gender. The enormous prices that de Kooning's *Women* fetch today, when a painting from the series becomes available for sale, testify to the prestige these images continue to enjoy in contemporary culture. What are women to make of pictures, universally celebrated by male critics, that are so openly hostile to the female? To parrot the accepted line that they are twentieth-century masterpieces seems the coward's way out.

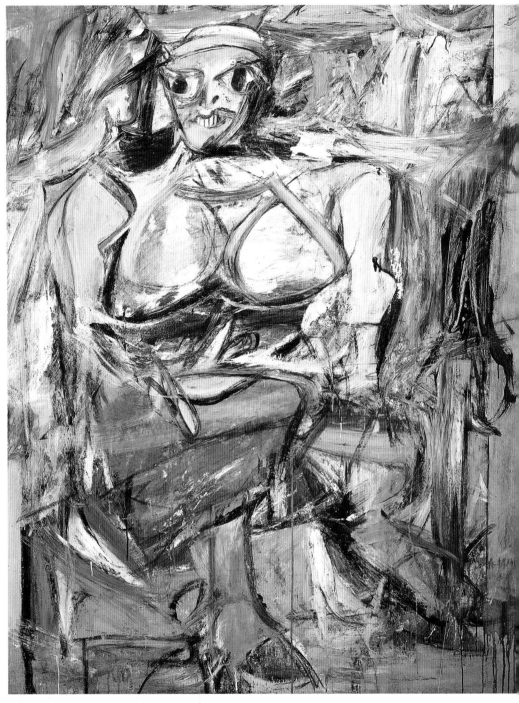

main picture: **WILLEM DE KOONING**
Woman I (1950); Museum of Modern Art, New York

127

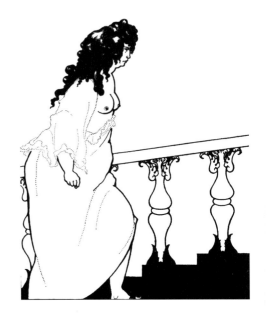

Judy Chicago Woman was considered a necessary evil to be kept in check by law, religion, male control, and social convention. One might say that late-medieval images of Eve by painters such as Bosch or Cranach deftly transmitted this idea. In addition to viewing woman as a necessary evil, Aquinas also accepted Aristotle's notion that woman is a defective male lacking vital force, a viewpoint which shaped the attitudes of Renaissance thinkers and many subsequent philosophers and writers.

This perspective, when combined with the prohibitions against professional training for women artists, resulted in formidable obstacles to female creativity, something I believe must be kept in mind when discussing women's efforts to establish themselves as artists.

above: **AUBREY BEARDSLEY**
Messalina (1897)

right: **HIERONYMOUS BOSCH**
Eve (detail from the center panel of **The Last Judgment** triptych, c. 1500);
Akademie der bildenden Künste, Vienna

FEAR AND FASCINATION

Fear of, yet fascination with, the female body was not, of course, a new theme in art. It has manifested itself in many forms for many hundreds of years. The Christian formulation was the image of Eve, presented as the partner and accomplice of the phallic serpent and the real agent of the Fall. This is the guise in which she appears in *The Last Judgment* by Hieronymous Bosch (c. 1450–1516). Her prominent position (to the right of center) in the complex composition and the flirtatiousness of her pose leave small doubt about her complicity with the agent of evil.

Another and quite different epoch which put a particular emphasis on the multiple meanings of the female body was that of late nineteenth-century symbolism. Absolutely central to symbolist art and literature was the image of the Fatal Woman— the woman who destroys men's souls by seducing their bodies. Aubrey Beardsley (1872–98) presents the fantasy in concise form with his drawing of the Roman empress Messalina, wife of Emperor Claudius. Made as an illustration to the *Sixth Satire of Juvenal*, it shows the decadent empress making her way to the brothel where she will exhaust all the men who come to her:

> *And many thirsted for encounters try'd,*
> *Departed tir'd with men, not satisfied,*
> *And foul'd with candle-smoak, her cheeks smear'd ore,*
> *The Brothel-steam to Caesar's pillow bore.*
>
> SIR THOMAS STAPLEFORD'S TRANSLATION, 1660

Neither fear nor fascination was ever in need of a literary excuse. Several striking paintings on this theme were made by the British artist Stanley Spencer (1891–1959). They show him contemplating the nude body of his second wife, Patricia Preece. Their relationship was a complicated one. Preece, who lived in a lesbian relationship with another woman, got him to sign over most of his property to her, then left him outside the bedroom door on their wedding night. Spencer, for his part, entertained fantasies of living in a *ménage à trois* with her and his first wife, Hilda Carline. In the picture illustrated here he and Preece are in the closest possible physical proximity, yet psychologically apart. Reluctantly allowing herself to

be contemplated, she looks into the distance with boredom and distaste. He stares, yet seems to make no contact with her as a personality. The painting shows his aware-ness of her indifference to him, but also his determination to possess her body, if not through actual sexual congress, then by the act of painting it.

Visual art is particularly good at conveying this kind of emotional complexity because it does not need to spell things out. In the case of Spencer's painting it seems very likely that different spectators will read it in different ways. Those who know the details of Spencer's biography, and of his tortured relationship with Preece, may read it more sympathetically than those who are ignorant of the circumstances. But the basic meaning—the determination to possess, at any rate in fantasy, what was refused the artist in fact, remains perfectly apparent. However, one also has to concede that the painting could not have been made without some sort of cooperation on Preece's part. That is part of the visual narrative too.

Only against a larger context can one begin to appreciate the guts required even to become an artist, much less to forge an iconography that might challenge prevailing attitudes toward women, particularly when these were expressed as sublimely as in the paintings of Velázquez, Giorgione, Ingres, Matisse, or de Kooning.

above: **STANLEY SPENCER**
Self-Portrait with Patricia Preece (1937);
Fitzwilliam Museum, Cambridge, U.K.

right: *Young Girl with a Dove*
(second century AD);
Capitoline Museum, Rome

YOUNG FLESH

Many men feel an erotic attraction for sexually immature females. This fixation is lavishly represented in art. Examples of it can be found as early as the Hellenistic period, which was the first to create convincing sculptural images of children and adolescents, though nude adolescents of both sexes do appear in fifth-century BC Greek vase paintings, usually in erotic contexts. The *Young Girl with a Dove* is a Roman copy of a Hellenistic original. Though the subject is fully, even voluminously clothed, the erotic subtext is unmistakable—the girl holds a dove, the symbol of her own sexual innocence, out of the reach of a snake, which is endeavoring to attack it.

Centuries later, at the time of the symbolist movement, the innocent, or alternatively the knowing, female adolescent formed the counterpart of the sexually sophisticated Fatal Woman. A number of the most famous artists of the late nineteenth and early twentieth centuries seem to have had a sexual fascination with very young girls. One of these was Paul Gauguin (1848–1903). When he moved to the South Seas, Gauguin took very young Polynesian girls as housekeepers and mistresses. In his correspondence he is quite frank about the nature of his relationship with them. In a letter to his fellow painter Armand Séguin he wrote:

> I have a 15-year-old wife, who cooks my simple everyday fare and gets down on her back for me whenever I want, all for the modest reward of a frock, worth ten francs a month.

However, it is not just women artists who have had to contend with images of women by men which are not only gorgeous examples of painting but are also generally accepted as masterpieces. Women in all areas of art practice must confront an enormous body of negative imagery centering on the female, some of which is considered the defining iconography of Western civilization.

These girls served as the models for many of his most celebrated paintings, which are striking records of the helpless vulnerability of their subjects. In a similar way, Egon Schiele (1890–1918), perhaps the most brilliant member of the Vienna Secession, shows his obsession with adolescent female bodies in many of his drawings, and contem-

right: **PAUL GAUGUIN**
Nevermore (1897); Courtauld Gallery, London

main picture: **EGON SCHIELE**
Standing Female Nude with Crossed Arms (1910);
Graphische Sammlung Albertina, Vienna

Judy Chicago When trying to deal with such work, even female art historians of repute sometimes display an equivocation so obvious as to be comic. Writing about de Kooning's paintings of women in the February 1998 issue of *Art in America*, Linda Nochlin attempts to grapple with the conventional view of these pictures as masterpieces while at the same time expressing her unease with the images. But she seems unable to resolve this:

> Despite the . . . purported misogyny . . . conveyed by the Woman series . . . it is clear that these are powerful figures . . . I am not sure I can agree with any single evaluation of the Woman series from the viewpoint of "positive" or "negative" gender representation. There is too much ambivalence here. And what, precisely, constitutes "positive" or "negative" when a cultural concept like "woman" (in general) is at stake?

Someone not professionally involved with art might ask some rather simple questions, which Nochlin avoids, such as: for whom were these "powerful figures" made? And what kind of power does this work convey?

One has only to look back at images of Kali or Eve as the personification of evil to see the long tradition from which de Kooning has—consciously or not—fashioned images of women which conform to a certain view of the female. This view, in my opinion, ultimately disempowers women while pretending to do the opposite; ultimately, though, these images speak only to those who see female power as fearful and destructive.

porary accounts describe the way in which he encouraged young delinquents to hang around his studio. Another Austrian painter of the period, Paris von Gütersloh, remembered them vividly:

> They slept, recovered from beatings administered by parents, lazily lounged about—something they were not allowed to do at home—combed their hair, pulled their dresses up or down, did up or undid their shoes . . . like animals in a cage which suits them, they were left to their own devices, or at any rate believed themselves to be.

When Schiele made the mistake of moving out of Vienna to the small provincial town of Neulengbach, half an hour away by train, his recklessness with regard to these ill-defined relationships with young children and adolescents actually earned him a short term of imprisonment.

More recently, Balthus, born Balthasar Klossowski de Rola in 1908, has founded his reputation largely on paintings featuring very young girls, sometimes nude, and often portrayed in attitudes which are eloquent of barely repressed sexual desire. This example uses symbolic devices to reinforce the erotic message. Voluptuously bending back, the girl reaches toward a playful cat, an animal often used to represent female sexuality. The composition is intensely voyeuristic, but the artist effectively stresses his own control of all the elements in it and his detachment from what is portrayed.

It is interesting to compare some of this work with a well-known painting by Mary Cassatt, *Little Girl in a Blue Armchair*, which shows a child even younger than those whom Balthus usually portrays. Cassatt conveys very accurately the unconscious sexual allure which her subject projects—her awareness of this aspect is unmistakable, and may seem surprising in view of the artist's very "proper" and respectable social background. But she contextualizes her subject in a way that Balthus does not—his adolescents are types, screens upon which a male fantasy can be projected, while Cassatt's child is a recognizable individual, a personality in her own right.

It is curious that pictures of this sort, even those by women artists, showing children as independent personalities, without their mothers, are so rare. Another aspect of this painting, noted by the art historian Griselda Pollock in her essay "Modernity and the Spaces of Femininity" (1987), is that the space itself is configured as if seen from a child's point of view: "The chairs loom large, as if imagined from the perspective of a small person placed among massive upholstered obstacles." The setting here is just as significant, in a totally different way, as it is in the painting by Balthus. Cassatt uses surrounding elements to show her empathy with the subject, just as Balthus stresses alienation. Here is a genuine example of the difference that gender itself can make to the way in which particular subject matter is seen.

Also, de Kooning has been considered an avant-garde artist, but really, how "avant" is it to cast the female as the embodiment of annihilative power?

And what of the range of emotion evidenced in male images of pubescent and aging females? In terms of the former, I suppose that if a grown man had internalized the distorted images of women that make up a good part of the art history presented in museums, he might conclude that a child would be less threatening.

above: **MARY CASSATT**
Little Girl in a Blue Armchair (1878);
National Gallery of Art, Washington, D.C.

left: **BALTHUS**
Nude with a Cat (1937);
National Gallery of Victoria, Melbourne, Australia

Nevertheless, the dictionary definition of pedophilia is "sexual desire in an adult for a child," and I always thought that it constituted a crime. But apparently, this does not apply to art—or to artists. In terms of aging female flesh, well, we all know what horror it can evoke, which makes the Hambling painting shown here all the more unexpected.

The Old Woman is our beginnings and our endings, and our beginnings again. Enriched by the experiences of living, she is the missing link in the sacred circle.

JEANNE BROOKS CARRITT, 1988

AGING FLESH

If youth and its meaning offer one crux in the way that women are represented in art, old age offers another and rather different one. This theme has already been touched upon previously, in connection with female self-portraits. In art, the duty assigned to the female is to be "beautiful," and the notion of beauty has often been narrowly defined. In antiquity there was little artistic respect for the physical ravages brought by age. This applied to the male body as well as the female one, but attitudes to old or older males were modified by respect for the figure of the revered thinker. Portraits, often imaginary, of philosophers such as Plato or famous dramatists such as Aeschylus helped to establish a dignified type for the portrayal of old age in men.

Old women seem to have been universally considered miserable and ridiculous. Though Greek grave *stelae* from the fourth century BC sometimes include old women as secondary figures—generally as servants—the effort to portray old age for its own

right: **MAGGI HAMBLING**
Dorothy Hodgkin (1985);
National Portrait Gallery, London

far left: **QUENTIN MASSYS**
A Grotesque Old Woman (c. 1500);
National Gallery, London

left: **REMBRANDT HARMENSZ VAN RIJN**
Margaretha de Geer (c. 1661);
National Gallery, London

below: *Drunken Old Woman* (third century AD);
Capitoline Museum, Rome

sake had to wait, like the portrayal of children, until Hellenistic times. Several life-size statues of old women survive, often Roman copies of Hellenistic prototypes. They stress the misery and degradation of age—these are derelicts clinging to the last rags of life—and the presumption, supported by epigrams of the same period included in the *Greek Anthology*, has to be that the Hellenistic audience found destitute old women, the equivalents of modern "bag ladies," amusing rather than pitiable.

One of the most exaggerated examples of the tendency to regard old women with complete lack of sympathy comes from a much later period, though the subject, as her costume indicates, is of high rank. It is the painting *A Grotesque Old Woman* attributed to Quentin Massys (1465/66–1530). Though supposedly a portrait of the exceptionally hideous Margaret Maultasch, Duchess of Tyrol, this image clearly derives not from anything seen in real life but from Leonardo da Vinci's curiously strained caricatures of ugly people, males as well as females.

The seventeenth century, with its much more complex and nuanced world view, was perhaps the first period that consistently saw genuine beauty in old age—in old women as well as old men. Rembrandt (1606–69) was a pioneer in this respect. His portrait of Margaretha de Geer, painted toward the end of his career, considers the elderly wife of a wealthy bourgeois with penetrating sympathy. In painting this picture, Rembrandt supplied a model for subjects of the same type which is still valid. By contrast, the painting by the British artist Maggi Hambling (b. 1948) of Professor Dorothy Hodgkin (1910–94), winner of the Nobel prize for chemistry, emphasizes not tranquil passivity (as Rembrandt's work does) but the activity of her subject, whose four hands show that she is in constant motion. This is an entirely new vision of female old age, presented by a woman artist.

Your gaze hits the side of my face

THE FACE

Toward the end of the twentieth century, discourse about the male gaze, and its meaning for art, has tended to dominate feminist discussions of the subject. Recently, for example, an attempt has been made to distinguish between the gaze, which must always be construed as aggressive—an attempt to possess and to dominate—and the glance, from which aggression is absent. *Untitled (Your Gaze Hits the Side of My Face)* by Barbara Kruger (b. 1945) is a visual summary of the doctrine of the gaze in its original form—it derives from a reinterpretation of the linguistic theories of the French poststructuralist philosopher Roland Barthes (1915–80), who saw language itself as a form of legislation. Kruger, like Barthes, has immersed herself in popular culture, but in a much more critical and analytical fashion than that of the pop artists of the generation immediately preceding her own. Her borrowed image, with its accompanying text, incorporates lessons learned from the Russian constructivist poster designers of the beginning of the twentieth century. The aim is to deliver the message as forcefully as possible, without apology or prevarication.

Kruger's work incorporates an apparently impassive classical head—a symbol of resistance. It makes a fascinating comparison with a drawing made by the pre-Raphaelite painter Dante Gabriel Rossetti in preparation for a work he never managed to finish. *Found* (1858) shows a young countryman who has come to London in search of his lost sweetheart. He finds her, but she cringes away from him, because she has become a "fallen woman." The drawing is eloquent of her confusion and shame as he looks at her. Here the gaze is also perceived as aggressive—long before the rise of modern feminism—but a suitably moralistic context is provided to justify it. The male who claims possession is presented as a rescuer; independent action on the part of a female can only lead to her ruin.

It is perhaps symptomatic of women's continuing problems with being looked at and represented by male artists, that works by two leading women surrealists find ways of concealing the face while simultaneously appearing to reveal it. *Small Portrait* by Kay Sage (1898–1963) hides the visage of the person portrayed with a pattern of interlocking slats. We read the image as female only because of the way the reddish-blond hair is arranged. The darkness behind the slats is in fact so dense that it is possible to imagine that this head is no more than a terrible void—that behind the mask exists

Judy Chicago It was in the 1970s and 1980s that women's oppositional art burst onto the art scene, igniting a wave of art by women which openly challenged male representation of the female body.

> Stand up for what you want to do . . .
> Stand up and be your own cliché . . .
> Stand up for women to decide
> Stand up, they're bodies you're inside.

HANNAH WILKE, 1982

above: **DANTE GABRIEL ROSSETTI**
Study for *Found* (1858);
Birmingham Museum and Art Gallery, U.K.

main picture: **BARBARA KRUGER**
Untitled (Your Gaze Hits the Side of My Face) (1981);
Mary Boone Gallery, New York

above: **KAY SAGE**

Small Portrait (1950); Frances Lehman Loeb Art Center,
Vassar College, Poughkeepsie, New York

main picture: **MERET OPPENHEIM**

X ray of My Skull (1964);
Kunstmuseum Bern, Switzerland

below: **ORLAN**

Seventh Operation (1993)

nothingness. In other words, the only way the subject can find to resist the claims made on her is to vanish altogether. The interpretation is reinforced by the fact that the form Sage invented also has many resemblances to a sixteenth-century jousting helmet with a gridded visor.

Meret Oppenheim (1913–85), the most consistently radical of all the women artists associated with the international surrealist movement, pursued a diametrically opposite course in her *X ray of My Skull*, revealing in order to conceal. Oppenheim realized that an individual's skull is in fact the "truest" representation of his or her appearance, stable, where all other elements—flesh and muscles—are constantly in flux. But by stripping away these elements, which reveal not simply passing emotions but also all the things which reflect personality, the subject is rendered unrecognizable. One thinks here of the sculptors who are employed by police forensic departments to build up the likeness of some anonymous murder victim when only the skull remains.

The French artist Orlan (b. 1947) has recently achieved celebrity by submitting to a series of plastic surgery procedures, which are recorded on video. Both the actual process and its result are regarded as part of the artwork. From the point of view of this book, one interesting aspect is that Orlan remodels her appearance in order to reproduce in her own flesh features seen in famous works of art. She wants in fact to become the living embodiment of these works, invariably the creations of male artists. This could be seen as an extreme example of the force of the male gaze, which in this case literally recreates the visage at which it is directed. Where Kruger's stone head is the emblem of recalcitrance, Orlan, conversely, makes herself the symbol of compliance.

right: *Torso of the Aphrodite of Cnidus*
(after Praxiteles—Roman from the Greek original,
fourth century BC); Louvre, Paris

main picture: **LOUISE BOURGEOIS**
Torso: Self-Portrait (1963–64)

THE TORSO

The torso, deprived of head and limbs—that is, of the power of either thinking or acting—has played a prominent role in the way in which women have been represented in art. We so commonly think of the torso as "classical"—as representative of Greek and Roman antiquity—that we forget that the Greeks and Romans would not have recognized a fragment of this kind as a work of art. For them, with the exception of certain specialized decorative contexts in which half-figures could be used, the human body had to be complete in order to be meaningful. Almost the only exception was the *herm*, a pillar with a male head and male genitalia—the male reduced in this case to his most active elements.

The cult of the torso belongs to the revival of interest in ancient art which took place in the Renaissance. Then, any fragment which was identifiably ancient was cherished. Damaged antique statues were completed wherever possible, and celebrated sculptors—on occasion, according to some sources, Michelangelo himself—undertook this kind of repair work, often composing imaginative new compositions by piecing together body parts which did not originally belong together. However, limbless torsos were found in sufficient quantity to make it impossible to complete them all, and gradually the torso established itself as a viable artistic entity. Male torsos, such as the *Torso Belvedere* in the Vatican collection, became recognized standards of perfection in sculpture; female torsos were not privileged in this way, but must have carried a strong erotic charge in a society only just becoming accustomed to the appearance of the female nude in any form. Such torsos, whether genuinely antique or newly made by celebrated artists such as Auguste Rodin (1840–1917) and Aristide Maillol (1861–1944), have retained this significance to the present day.

Women artists approaching the theme of the torso subjectively—from inside their own bodies—have often shown understandable confusion. This is eloquently expressed in the *Torso: Self-Portrait* by Louise Bourgeois illustrated here. Bourgeois's version

 Shame, which is considered to be a feminine characteristic "par excellence" . . . has as its purpose . . . concealment of genital deficiency.

So wrote Freud in *Femininity* (1933), echoing the view Aristotle (384–322 BC) stated centuries earlier in *Politics*:

The woman is as it were an impotent male . . .

Freud then goes on to ask whether women are anything more than a receptacle.

above: **RENÉ MAGRITTE**

Le Viol (1934)

above right: **MERET OPPENHEIM**

Ma Gouvernante (1936); Moderna Museet, Stockholm

of the subject offers a grotesque profusion of female signifiers: multiple breasts which can be read as leaves, springing from a plant rooted in the vagina; leaves which, low on the torso, are in the process of becoming vulvas, but which also (the top pairing) can be read as Venus's doves.

This uncontrolled riot of fertility imagery makes a striking contrast with another modern torso—in this case one by a man—*Le Viol*, by René Magritte (1898–1967). *Le Viol* (*The Rape*) is only one of a long series of images of the female torso produced by this leading surrealist. It disturbingly transforms a woman's body into a face—her breasts become eyes, her genitals become a mouth. The implication is that the female is a body not controlled by a mind, a view quite close to that of Aristotle, who remarked that "the courage of a man is shown in commanding, of a woman in obeying."

Magritte's *Le Viol* needs to placed beside a number of torso images by women, in addition to the one by Louise Bourgeois already cited. For example, *Ma Gouvernante*—the female as a trussed chicken, by the irrepressible Meret Oppenheim—is a sardonic retort to Magritte's sexism, as witty and concise as one might expect from this artist.

The image of the torso takes on a particular poignancy when the body displayed is self-confessedly that of the artist herself. The British artist Jenny Saville (b. 1970) has made a considerable reputation with monumental female figures based on her own body. Painted with a high degree of professional skill, the flesh is scarred with feminist inscriptions. Saville's paintings simultaneously give and take away. Both by

their commanding size and their control of technical means, they indicate that the painter is prepared to face down any male competitor. But they also seem to reveal a striking degree of self-hatred. These are not the work of someone who actually likes her own body.

The modest ceramic torso by Nancy Fried (b. 1945) is a memorial to an encounter with breast cancer. It shows a touching acceptance of the ravages of disease and a quiet acceptance of the female body—even the wounded body—which make it admirable as a work of art. When compared with the work of Saville, this has a striking absence of rhetoric.

left: **NANCY FRIED**
Hand Mirror (1987);
D. C. Moore Gallery, New York

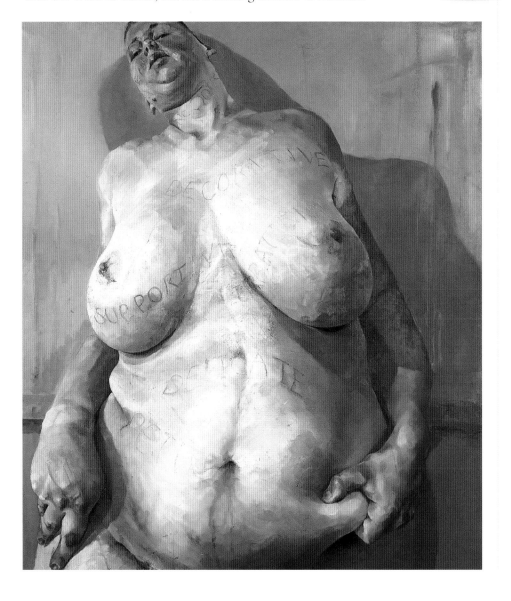

left: **JENNY SAVILLE**
Branded (1992); Saatchi Gallery, London

No wonder so many women artists have felt compelled to try to work out if their bodies, particularly their genitals, were indeed something to be ashamed of. That many women feel intense shame about their sexuality and their vaginas is proven by numerous surveys and, most recently, by Eve Eisman's *Vagina Monologues*, which chronicles female attitudes toward a part of the anatomy still described by some women as "down there."

Judy Chicago There are some feminist theorists who believe that it is impossible to create an alternative representation of women, to "decolonize the female body," as the British writer Griselda Pollock put it (*Framing Feminism*, 1987). Or, as Lucy Lippard stated in *From the Center* (1976):

> It is a subtle abyss that separates men's use of women for sexual titillation from women's use of women to expose that insult.

THE CUNT

One of the most celebratedly transgressive images in art is *The Origin of the World* by Gustave Courbet (1819–77). Until comparatively recently, it was a painting famous only by word of mouth. One of its twentieth-century owners was the renowned French psychoanalyst Jacques Lacan (1901–81), who tried to marry the new French linguistic philosophy to the doctrines of Freud. The work has now entered the French national collection and is accessible to all at the Musée d'Orsay in Paris.

The Origin of the World is one of a small group of erotic paintings purchased from leading French artists by the wealthy Turk Khalil Bey. Others were Courbet's *Le Sommeil*, showing two lesbians entwined on a bed, and Ingres's *The Turkish Bath* (see p. 159). At the time they were painted, these images belonged to a culture of slightly clandestine eroticism which was entirely the domain of men. Though the smallest of the three, *The Origin of the World* was the most direct: it celebrated a part of the female body that could not be mentioned in mixed company. It also asserted male control over it. Maxime du Camp (1822–94), man of letters and pioneer photographer, described how Khalil Bey hung the picture in his dressing room, but kept it hidden by a green veil:

> *When one draws aside the veil one remains stupefied to perceive a woman, life-size, seen from the front, moved and convulsed, remarkably executed, produced* con amore, *as the Italians say, providing the last word in realism. But, by some inconceivable forgetfulness, the artist, who copied his model from nature, had neglected to represent the feet, the legs, the thighs, the stomach, the hips, the chest, the hands, the arms, the shoulders, the neck, and the head.*

The significant phrase is "moved and convulsed." Maxime du Camp is so riveted by the painting that he projects onto it the idea that the woman depicted is experiencing an orgasm. This gives some notion of both the force and the forbidden nature of the image.

The beginning of the change in culture and manners which now permits Courbet's paintings to be shown openly in one of the world's great museums began in the 1960s. One contributory factor was the birth of pop art. Pop gleefully assimilated the imagery of mass culture. A lot of this was erotic. What had been guiltily stashed under the mattress in the 1940s and 1950s was now enlarged, adroitly simplified, and hung on gallery walls for the contemplation of all. The transgressive element inherent in "girlie" imagery of this sort slid effortlessly from one social category to another. Once seen as the symbol of blue-collar resistance to the refinements of high culture, it now became the property of the cultural elite—a guarantee of avant-garde credibility. One of the main beneficiaries of this shift in perception was Tom Wesselman (b. 1931), whose pictures in the *Great American Nude* series—flat, faceless images of nude and semi-nude women with their sexual characteristics brutally emphasized—were typical products of the pop revolution.

above: **GUSTAVE COURBET**

The Origin of the World (1866); Musée d'Orsay, Paris

Not all of Wesselman's paintings are as sexually emphatic as the example illustrated, but the kinship with Courbet's work is obvious. Female potentiality is reduced to one thing—the ability to give sexual pleasure to men.

Not surprisingly, this set of attitudes provoked retorts as soon as the feminist art movement began to manifest itself. One of the most forthright, though by no means the earliest, is the self-portrait from the *Intra-Venus* series by Hannah Wilke (1940–93). Made when she was dying of cancer, it is a savage confrontation with and contradiction of stock attitudes about the female body. Here, naked and exhausted, Wilke lies in a bathtub in almost the same pose as that assumed by Wesselman's compliant cutie.

Not all of the cunt images made by men are as crass as Wesselman's, and not all of those made by women are as tragic as Hannah Wilke's. Male artists, however, can seldom resist the appeal of the symbolic. The spectator's eye must be distracted from basic physiological facts. A good example is a work by Francesco Clemente (b. 1932), who, in *I Hear*, shows a woman in an open-legged pose and replaces her head with a large flower, the emblem of the vulva. One interesting feature of this, however, is that while he suggests that the cunt is in fact beautiful, he also consigns its owner to anonymity.

Be that as it may, as long as negative attitudes—and images—of the female body dominate the landscape, there will be many who will feel compelled to try to mount a visual challenge to them, especially now that women artists are finally able to express themselves more fully. In my own work, I dealt with the nature of the vulva as a symbol of female identity.

above left: **HANNAH WILKE**
February 15, 1992 (from *Intra-Venus*, 1992–93)

above right: **TOM WESSELMAN**
Helen (1966)

As is clear from the controversy which has raged over my imagery, particularly in *The Dinner Party*, and, more recently, the reaction to the Mona Hatoum image cited by Ted, this is still a prickly subject (if I can be forgiven some levity). But what actually differentiates women from men, apart from our bodies? The relationship between nature and culture is a complex one, as has been asserted many times. Until we work it out, we are left with our bodies, in which—for better or worse—we reside.

> I call it cunt. I've reclaimed it. "Cunt." I really like it. "Cunt" ... tell me, tell me "Cunt, Cunt," say it, tell me "Cunt, Cunt."

EVE ENSLER, *RECLAIMING CUNT*, 1998

top left: FRANCESCO CLEMENTE
I Hear (1988)

top right: JUDY CHICAGO
Peeling Back (from *The Rejection Quintet*, 1974)

right: JUDIE BAMBER
Untitled # 1 (1994)

main picture: MONA HATOUM
Corps Étranger (1994);
Museum of Modern Art, Oxford, U.K.

Judy Chicago, in one of a series of images on this theme, assimilates cunt and flower more directly. Judie Bamber (b. 1961), on the other hand, in *Untitled # 1*, has produced a meticulous portrait of the cunt of a particular individual, which is as personal as a likeness of a face might be.

The culmination of recent female explorations of body and cunt imagery has undoubtedly been *Corps Étranger*, an environmental and video work by the British-domiciled Palestinian artist Mona Hatoum. Hatoum introduced an endoscope into her own body, and the images thus recorded are projected onto the floor of an enclo-sure—a simultaneously private and public space, a kind of miniature theater where only a handful of spectators can experience her work at one time. All the most secret recesses of the female body, not merely the vagina, thus became public property and were—as the title of the piece suggests—in a subtle way "estranged" from their owner.

When the piece was first shown in Britain a number of male critics had significantly visceral reactions to it, which always seemed based on the assumption that the artist's sexual organs were the only things represented. One critic proclaimed that he didn't see why he should be required to look at what he called "Mona Hatoum's wobbly bits" in the course of his professional duties. One feels tempted to ask him what his reaction to Courbet's *Origin of the World* would be if he encountered it in a survey of the artist's work. Thanks to both context and authorship, it probably would not cause him the slightest uneasiness—which suggests that women artists still have a long way to go in terms of being able to express what they want.

Household Vanities

A sheet of glass. Where shall I put the reflective silver?
On this side or the other: in front or behind the pane?

CLAUDE CAHUN, 1930

The mirror has a long history in art. In addition to helping artists define space, dimension, and perspective, it allowed artists to paint self-portraits. Leonardo proclaimed that "the mirror...should be your teacher," though he stressed that there was a distinction between the artist and the mirror, in that the mirror could only reflect the world, whereas, in his opinion, the artist should invent a new one.

right: **HELEN CHADWICK**

Vanity II (1986); Zelda Cheadle Gallery, London

WOMAN IN THE MIRROR

The mirror is often seen as the emblem of female narcissism, and it is in this sense, I think, that the British conceptual and installation artist Helen Chadwick (1953–96) wanted her audience to see it. Her stunning photographic self-portrait *Vanity II* originally formed part of a large installation whose theme was the changes wrought by time. It refers, as the title indicates, to the long-established tradition of the *vanitas* self-portraits, popular in the sixteenth and seventeenth centuries. In these self-images the artist simultaneously boasts of his or her own good looks and skill, while allegorizing the inevitable passing of both. In the mirror, Chadwick includes a view of one of her own most ambitious installations, now in the collection of the Victoria and Albert Museum, as a guarantee of her own status as an artist. The image has now been given additional poignancy by Chadwick's premature death.

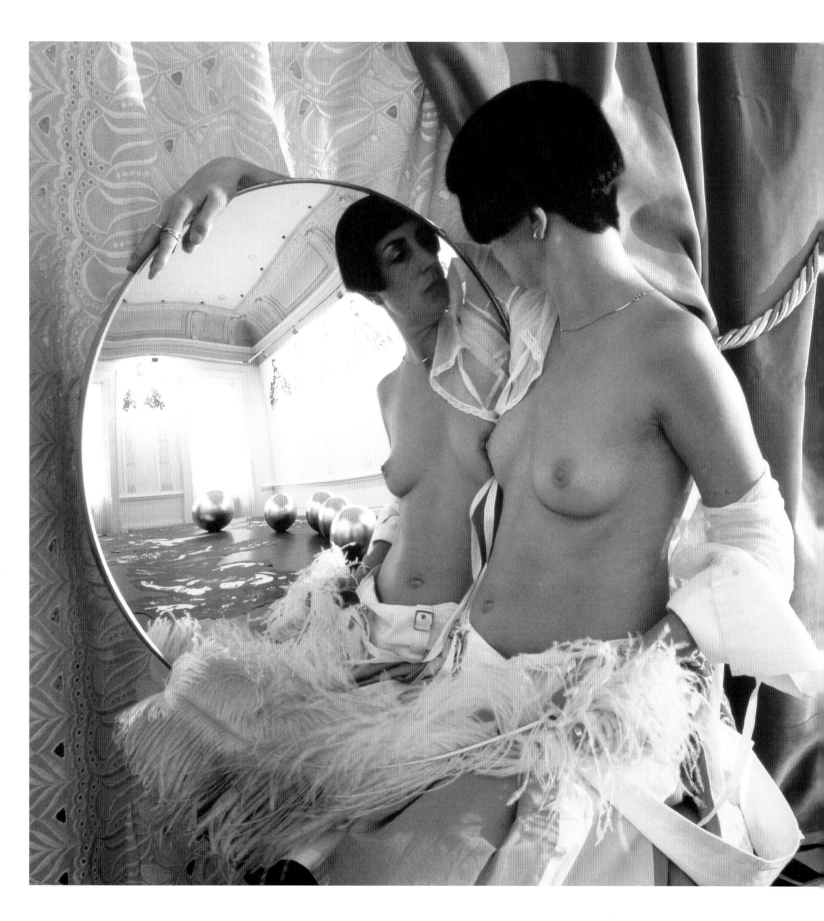

During the Renaissance, the perfect male form was considered the mirror of the soul, though traditionally, the mirror—and specifically mirror gazing—was identified with the female. Between the sixteenth and twentieth centuries, works of art that involved women gazing into mirrors represented women almost exclusively as the object of the male

above: *Marcia* (c. 1402); Bibliothèque Nationale, Paris

below: **Sir Peter Paul Rubens**
The Toilet of Venus (1614–15);
Liechtenstein Collection, Vaduz, Liechtenstein

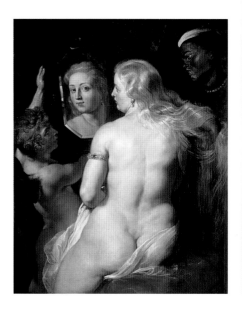

WHO IS LOOKING AT WHOM?

One crucial element in any discussion of images of women with mirrors must be the much-debated question of the gaze, which has already been discussed in this book. The answer may at first glance seem obvious—the subject is looking at herself. Sometimes she looks at herself in order to make a record for posterity. This is what is implied by a charming medieval illumination, *Marcia,* from the beginning of the fifteenth century—an illustration to Boccaccio's *Concerning Famous Women.* Basing his account on that of the classical historian Pliny the Elder, Boccaccio recounts how a woman artist painted her self-portrait "with the aid of a mirror, preserving the colors and features and expression of the face so completely that none of her contemporaries doubted that it was just like her."

Several rather obvious ironies attach to this. One is that Boccaccio changed the name of his heroine—Pliny called her Iaia of Kyzikos. Another is that, unlike some of the male painters named by Pliny, such as Zeuxis and Apelles, Iaia has been completely forgotten—thrust out of history, like so many women artists.

A woman looking in a mirror does not, of course, have to be painted by herself, or by another woman. She can also be painted by a man, as she has been many times in history. Two celebrated examples are included here—Rubens's *Toilet of Venus* and Seurat's *Young Woman Powdering Herself.* Both works raise points of interest. Venus is portrayed nude, with her back to the artist. She is therefore to some extent depersonalized—she becomes a body to be looked at, not a fully developed personality. Since she is not only nude but also engaged in a peculiarly intimate female rite—that of enhancing her own beauty—there is also the feeling that the artist is invading her private space. For a man to paint a woman thus engaged is definitely to make a claim that he in some way has rights over her, or actually possesses her. In this case, however, Venus's privacy is somewhat protected both by Eros, her son, who stands to the right and holds up the glass, and by the black female attendant who hovers behind her and serves as a kind of chaperone. It is also interesting to note the hesitant but still challenging way in which her eyes meet those of the artist—or spectator—in the mirror itself, and the doubtful expression on her face. Rubens, perhaps unconsciously, has recorded the discomfort felt by his model about the situation in which he has placed her.

A very direct claim to possession is made in the painting by Georges Seurat (1859–91). Little is known about Seurat's life. He compartmentalized his existence to an extraordinary extent. None of his artist friends, for example, seems to have known until after his death that he lived with a mistress, Madeleine Knobloch, by whom he had a son. *Young Woman Powdering Herself* is a presumed likeness of Madeleine. It is Seurat's only painted portrait. Seurat's gift was for stylization and the generalization of form, and he was therefore peculiarly ill-equipped to give us any idea of his subject's

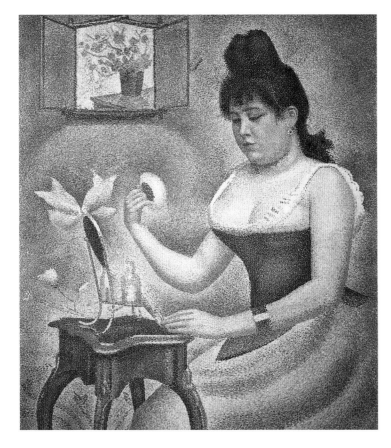 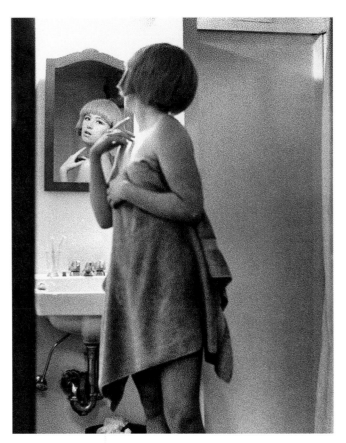

character. She sits, plump, rather vulgar-looking, and impassive, in front of a ridiculously spindly dressing table, from which nearly all the clutter involved in the business of making up has been summarily removed. Eyes downcast, hand frozen in midair, she is more like an inanimate object than a real person.

One curious feature of the painting is the object hanging on the wall to the left. It could be a painting, or even a rather formalized representation of a window, but its form—a folding triptych—makes it almost certain that it is meant to be another mirror. In it one sees reflected a vase of flowers, placed on the corner of a table. The implication is that Madeleine herself is like this arrangement of flowers—that she exists purely for Seurat's contemplation.

It is useful to contrast this with the image Cindy Sherman made of herself shown above at right. Her relationship to the mirror in which she sees herself is as active as Madeleine Knobloch's is passive—she hams it up, striking a theatrical pose redolent of conscious narcissism. The photograph, from Sherman's *Untitled Film Stills* series, is intended as a criticism of the way women have been presented in movies and in advertisements—as the helpless victims of their own vanity. Sherman's work, however, often seems to show a kind of knowing complicity with the cultural situation she is ostensibly criticizing—one reason, perhaps, why the art market appears to feel so comfortable with her work.

above left: GEORGES SEURAT
Young Woman Powdering Herself (1888–90);
Courtauld Gallery, London

above: CINDY SHERMAN *Untitled* (1997)

spectator's pleasure. Often, these moralized about the vanity of women, while lingering on the female body for the enjoyment of the painter and his audience.

The mirror has figured prominently in the work of many contemporary women artists. This is probably because, as Whitney Chadwick writes in the introduction to the catalogue *Mirror Images: Women, Surrealism, and Self-Representation* (1998):

> For women artists, the problematics of self-representation have remained inextricably bound up with woman's internalization of the images of her "otherness."

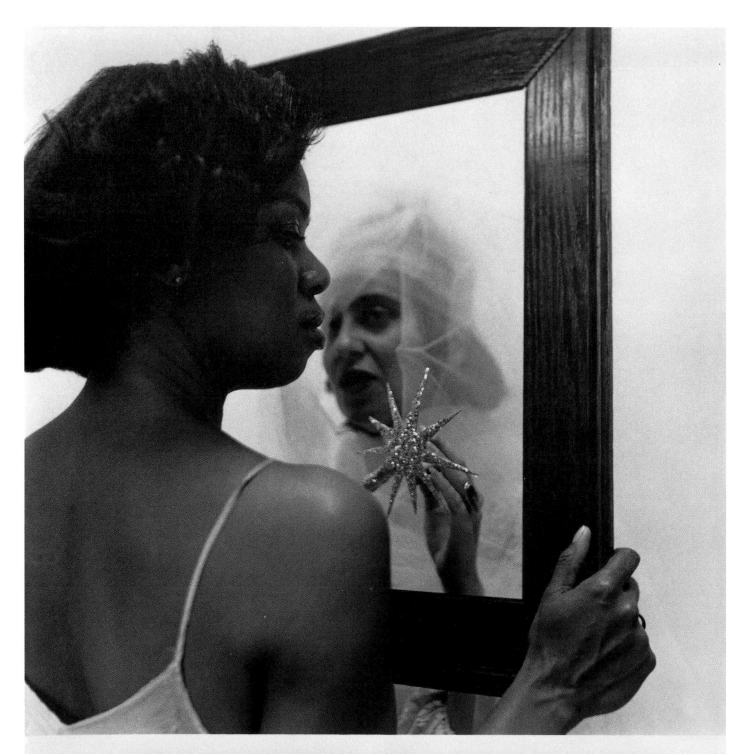

LOOKING INTO THE MIRROR, THE BLACK WOMAN ASKED, "MIRROR, MIRROR ON THE WALL, WHO'S THE FINEST OF THEM ALL?" THE MIRROR SAYS, "SNOW WHITE, YOU BLACK BITCH, AND DON'T YOU FORGET IT!!!"

MIRROR, MIRROR ON THE WALL...

Since self-examination, and through this an examination of the situation of women, has been one of the most frequent themes in recent feminist art, it is not surprising to find that the mirror has played a prominent part in the system of imagery which has grown up around it. Carrie Mae Weems (b. 1953) combines gender and race in *Mirror, Mirror,* in which the forthright inscription carries at least as much weight as the actual image. Not all the meanings are on the surface, however. The piece is a reminder of the way in which our attitudes are formed at an early age by things like folk tales and fairy tales, and the illustrations that accompany them. This is especially the case when the fairy tale is transformed, translated, and rendered almost universally available by modern mass culture. The first full-length Disney animated motion picture, *Snow White and the Seven Dwarfs* (1937), overseen by Walt Disney himself, offered an image of youthful female beauty and desirability which must have affected generations of black children, who found themselves classified by implication as permanently inferior. "Whiteness" and "goodness" are insistently related in the movie.

An image of a different sort by the photographer Nan Goldin (b. 1953) tells another story. Goldin is the most influential of a whole generation of American photographers who aimed to get rid of photographic formality and offer a vision of life in the raw. She uses her own lifestyle as material for a brutally candid photographic diary. *Self-Portrait in Blue Bathroom* employs flash, gleamingly reflected in the bathroom tilework, to make a self-portrait in which Goldin seems surprised to be confronted by her own likeness. It catches the moment in which the self perceives itself as being also the indifferent or hostile other. Many women artists seem to have created images showing women troubled by a similar feeling of alienation from their true selves.

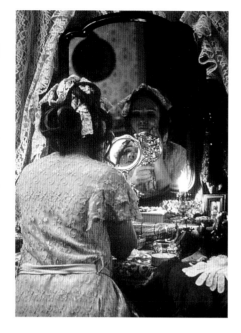

Judy Chicago As there is now a good deal of imagery related to the mirror by women, one question that arises is: does this constitute a female tradition? According to Frances Borzello, writing about self-portraiture in 1998,

> If tradition is taken to mean that certain themes ... recur through the centuries, then there is a tradition.

She goes on to assert that women artists of the past seem to have had no awareness of the work of the women who preceded them, a comment which brings to mind the quote by historian Gerda Lerner on page 45 suggesting that women were constantly having to reinvent the wheel.

main picture: **CARRIE MAE WEEMS**
Mirror, Mirror (1987)

above: **KAREN LE COCQ**
Leah's Room
(performed at Womanhouse, Los Angeles, 1972)

left: **NAN GOLDIN**
Self-Portrait in Blue Bathroom (1991)

Mirror imagery can be used to reflect on the history and traditional roles of women as well. In a performance piece entitled *Leah's Room*, created by Karen Le Cocq and Nancy Youdelman at Womanhouse (1972), a woman continually applied layers of makeup to her face while gazing obsessively into a mirror. The allusion was to Colette's novel *Chéri* (1920), in which a middle-aged courtesan, acting against her own better judgment, continues an affair with a much younger lover. The artists said that their subject was

> *the pain of aging, of losing beauty, pain of competition with other women. We wanted to deal with the way women are intimidated by the culture to constantly maintain their beauty and the feeling of desperation and helplessness once this beauty is lost.*

WHO IS THE FAIREST OF THEM ALL?

There were some paintings by women which took the relationship between the female—self or other—and the mirror as their subject long before the rise of the feminist art movement in the 1970s. These paintings mark a series of stepping stones on the path toward female self-recognition, and the messages they convey are interestingly varied, especially when they are compared to male versions dealing with the same category of subject matter.

Judy Chicago A tragic consequence of the ongoing exclusion of women's achievements from our history books and museums is that younger women have no opportunity to learn what their predecessors thought, taught, or painted. Thus, how are they either to build upon those accomplishments or break the cycle of repetition pointed out by Lerner?

Berthe Morisot's *Young Woman Powdering Her Face* invites direct comparison with Seurat's version of the same theme (see page 151). Morisot's figure is not stylized—she is a recognizable individual, placed in a fully characterized *haut bourgeois* setting. The young woman holds her powder puff in one hand and tilts her mirror toward herself with the other, so as to get a better view of what she is doing. Far from being in the state of suspended animation that seems to have seized Seurat's Madeleine, she

is unself-consciously occupied with her own concerns and apparently unaware of the presence of anyone else. Morisot has been particularly successful in catching the intent expression on her subject's face, the way her eyes focus on what she is doing. Making oneself up is here defined not as a concession to vanity but as a form of work, one of the routine tasks a woman in this particular social position has to perform—a self-defining ritual undertaken not only for herself but also for others. *Antoinette at Her Dresser* by Mary Cassatt, Morisot's impressionist colleague and

above: **ZINAIDA SEREBRYAKOVA**
Self-Portrait at the Dressing Table (1909);
Tretyakov Gallery, Moscow

right: **MARY CASSATT**
Antoinette at Her Dresser (date unknown)

main picture: **BERTHE MORISOT**
Young Woman Powdering Her Face (1895);
Musée d'Orsay, Paris

In my own lifetime, I am witnessing this repetition in terms of the art of young women of the 1990s, who are—without realizing it—repeating many of the themes and ideas which characterized feminist art of the 1970s. If they were, in fact, expanding upon that work, I would be gladdened, but this is too often not the case.

I believe that until women artists have an understanding of the traditions of female art practice, this endless repetition will continue. It is with the intention of helping to bring about a change in the education of artists that this book has been written.

As to ablutions, I was keen to include this subject matter, in part because many women artists have focused on it.

contemporary, is much more contemplative in tone. Antoinette rests her elbow on her dressing table and examines herself in a hand mirror. She is not in the action of applying makeup—she seems, instead, to be meditating, not so much about her appearance as about her own character and situation. This is a picture which clearly and directly poses the question "Who am I?"

Zinaida Serebryakova (1884–1967) is the youngest and least celebrated of the three artists featured in this category. Her *Self-Portrait at the Dressing Table* was painted in 1909—it owed its origin to the fact that the artist was snowed in at her family estate near Kharkov, with no other model available. She wanted, she said afterward, to record herself surrounded by the trifles which made up her everyday environment. Serebryakova never formed part of the experimental groups that flourished in Russia during the pre-Revolutionary period; her chief contacts were with the comparatively conservative World of Art circle that surrounded Diaghilev in St. Petersburg, in the period before the creation of the Ballets Russes. Her artistic vision is nevertheless extremely direct—the picture shows someone who is on perfectly good terms with herself, who feels no need to boast or pose. Though the gesture she makes, pulling back her long hair, is an active one, the tone of the picture is not one of nervous questioning. Instead it reveals an emotion rare in any form of self-portraiture—male or female—a sense of amusement at the fact of existence. "How pleasant," it seems to say, "to find myself here, and to be able to produce this record of who I actually am."

LA TOILETTE

The rituals of the bath and the toilette play complex cultural roles, and the ways in which women have been represented in connection with them carry, in consequence, an equally complex freight of meaning. The young girl portrayed in the central medallion of a fifth-century Greek *skyphos*, or wine cup, is preparing a bath for someone, but almost certainly not for herself. The likelihood is that she is a young *hetaera*—her nudity suggests this—and that she is making the bath ready for the arrival not of a woman but of a man, whom she will cosset appropriately and with whom—perhaps—she will engage in sexual intercourse.

Hetaerae were courtesans, freedwomen, and resident noncitizens rather than slaves; in Athens their profession was fully recognized by the state, and they paid taxes accordingly, just as men did. Like Japanese geishas, they were expected to be intelligent and well read, and usually they were accomplished musicians. They were often valued as stimulating companions who could hold their own with any man, and not merely as potential bedmates. To employ a *hetaera*, even a young, unskilled apprentice like this one, was a privilege of the wealthy man. The image is therefore a reminder that, from a historical point of view, the apparently simple actions of washing and dressing are loaded with meanings which have as much to do with class as with gender.

main picture: ***Girl Preparing a Bath*** (c. 480 BC); Musées Royaux d'Art et d'Histoire, Brussels

Judy Chicago The meanings attached to the bath and bathing are manifold—from simple ablutions to purification and fertility rites; magic; healing; union with nature; and public bathing, including the spa. Nor can one ignore voyeurism, specifically the objectification of women, who have repeatedly been the subject of the male gaze as they prepare for or indulge in the bath and its associated rituals (think, for example, of those luscious paintings by Bonnard in which the female figure often seems to be dissolving into the tub). The Ingres *Turkish Bath* could be said to be the classic example of this age-old tradition, one in which women rarely do anything as mundane as actually wash themselves. It would probably be redundant for me to express my dislike of such pictures—even the Degas, primarily because of the rear-end view.

above: *Queen Kawit at Her Toilet* (c. 1567–1320 BC)
Egyptian Museum, Cairo

right: **TOUSSAINT DUBREUIL**
Hyante and Climène at Their Toilet
(late sixteenth century); Louvre, Paris

CLEAN AND READY

An ancient Egyptian relief from the Eighteenth Dynasty (c. 1567–1320 BC) serves as a reminder that the ceremonial toilette also has a long history. The importance attached to it may be judged from the fact that the scene comes from the sarcophagus of a queen. Queen Kawit is portrayed seated in a chair, on a much larger scale than the two people who attend her. In one hand she holds a small copper mirror with a carved wooden handle—many similar examples have been found in Egypt— and in the other, a shallow bowl from which she drinks. Behind her stands a woman who is attending to her hair or, in this case, more likely her wig. In front of her is a male attendant who is pouring her another drink, ready as soon as she has drained the first. The ceremony clearly acted as a daily reminder of Kawit's royal status, which is why it was given such a prominent place in the ornamentation of her funerary equipment. A comparable scene can be found in a painting by the French artist Toussaint Dubreuil (1561–1602), which shows two aristocratic ladies getting ready for their day. The scene

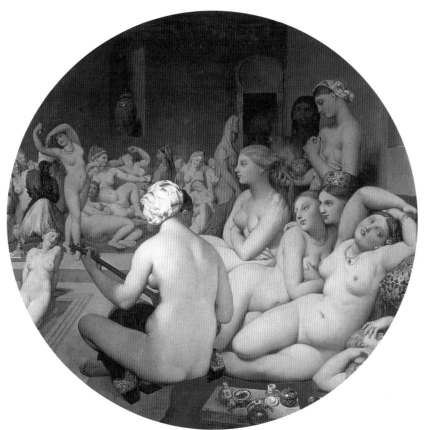

has been given the erotic, voyeuristic twist beloved of the artists of the School of Fontainebleau, but there is still no doubt that it reflects the courtly customs of the time. Though in this case all the attendants are female, there are so many people present that this is almost a public event.

In fact, as literary and visual records show, the modern concept of privacy is a comparatively recent invention, even where the most intimate functions are concerned. Until the French Revolution, for example, the kings and queens of France not only dined in public but also rose from their beds, washed, and were dressed in public, ritually attended by some of the highest officers of state. Sometimes they even defecated in public, seated in royal dignity upon a closestool. The lively memoirs of the Duke of Saint-Simon (1675–1755) give a vivid picture of some of these rituals as they existed late in the reign of Louis XIV. The first act of Richard Strauss's opera *Der Rosenkavalier* (1911) offers a comic but reasonably authentic picture of the levée of an elegant aristocratic woman in the Vienna of the mid-eighteenth century. Many of the jokes in the libretto turn on the lack of privacy just described.

What this means is that we have to think of scenes of this type not only in terms of vanity, narcissism, and the male gaze, but also of status. They demonstrate the degree of respect which women who were high in the social hierarchy were able to enforce. Each morning ritual was a reaffirmation of this.

above left: **EDGAR DEGAS**
The Bath (1886); David David Gallery, Philadelphia

above right: **J. A. D. INGRES**
The Turkish Bath (1863); Louvre, Paris

BATHING

A nude woman in her bath has always carried a strong erotic charge for male artists. Orientalist painters, J. A. D. Ingres and Jean-Léon Gérôme (1824–1904) among them, assimilated the bathing woman to the compliant odalisque. Ingres's *The Turkish Bath* is the culmination of this. The women give off an air of erotic frustration—the chauvinist implication being that only by the presence of a man can this be assuaged.

Degas takes a different tack. His women may have been Parisian prostitutes, but it is not necessary to place them in this context. Degas was not a visitor to the *maisons closes*. His subjects are working-class female models. Their attraction was their animality and—perhaps even more so—their difference from himself. It would be hard to find a better example of the male gaze than this long series of women bathing.

The Bath by Prilidiano Puyrredón (1823–70) is the work of a nineteenth-century Argentine painter who appears to have been largely self-taught. Compared with a bathing nude by Degas this woman may be less sophisticated, but she also has a great deal more personality. She looks around to welcome the visitor, presumably male, who seems about to intrude as she sits naked in her tub. In this sense—because she is fully aware of being looked at and seemingly quite comfortable with the fact—she appears to be more in control of her situation than the women in Degas's paintings.

Ruth Weisberg's (b. 1942) *The Basin II* would have been inconceivable without Degas's prior example. However, there are differences of approach. Degas's bathers are frequently prone and imploring; Weisberg's figure is not submissive, and is also almost fully clothed. The emphasis therefore is on the action depicted, not on the erotic potential of the female body.

Judy Chicago Another reason that I find this subject intriguing is that it involves changing conceptions of privacy, status, and class, and demonstrates ways in which artists have dealt with the animality sometimes associated with bathing. Male artists have eroticized bathing or distanced themselves from it by projecting their fantasies onto women, something which recalls the Susan Griffin quote about associations between women and nature on page 71. All the more reason to note the obvious distinctions between the images by Ruth Weisberg and Vanessa Bell and those by the male artists on these pages.

Perhaps the most impressive bathing scene by a woman is *The Tub* by Vanessa Bell (1879–1961). It is a symbolic statement into which many threads are woven. It is, however, the figure of the bather herself that draws attention. Meditatively plaiting her hair, she seems withdrawn, totally self-contained. She is not simply an object to be looked at, but draws the viewer into her own world of mysterious dreaming.

above: **PRILIDIANO PUYRREDÓN**
The Bath (1865);
Museo Nacional de Bellas Artes, Buenos Aires

right: **RUTH WEISBERG**
The Basin II (1990)

main picture: **VANESSA BELL**
The Tub (1917); Tate Gallery, London

Judy Chicago As previously noted, the subject of the bath and the toilette has recently become the focus of works by a number of women artists, who seem to offer a decidedly different point of view. This is particularly true of the rather transgressive images by Hannah Wilke and Sally Mann, which represent a new level of candor in female art.

There is a photograph by Mann which I greatly admire showing her and her two daughters pissing, silhouetted against the setting sun. Because of legal prohibitions against such pictures if they involve children, we could not include it. What amazes me is that anyone could confuse her photograph, which is clearly about female empowerment, with one that is debasing in any way. However, I believe this to be yet one more example of the imperspicuity surrounding images of women —the subject, of course, upon which this book aims to shed some light.

PISSING

Female urination has always been a tricky subject, more a matter for sniggering than for any kind of rational discourse. The same is true of male urination, though to a much lesser extent. A male pissing in public is making a direct display of his masculinity—a fact acknowledged by various fountain figures in which the jet of water comes either directly from a male figure's penis or up from between his thighs. Female urination is something most men do not want to think about—a fact confirmed in a curiously unconscious but decisive way by the number of new or newish public buildings, designed by male architects, which have made a totally inadequate provision for female lavatories and have had to be modified subsequently. Prominent examples of this are the Barbican Arts Centre in London and the Getty Center in Los Angeles.

The rare depictions of female urination before the present epoch were made for candidly pornographic purposes. This is obviously the case with *Girl Urinating* by François Boucher (1703–70). Boucher, in addition to occupying the official position of first painter to Louis XV (*premier peintre du roi*), with the flow of official commissions this entailed, worked for the semiclandestine market in erotica that flourished in France at this time. Erotic works were more often prints, which could be hidden in portfolios, than paintings made to be hung on a wall, so even for its period this is a relatively unusual work. The woman is making use of a *bordaloue*, a kind of portable urinal which could be easily concealed between the thighs. It took its name from the seventeenth-century Jesuit preacher Louis Bordaloue, whose inordinately lengthy sermons supposedly tested the bladders of the ladies of the French court. The painting is therefore a snide joke at the expense of women's bathroom habits.

Recently, feminist artists, particularly those making use of photography, have tried to reclaim the idea of female urination as something that could be the subject of serious artistic discourse. The reason photography plays an essential role is that photographic images are still thought of as a form of authentication, even though we now know how easy it is to alter them using digital techniques. A photograph of a woman pissing, therefore, has much more emotional force than a painting or drawing of the same subject.

"A photograph," it has been said, "is the only crime that offers its own proof." The image of the dying Hannah Wilke on a portable hospital toilet, from the *Intra-Venus* series already discussed (see page 145), is so tragic that it would take an extremely hard-hearted person to snigger at it, though many spectators, both male and female, might want to turn away, unable even to look.

The photographer Sally Mann (b. 1951) has made several controversial images of herself and her daughters urinating, as a kind of defiant assertion of femaleness—with the subtext that the act of pissing can actually be a sensual pleasure for women, and that this is something which deserves to be acknowledged. The best known of these is, in the present climate of opinion, too dangerous legally to print, since some viewers find in it pedophiliac overtones, which Mann never intended. We offer an alternative here, an image whose subject is a simple but startling reversal. A woman in a bathtub spreads her legs in order to expose her cunt to a running tap. The subtext is that pissing can be a luxuriously pleasurable act.

top left: FRANÇOIS BOUCHER
Girl Urinating (date unknown)

above: SALLY MANN
Untitled (1997)

bottom left: HANNAH WILKE
August 17, 1992 (from *Intra-Venus*, 1992–93)

Judy Chicago

Womanhouse, a daring, avant-garde site installation . . . and an unexpected happening . . . in 1972 . . . transformed . . . a condemned mansion . . . into an artistic revelation about women in their homes . . . Womanhouse held the raw, explicit expression of an incipient feminist sensibility that has . . . provided a source and reference for a tradition of innovative and socially concerned contemporary art made by women.

CRITIC AND HISTORIAN ARLENE RAVEN, QUOTED IN *THE POWER OF FEMINIST ART*, 1994

right: JEAN-BAPTISTE-SIMÉON CHARDIN
The Scullery Maid (1738);
Glasgow Art Gallery and Museum, Scotland

below: JUDY CHICAGO
Cock and Cunt Play (performance at Womanhouse, 1972)

BUT WHO WILL DO THE HOUSEWORK?

The Womanhouse in Los Angeles, one of the roots of the feminist art movement in the United States, placed special emphasis on the burden of domestic chores as an inhibiting factor for women's creativity and indeed for the larger goal of self-realization for the female population in general. For example, in Judy Chicago's *Cock and Cunt Play* (1971), performed within the Womanhouse setting, the She character asks for help in doing the dishes.

He (shocked): *Help you do the dishes?*
She: *Well they're your dishes as much as mine!*
He: *But you don't have a cock! A cock means you don't wash dishes.*
You have a cunt. A cunt means you wash dishes.

If one looks at domestic labor in its broadest context, and its reflection in art, a number of issues are worth noting. In the large households of the Middle Ages, men were employed for household tasks almost as much as women, a fact confirmed visually by some of the calendar illustrations in one of the most splendid illuminated manuscripts of the fifteenth century, the *Très Riches Heures du Duc de Berry*. Even three or four centuries later, the top positions in large households were held by men. An example is the famous chef Marc-Antoine Carême (1784–1833), who was employed successively in the households of Talleyrand, the Prince Regent of England, Tsar Alexander I, and the Rothschild family.

Gradually, however, with the rise of the middle class, it was increasingly assumed that domestic work would be done by women. The chief female figure in the house—the wife of the owner—did not necessarily undertake this labor herself, but she was expected to supervise, in order to leave men free for other things. This hampered her ability to undertake creative tasks. A case in point is the painter Judith Leyster, who, as we have seen, represented herself in her self-portrait as a noticeably free spirit (see page 114). Leyster was a fully fledged member of the Haarlem Guild of St. Luke, the local professional organization, and had her own workplace. Records show that she had apprentices, who were male, and participated on an equal footing with men in the affairs of the guild. In 1636, however, after only a short period as a professional, she married another painter, Jan Molenaer, and promptly disappeared from guild records. She appears only as someone involved in her husband's business as an art dealer. The assumption must be that she was forced to put her husband's career before her own and that she retired to the domestic sphere in order to facilitate this.

At about this time, painters began to take an interest in domestic tasks as a subject matter for art. Examples are *Woman Pouring Milk* by Jan Vermeer (1632–75) and *Old Woman Frying Eggs* by Diego Velázquez. The status of these women is not entirely clear, but the implication, certainly in the case of the Vermeer, is that they are domestic

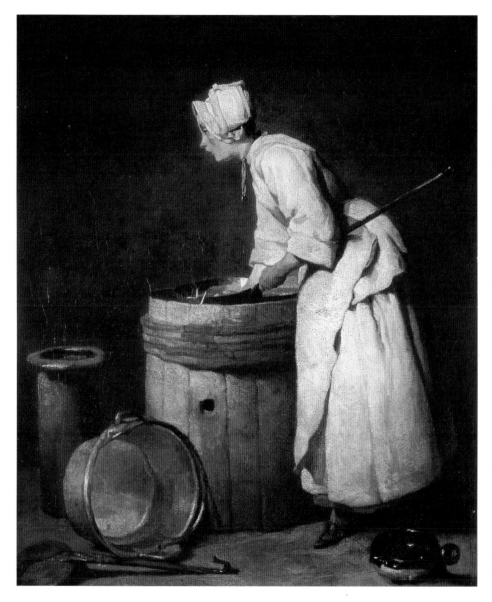

servants. The perception of this range of subject matter seems to have been relatively neutral. It was interesting enough to paint, but it carried no strong moral overtones. This situation changed in the eighteenth century, when the philosopher Jean-Jacques Rousseau (1712–78) exercised an enormous influence over European thought. Rousseau idealized not just the simple life—egalitarian, stripped of pretensions and close to nature—but also domesticity. This is the theme of his novel *The New Eloise*, which is a paean to the domestic virtues.

The Scullery Maid by Jean-Baptiste-Siméon Chardin (1699–1779) antedates Rousseau's novel, but idealizes domestic work in much the same fashion. This young woman, performing one of the dirtiest of domestic tasks, is, in contrast, everything that is clean, proper, and charming. Chardin undoubtedly perceived her in this way— he once said, "One uses colors, but one paints with feeling."

ACT I

Two women, dressed identically in black leotards, enter stage left. On stage right is a large sink full of dirty dishes. Stage center, an oversize bed. Regular lighting. Stage is merely one end of a large room with audience seated on floor facing performers. First woman (SHE) has a plastic vagina strapped to her crotch. SHE crosses stage to sink, turns, and faces audience, head turned toward second woman (HE), who has followed SHE across stage and stopped behind her, also facing audience. HE has a plastic phallus strapped to her crotch. Lights darken. Single spot on performers and sink.

SHE: *Will you help me do the dishes?*
HE: (SHOCKED) *Help you do the dishes?*
SHE: *Well they're your dishes as much as mine!*
HE: *But you don't have a cock!* (GRASPS COCK AND BEGINS STROKING IT PROUDLY)
SHE: *What's that got to do with it?*
HE: *A cock means you don't wash dishes. You have a cunt. A cunt means you wash dishes.*
SHE: (LOOKING AT CUNT) *I don't see where it says that on my cunt.*
HE: (POINTING AT HER CUNT) *Stu-upid, your cunt/pussy/gash/hole or whatever it is, is round like a dish. Therefore it's only right for you to wash dishes.*

JUDY CHICAGO, *COCK AND CUNT PLAY*, 1971

HOUSEWORK—WHAT, ME?

The exaltation of domestic virtues did not alter the fact that domestic tasks were now firmly the business of women. The ridiculousness of men attempting to perform domestic labor was summarized for the classically educated men of the time by the Greek legend of Hercules and Omphale. Omphale, the woman who reduced her besotted lover Hercules to using a distaff, was a favorite comic subject in baroque art. It is worth considering the parallels between this legend and the discussion of the long-held association of women with spinning (on page 72). The illustration here is by the French painter François Le Moyne (1688–1737), a slightly older contemporary of Chardin. The languishing, feminized look cast by the besotted muscleman toward his beloved, whose posture asserts her dominance, is worth noting.

In the present context it makes an interesting contrast with a performance piece by a contemporary woman artist, Janine Antoni (b. 1964). In *Loving Care*, Antoni dipped her hair in dye and proceeded to scrub the floor with it. The action has several levels—

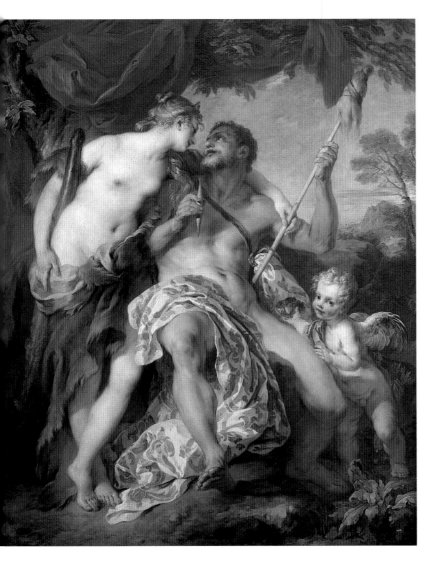

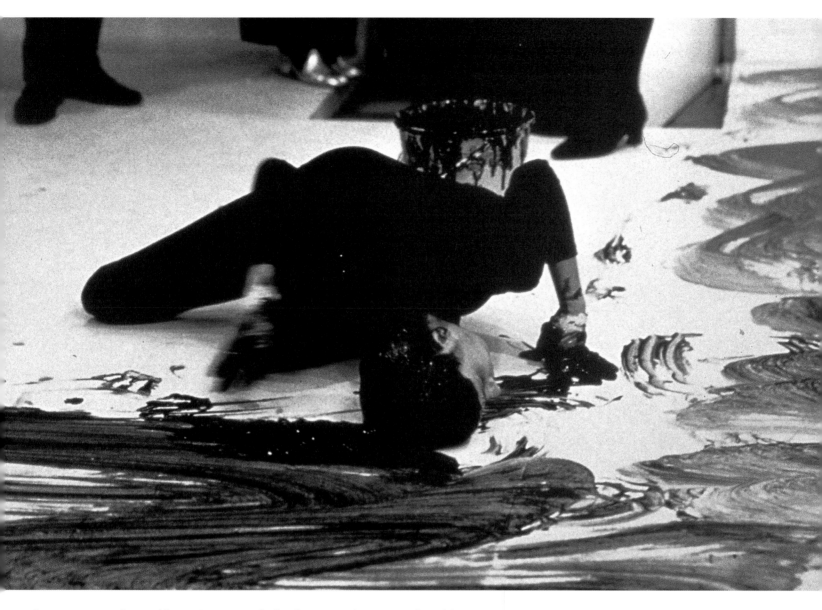

the woman, condemned by society to scrub the floor, uses the action of scrubbing to produce a work of art. She herself is the scrubbing brush. The marks she produces have a visible kinship to the paintings of Jackson Pollock (1912–56), the most self-consciously macho of all the abstract expressionists, who also generally worked with his canvas laid on the floor. The action of scrubbing has always been a favorite theme in feminist performances. In 1972, 20 years before Antoni, Chris Rush performed an action called simply *Scrubbing* at Womanhouse. In another Womanhouse action, called *Duration Performance*, Sandra Orgel turned the tedious task of ironing into a public spectacle. The cathartic and therapeutic effect of performance work of this sort, for both performers and audience alike, is worth noting. By making domestic tasks into public rituals, women both vented their anger and at the same time endowed these tasks with a new dignity.

above: **JANINE ANTONI**
Loving Care (detail of performance *I Soaked My Hair in Hair Dye and Mopped the Floor with It*, 1992)

far left: **FRANÇOIS LE MOYNE**
Hercules and Omphale (1724)
Louvre, Paris

left: **SANDRA ORGEL**
Ironing (1972)

Judy Chicago I should like to return to my earlier discussion about the reinvention of the wheel, something which—in my opinion—anyone concerned about the development of women's art must address. I believe that one explanation for this repetition is that many of the same life issues exist for young women today as were experienced by my generation. But why can't they learn from what we did, taking the range of responses, ideas, and explanations embodied in the art of dozens, if not hundreds, of women artists?

One important reason—as I mentioned in the introduction—is that too many young people are still not learning enough about women's art. Yes, they may have studied my work or the work of one or two other women artists, primarily—as I understand it—in women's studies courses. But in too many art and art history classes, the work of women artists continues to be dealt with as a singular exception, rather than as a rich body of material to be recognized, drawn on, and built upon.

HEAVY LABOR

The labor of the laundrywoman, one of the heaviest physical tasks undertaken by females, was one of the more unexpected themes of nineteenth-century art. Honoré Daumier devoted a series of pictures to the subject. Degas made an effective series showing women ironing, and this theme was later taken up, after the turn of the century, by Picasso during his Blue Period. Some of the academic painters of the time, such as the Russian Abraham Archipov (1862–1930), depicted the great public laundries of the period, with their clouds of steam.

Because of the sheer amount of hard work involved, the middle-class urban households of the nineteenth and early twentieth centuries often sent their laundry out, to be done off the premises. Others had specialist laundrywomen who came in to take care of the task. This, like many of the heavier aspects of domestic labor, is now supposedly taken care of by machines. The housewife has therefore, in theory at least, been freed to do other things. In fact, as women artists have often discovered, the machine has its own way of enslaving the person who uses it. This is the essential point of Barbara Kruger's photographic silkscreen *Untitled (It's a Small World but Not If You Have to Clean It)*, which parodies the advertisements for domestic appliances in women's magazines. The great buildup of resentment over domestic work, one of the most frequent themes in contemporary feminist art—especially in North America, where domestic appliances are at their most sophisticated and developed—may spring from the perception that, far from being a means of liberation, these machines have become instruments of continuing enslavement: "I gave you a new vacuum cleaner, so why are you complaining about having to sweep the floor?" As women in general, not

right: **HONORÉ DAUMIER**
The Laundress (after 1850); Musée d'Orsay, Paris

far right: **BARBARA KRUGER**
Untitled (It's a Small World but Not If You Have to Clean It) (1990);
Mary Boone Gallery, New York

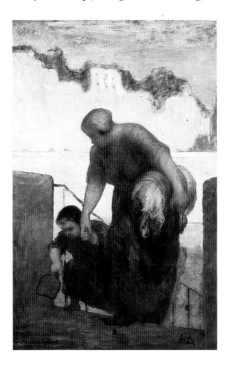

Contrary to Frances Borzello (see page 153), I believe that women artists do have a tradition, albeit one that has progressed in fits and starts and is still not visible in its entirety. For despite the many changes which have been achieved in women's art, the most significant change still eludes us— the permanent institutionalization of women's place in art history. What I mean by this is that, even though there are many more women exhibiting today, both art-historical practice and the permanent collections of major museums continue to feature the art of men while erasing, ignoring, or marginalizing the evidence of what is an ever-increasing body of art by women.

I am convinced that a new understanding of the history and context of women's art must be constructed, one which allows it to be seen within its own traditions while at the same time acknowledging its relationship to male art practice. This new perspective must then become an ineradicable part of our cultural heritage; only then will young women artists finally be able to claim their heritage and stop reinventing the same old wheels.

merely artists, look for fulfillment in things done outside the home, and as men and women become increasingly equal in the nondomestic workplace, this argument is likely to sharpen, and women's art will reflect the fact.

It is an argument not just about drudgery but also about physical and mental claustrophobia. An installation from Womanhouse made by Sandra Orgel (b. 1952) tackled this different aspect of domestic labor from a new perspective. It showed a female dummy literally imprisoned in a linen closet. This concise image made a great impression on visitors at the time and has often been reproduced since in publications about feminist art, which seems to demonstrate the significance of its impact. It is a great example of the way in which successful symbols operate—through a relatively small shift in perception, and also by fusing things which, seen in isolation from one another, would not have the same impact.

above: **SANDRA ORGEL**
Sheet Closet (1972)

Exploring Identities

In some sense I made a gift of my body to other women:
giving our bodies back to ourselves.

CAROLEE SCHNEEMAN, 1973

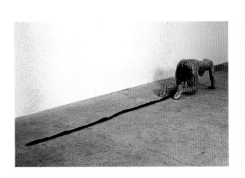

above: **KIKI SMITH**
Tale (1992)

bottom right: **SHIGEKO KUBOTA**
Vagina Painting (1965)

top right: **CAROLEE SCHNEEMAN**
Interior Scroll (1975)

WOMEN ACT UP

Since a good deal of the prejudice women encounter in their daily lives is specifically directed at the female body, it is not surprising to find that feminist art has consistently placed an emphasis on the female body as something to be examined in a new way. This is not merely a way which rejects the controlling male gaze but one which recognizes the body as an active force in its own right.

Several other considerations must be added to this one. First, the inherited perception that the female body is somehow unclean. This is linked to traditional taboos concerning menstruation. Second, the feeling—common among many feminist artists—that traditional ways of making art, such as painting, were themselves so tainted with patriarchy that women had to look for completely new forms. Third, the desire to make a polemic, to seize the public's attention by using one of the well-established techniques of the avant-garde—the element of shock.

Carolee Schneeman, a leading exponent of performance art and body art, once remarked,

There's something female about performance itself, I think because of how it is ephemeral and close to the unconscious—involving display, use of the self.

One of the earliest performance pieces of this sort was *Vagina Painting* by the Japanese artist Shigeko Kubota. This performance took place at the Perpetual Fluxfest, held in New York in 1965. The background to the piece is interesting. Kubota had only recently moved to the United States. She was one of the links between the extreme avant-garde Japanese Gutai Group, which was already doing performances in the 1950s—long before pop art "happenings" made them fashionable in New York—and Fluxus, largely based in Europe and containing as many avant-garde musicians as it did artists. The most celebrated product of Fluxus was the German sculptor and performance artist Joseph Beuys (1921–86).

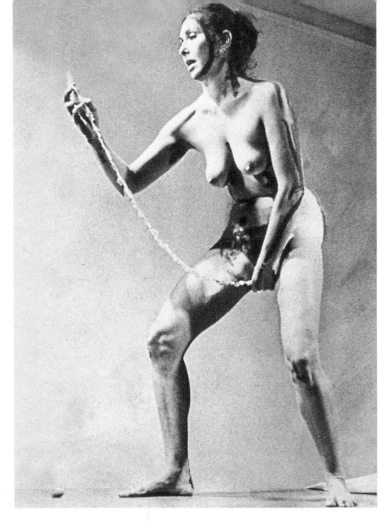

Like Janine Antoni's much later *Loving Care* (see page 167), *Vagina Painting* is a critique of what some people have perceived to be Jackson Pollock's abstract expressionist machismo. Kubota squatted over the floor and painted red strokes on its surface with a brush attached to her underwear. The choice of paint color makes the reference to menstruation obvious. Pollock's drip paintings have sometimes been read by critics as metaphors for seminal discharge.

Carolee Schneeman herself has made some of the most important performance pieces of this sort. The best remembered, because it was recorded in striking photographs, is her *Interior Scroll*, in which she slowly pulled a poem scroll—inscribed with her poem "I Met a Happy Man"—from her vagina. In this way, the female body was giving birth, in an absolutely literal sense, to the fully created artwork.

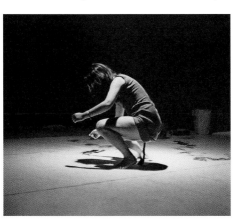

Tale by Kiki Smith (b. 1954) is not a performance, but a sculpture made using a body mold. The message is far more negative than it is in the two works described above. The female body here advertises its "filthiness" by leaving a long trail of excrement behind it as it crawls, humiliated, across the floor. Smith condemns hidden attitudes toward female flesh by outing and brutally exaggerating them.

Judy Chicago In 1970 I moved to Fresno, California, which is in the middle of nowhere. I went there for a year to paint, write, think, teach, and reconstruct myself. It was there that I launched the first feminist art educational program, intended to help young women become artists without having to deny their womanhood.

It was also at this time that I began to dream about a new kind of art, one that was woman-centered, an art that I have spent the ensuing years trying to create and which—with joy—I've watched develop all over the world. I celebrate the many voices and the diverse imagery in this chapter, for they suggest the possibility of an expanded notion of the human experience and an enriched definition of art.

Women artists in the 1970s began to explore those areas of female experience … which have been denied autonomous expression … within cultural forms controlled by men … women have specifically used their self-images to explore the relationship between personal experience and the "social" construction of femininity.

ROSEMARY BETTERTON, 1987

above: **CATHERINE OPIE**
Dyke (1992)

right: **ELEANOR ANTIN**
The King (1972);
Ronald Feldman Fine Arts Gallery, New York

DRAGGED UP

The topic of performance leads quite naturally to the subject of role-playing in general. Sometimes they reinforce; sometimes, on the other hand, they contradict. The large photograph *Dyke* by Catherine Opie (b. 1961) brands its subject as a lesbian by means of a tattoo executed in large Gothic letters. The implication is that the subject is—quite literally—being accused of lesbianism behind her back. It suggests, in addition, that lesbians carry some kind of distinguishing mark that enables society to recognize them at once for what they are.

Eleanor Antin's *The King* goes to the opposite extreme. Here, a woman has disguised herself so thoroughly as a man that her gender is entirely concealed. Antin (b. 1935) has made use of a wide range of invented personalities in her work, but the other personalities are mostly female. Antin, assuming these identities, wants to stress the division between the real self and the created self, as well as their symbiotic relationship. One question asked by the king is: "Why can't I assume traditionally male functions, such as the power to command, if I want to?"

Cross-dressing is not, of course, new. It was especially prevalent in Europe during the years that followed World War I. There seem to have been a number of reasons. Women had taken over many male functions during the war and resented being forced back into their old positions. The way they dressed often expressed this even when they were not specifically cross-dressing. The couturière Coco Chanel (1883–1971) founded her fortunes on new, simplified designs offering women a much greater degree of physical freedom, which owed much to the tailored clothes worn by her English lover, Boy Capel. The new freedom of manners also

meant that those who were not conventionally heterosexual felt able to declare their sexual preferences by means of their clothes. Romaine Brooks's *Una, Lady Troubridge* portrays one half of a celebrated lesbian couple. Troubridge's partner was Radclyffe Hall, the author of *The Well of Loneliness* (1928), a lesbian novel that caused a considerable stir on both sides of the Atlantic. Though Troubridge was the femme member of the pair, she declares her preference by donning a version of men's evening dress. Brooks was herself lesbian—something which did not prevent her from viewing Troubridge's affectations with a sharply judgmental eye.

There are two types of drag ...The first of these is drag as travesty, where the artist is using a sort of exaggerated costuming in order to play with the possibilities of switching identity ... while many artists in the late '60s and early '70s did pieces incorporating the methodologies of drag, they were using those methodologies to question identity, not sexual preference ... Younger artists have shifted from using drag as a subject matter (depictions of people in drag) to drag as a method ...While the earlier approach to drag deals with it as a type of parody of gender norms, and emphasizes drag's artificiality, this new approach often involves artists taking on each other's personas and voices, and is thus based on the notion of drag "realness": the ability to pass.

LAWRENCE RINDER, 1995

left: **ROMAINE BROOKS**
Una, Lady Troubridge (1924);
National Museum of American Art, Washington, D.C.

TOGETHER AT LAST

The representation of lesbians in art has a relatively long history, but until the twentieth century these representations have generally been the work of men. As contemporary pornography indicates, lesbian activity has a peculiar fascination for the heterosexual male viewer—perhaps because, as some psychoanalysts suggest, it simultaneously arouses curiosity and soothes castration fears. How do they satisfy each other? And wouldn't they be better off with a man? The subject for centuries carried such an aura of the forbidden that it was usually necessary to present it in mythological guise. The favorite myth was that of Jupiter and Callisto. Callisto was a virgin follower of the equally virgin goddess Diana. Jupiter took Diana's shape in order to approach her. The viewer could therefore enjoy the spectacle of two women together, apparently preparing to make love, while comforted by the knowledge that one of them was really a man.

More candid representations of apparent lesbian activity are rare. One is the Second School of Fontainebleau double portrait showing Gabrielle d'Estrées (1573–99), mistress of Henry IV, and her sister in the bath together. Her sibling reaches out to pinch Gabrielle's nipple, while a lady in waiting dozes in the background. The gesture may be intended to indicate Gabrielle's fecundity—she bore the king three children—but it reads as an incestuous lesbian approach. It has been interpreted in this sense by a modern parodist, Christina Schlesinger (b. 1946), who has adapted the composition as a sign for a lesbian bar.

The Courbet painting of two lesbians asleep together, *Le Sommeil*, produced for Khalil Bey (see page 144), opened the way for modern representations of the subject. One of the most powerful is *Les Deux Amies* by Tamara de Lempicka (1898–1980), painted, like nearly all of de Lempicka's best compositions, in the 1920s. In common with many women artists, de Lempicka was an outsider. She took things from the cubists, from Ingres, and also from early sixteenth-century mannerists like Jacopo Carucci Pontormo to create a style entirely her own. Her lesbian paintings, which also include portraits of her female lovers, record the fact that she was bisexual and took no pains to hide it.

top: *Gabrielle d'Estrées and Her Sister in the Bath* (c. 1592); Louvre, Paris

above: **CHRISTINA SCHLESINGER** *Sign for a Lesbian Bar* (1994)

Another, wholly lesbian, painter of the interwar period, Gluck (Hannah Gluckstein, 1893–1978), commemorated herself and one of her lovers in the double portrait *Medallion* (see page 177). Here the emphasis is not on exaggerated masculinity, but on androgyny. The lovers are presented as twin souls, gazing into some kind of transcendent future, where they will at last be fully empowered to be themselves. The carefully cultivated androgyny of Gluck's appearance was also caught by Romaine Brooks, who painted a likeness of her and exhibited it under the title *Peter, a Young English Girl*.

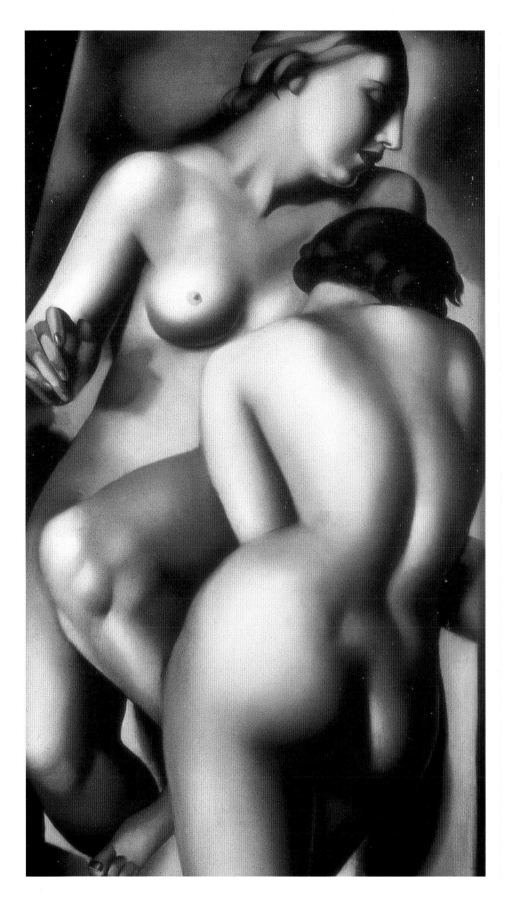

left: TAMARA DE LEMPICKA

Les Deux Amies (1923)

Judy Chicago In 1978, the artist Harmony Hammond organized one of the first exhibitions of lesbian art in New York. Writing about this show, Hammond said:

> The heterosexualization and erasure of work by lesbian artists in both mainstream and feminist art communities was a reality we were forced to confront. While some artists made the decision never to show in the art world, where women much less lesbians were hardly welcome, others remained closeted out of fear that their work would not be taken seriously. It was hard to convince women who were self-identified as lesbians and as artists to place their work in lesbian art contexts.

If all women simply left men, refused to have anything to do with them—ever, all men, the government, and the national economy would collapse completely.

VALERIE SOLANAS, S.C.U.M. MANIFESTO, 1968

The boundaries being tested today ... are not just "racial" and national. They are also those of gender and class, of value and belief systems, of religion and politics. The borderlands are porous, restless, often incoherent territory, virtual minefields of unknowns for both practitioners and theoreticians. Cross-cultural, cross-class, cross-gender relations are strained, to say the least ... remember, change is a process, not an event.

LUCY LIPPARD, 1990

Recent lesbian art has tended to concentrate more on the fact of lesbianism than on the way in which individual lesbians have chosen to present themselves to the world. Harmony Hammond (b. 1944), a leading American artist identified with lesbianism, often eschews representation in favor of purely symbolic forms. *Radiant Affection* consists of two large identical forms bound with rags which can be read as highly simplified vaginas. Hammond, in an interview with the art critic Arlene Raven, implies that she identifies herself with the ancient Amazons, whom the Greeks described as daughters of the goddess Harmony.

Hammond does, however, have something in common with Gluck—a fascination with twinning, which is expressed in the piece illustrated. In the interview with Raven, the artist mentions her interest in Frida Kahlo's double self-portrait, *The Two Fridas* (1939). "[Kahlo] is her own blood relative," Hammond says, "mother, daughter, and sister." And to reinforce this, she quotes some lines from the poet Adrienne Rich:

Two women, eye to eye measuring each other's spirit, each other's
limitless desire, a whole new poetry beginning here.

Much lesbian art seems not only to be inspired by the wish to discover or explore a separate kind of female identity, but seems also to be driven by the desire to find a perfect mirror image of the self—an other who is not the other. The sense of isolation often suffered by the lesbian surrounded by straight society is compensated for by the creation of a double, or *doppelgänger*—a mirror image, but one with the power to move and speak independently.

right: **HARMONY HAMMOND**
Radiant Affection (1983–84)

main picture: **GLUCK (HANNAH GLUCKSTEIN)**
Medallion (c. 1937)

CULTURAL RELATIONS

Same-sex attraction produces feelings of otherness in a largely heterosexual society. Its power of alienation is not nearly so pronounced as the effect of racial difference, because it is never quite so visible. Placed within the context of feminist visual art, race is a peculiarly difficult subject and calls for careful treatment. If a white commentator treats black or Hispanic female artists completely separately, for example, he or she is likely to be accused of ghettoization, and therefore of implied racism. Refusal to acknowledge racial difference, or simply privileging it in favor of gender, can be seen as equally offensive. African-American and Hispanic artists have already found a place in earlier sections of this book, among them two leading African-Americans, Elizabeth Catlett and Faith Ringgold, who are declared feminists.

Catlett once introduced herself to a symposium at Pennsylvania State University by saying: "I'm Elizabeth Catlett and what's important to me is first that I am black, and secondly that I'm a woman, and thirdly that I'm a sculptor." Ringgold, describing a crisis in her career, is reported to have said: "I had to find out who I was again—I was back at the drawing board. And that's when I figured it out, in 1970–71, that I was a black *woman*." The stress on "woman" is hers. Ringgold's statement, with its careful distribution of emphasis, suggests how difficult her situation is in the context of contemporary society.

Western European art encountered the question of otherness as soon as the New World began to be colonized. *A Tarairiu Woman* is by the Dutch artist Albert van der Eeckhout (active 1637–64). He traveled to South America as part of an expedition led by Prince Maurice, who had been sent to govern the Dutch colony set up in Brazil. His paintings of indigenous Indians are often presented as being among the first objective depictions of this kind of subject. One has to note, however, how insistently this woman is characterized as a cannibal, with a severed human foot sticking out of the basket on her back. This detail offers telling evidence of the way in which artists, even when they are doing their best to present the facts, tend to succumb to cultural stereotypes. Obliterate the foot, and the painting comes much closer to being acceptable as a "true" ethnographical record.

Pouch Girl, by the contemporary sculptor Sokari Douglas Camp (b. 1960), forms an amusing riposte to this. Douglas Camp is Nigerian, from a chiefly family. She divides her time between London and Nigeria. Her sculpture of a woman carrying her baby in a pouch resting on her chest is a sympathetic and witty rendering of something she may have seen either in Britain or in her native country. Whichever is the case, some details of costume subtly suggest the woman is black. The actual technique—the sculpture is made of wrought metal—leaves things carefully unspecific. Douglas Camp looks not for what alienates, but for what people have in common.

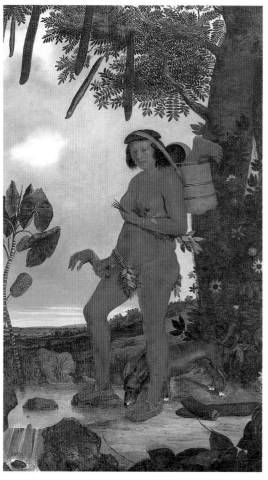

above: **ALBERT VAN DER EECKHOUT**
A Tarairiu Woman (c. 1641);
National Museum of Denmark, Copenhagen

main picture: **SOKARI DOUGLAS CAMP**
Pouch Girl (1991)

In a vast arena of media, styles and approaches, many women of color are investigating the inextricable fusion of past and present history and of gender with race and ethnicity, while simultaneously deconstructing mainstream representations.

<p style="text-align:right">YOLANDA LOPEZ AND MOIRA ROTH, 1994</p>

So where we are now is that a whole country of people believe that I am a "nigger" and I don't, and the battle's on! Because if I am not what I've been told I am, then it means that you're not what you thought you were either!

<p style="text-align:right">JAMES BALDWIN, 1963</p>

below: **YONG SOON MIN**
Make Me (1989)

main picture: **LOIS MAILOU JONES**
Les Fétiches (1938);
National Museum of American Art, Washington, D.C.

WHO AM I?

One of the most pressing and significant questions artists of color have been asking themselves, as suggested by the statements made by Elizabeth Catlett and Faith Ringgold quoted above, is "Who am I?"

In African-American art one of the focused examples of this kind of questioning is a well-known painting by Lois Mailou Jones (b. 1905) entitled *Les Fétiches*. It was painted in 1938, shortly after the artist had won a fellowship to study art at the Académie Julian in Paris. It is self-evident that early cubism, and especially Picasso's *Les Demoiselles d'Avignon* (see page 110), has influenced this work. But what is Mailou Jones doing? Is she simply copying Picasso, the most powerful artistic influence in Paris at that time, or is she using Picasso's example as a means of recuperating a part of herself?

Before she left for France she had met and been much influenced by Dr. Alain Locke, head of the philosophy department at Howard University, Washington, D.C., where Mailou Jones also taught, and was to continue teaching for the rest of her career. Locke was perhaps the most powerful and best-informed advocate of the need for black American artists to reclaim ancestral forms.

Les Fétiches has none of the savage alienation which typifies *Les Demoiselles*—Picasso once remarked of his friend and colleague Braque that he did not understand African art "because he was not superstitious," and other sources report that Picasso actively discouraged explanations about the meaning of the African sculptures he admired. The atmosphere of Mailou Jones's painting is beneficent—the painter seems simply to have rehabituated herself to something that was already essentially hers.

Anxieties about identity persist, however. They are actively expressed, for instance, in a sequence of photographs by the American-Korean artist Yong Soon Min. In the photographs she manipulates her own face in pursuit of an identity which will be settled and satisfactory, no longer fluid. Inscriptions on her face suggest what her alternatives are: model minority; exotic emigrant; objectified other; assimilated alien.

The imagery about Asian women is contradictory. On the one hand, they are represented as sexually exotic creatures and at the same time, they are seen as completely dominated by their men ...

PRATIBHA PARMAR, 1987

top: **MARGO MACHIDA**

Self-Portrait as Yukio Mishima (1986)

above: **TOMIE ARAI**

The Laundryman's Daughter (1988)

SELF AND OTHERS

Contemporary women artists, the younger ones in particular, have tried to tackle the problem of identity in a wide variety of ways. One strategy is that of comparing the self they possess to that of some other personality who they hope may help them to locate and objectify things which until then have remained undefined. The American-Japanese artist Margo Machida (b. 1950) looks partly to her matrilineal heritage for information, exploring relationships she describes as "often conflicted" with her mother and maternal grandmother. She also looks to a man—the excessively macho but also homosexual Japanese novelist Yukio Mishima (1925–70), who committed suicide after an unsuccessful attempt at a political *coup d'état*. She explains that this is "because he made his own body the site upon which intense struggles for self and cultural definition were played out."

Tomie Arai (b. 1949), both Chinese and Japanese by racial inheritance, also examines aspects of the Asian-American heritage in her work. *The Laundryman's Daughter* is not as personal as it seems—it is based on an anonymous archive photograph, culled from the Chinatown History Project in New York. It shows a young woman in a traditional outfit next to her seated mother. The artist has added, as a portrait held in the mother's hands, a likeness of the absent father. Fragmented images surrounding the central one suggest the immigrant setting—a Chinatown tenement and a view into a laundry. Arai is here both examining and distancing her own family history—members of her family were also involved in the laundry business.

Santa Barraza (b. 1951) sees herself as a product of the borderland between Mexico and the United States, describing herself as "a mestiza, a *México Tejana*, and visual artist." She examines the legends of the pre-Columbian gods—such as that of the moon goddess Coyolxauhqui, who was dismembered by her own brother, thus ushering in the era of male dominance—as well as more recent images, such as that of the Virgin of Guadalupe and that of La Malinche. Her painting *La Malinche* invites several different kinds of decipherment and interpretation.

La Malinche, also called Doña Marina by the Spaniards with whom she threw in her lot, was the Indian mistress of Hernán Cortés (1485–1547), the Spanish conqueror of Mexico, and served as his interpreter throughout the initial period of the conquest. It was she who persuaded the Aztec ruler Montezuma that Cortés was an incarnation of the Aztec god Quetzalcoatl. Because they did not speak the Indian languages, her lover and the Spaniards were forced to see the local political situation largely through her eyes. One of La Malinche's motives seems to have been revenge, because she belonged to an Indian people who had been subjugated by the Aztecs. She was simultaneously the betrayer of her people and one of the most remarkable figures in the whole history of the American continent. Barraza shows her with a headcloth that looks like a halo. Her lover Cortés stands in the background, a priest brandishes

a cross at a hanged Indian to her left, and a fetus—the image of the new order of *mestizaje*—nestles at her breast. The vegetation—all desert plants which can survive with little water—suggest the toughness of the survivor. Barraza clearly sees herself as possessing a complex identity, perceiving herself, like La Malinche, as being both betrayer and betrayed.

above: **SANTA BARRAZA**

La Malinche (1991)

> Black women have been doubly objecti-
> fied—as black, as women; under white
> supremacy, under patriarchy. It has been
> the task of black women artists to trans-
> form this objectification; to become the
> subject commenting on the meaning of
> the object, or to become the subject
> rejecting the object and revealing the real
> experience of being.

MICHELLE CLIFF, FROM *OBJECT INTO SUBJECT: SOME THOUGHTS ON THE WORK OF BLACK WOMEN ARTISTS*

(C. 1930)

FREE AT LAST?

One of the widespread assumptions that African-American artists have had to deal with over the years, and this particular example applies to women perhaps even more than men, is that they are now liberated, and thus free to do as they like. This is the implication of a statuette called *La Citadelle—Freedom* by the black sculptor Augusta Savage (1892–1962). Savage was highly influential in the New Negro Movement in New York after World War I. Having been accepted by the Fontainebleau School of Fine Arts in 1923, she was subsequently rejected when the school discovered that she was an African-American. Her cause then became the focal point of a campaign by

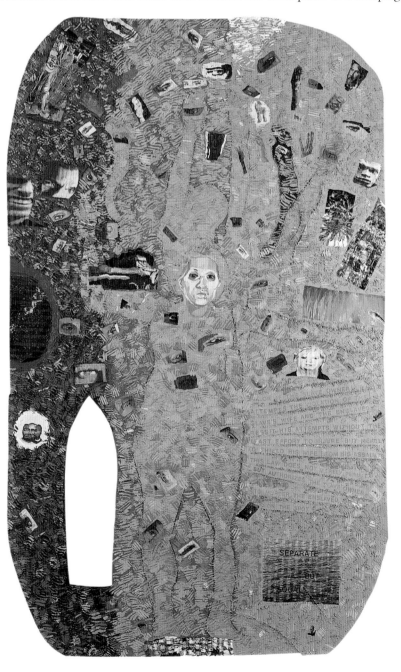

right: **HOWARDINA PINDELL**

Autobiography: Water/Ancestors, Middle Passage/
Family Ghosts (1988);

Wadsworth Atheneum, Hartford, Connecticut

such eminent African-American leaders as W. E. B. Du Bois. She went on to study privately in both the United States and France. Though Savage has been widely celebrated by critics as one of the earliest African-American artists consistently to use African physiognomy in her work, thus breaching a long-standing rascist taboo, this work is essentially European in form—it belongs to the tradition of the precious table piece created in the Renaissance by artists like Antico (Pier Jacopo Alari Bonacolsi, c. 1460–1528) and Andrea "Il Riccio" Briosco (1470–1532). That is, while the content and gesture speak of liberation, the actual form of the works does not.

Autobiography: Water/Ancestors, Middle Passage/Family Ghosts, by the well-known contemporary black artist Howardina Pindell (b. 1943), is considerably less optimistic than Savage's work in content, but it is also acknowledged to be far more original in method. It uses a kaleidoscope of ideas and images, including: a sewn insertion in the shape of the artist's own body; the white silhouette of the hull of a slave ship; a whitened self-portrait inspired by the popular black musician Michael Jackson's makeup for the promotional video for his song "Thriller"; and the embedded text of a slave trade law. These elements are organized in a way which owes a great deal to detailed studies that Pindell has made of traditional African methods of costume and decoration.

Viewers and critics who are not African-American are presented with a choice when viewing such pieces. They have to distinguish between what—if anything—they want African-American artists to say, and what the artists themselves actually do have to say. The non-African-American audience also has to accept that even in artistic works in which the search for identity remains evident, the final result may not be addressed directly to people of different ethnicity. With much new African-American work it may be said that the general audience is being permitted to eavesdrop, rather than being spoken to directly by the artist. Yet the makers of this work do, with a very few exceptions, wish to be accepted as "mainstream" artists. They want to be judged on the same terms as their contemporaries, of whatever ethnic background. These inherent contradictions, and the delicacy of the subject, render the discussion of African-American art particularly problematic. Black critics and analysts are frequently seen as partisan advocates by the white art establishment, whereas white critics are perceived by African-Americans as lacking in empathy.

left: **AUGUSTA SAVAGE** *La Citadelle—Freedom* (c. 1930)

above: **BETYE SAAR**

Lest We Forget, Upon Who's Shoulders, We Now Stand
(1998); Michael Rosenfeld Gallery, New York

FROM MOTHER TO DAUGHTER

A feature of contemporary women's art seems to be its collective, and sometimes familial, spirit. The mythology of art inherited by the contemporary white male artist insists that he has to reinvent himself totally: nothing can be handed down, everything must be created anew, without reference to anything that has been created previously. From Womanhouse onward, women's artistic groups have tended to work together, and enterprises like Judy Chicago's *Dinner Party* (see page 13) have illustrated how a raising of consciousness takes place when there is a sharing of skills.

In one sense this represents a reversion to the studio practice of the premodernist epoch, in which artistic skills were handed down within a family—in the studio of Tintoretto (1518–94), for example; or in that of Jacopo Bassano (c. 1517–92) and his sons. Indeed, many women artists of the past, among them Artemisia Gentileschi, arrived at their profession via this route. There is, however, only one instance I know of in which a woman artist planned to hand on her profession to her daughter. This was Lavinia Fontana (1552–1614)—in terms of material success and public honors by far the most successful female artist before the epoch of Rosalba Carriera, Angelica Kauffmann, and Vigée-Lebrun. At the height of her success in Rome, where she was a portraitist at the court of Pope Paul V and a painter of altarpieces, the Persian ambassador to the Vatican claimed that of all the wonders he had seen in Rome, Lavinia Fontana was by far the greatest. Fontana had three children, but wanted her only daughter rather than her sons to follow in her footsteps, and her last years were shadowed by the girl's early death in 1605, which put an end to her mother's hopes. This is one of the might-have-beens of art history: a dynasty of female artists, able to rely on papal favor.

Today, pairings like that of the African-American mother and daughter Betye (b. 1926) and Alison Saar (b. 1956) suggest that feminist art has a directly heritable element. This, at least in Judy Chicago's work, has been one of its declared goals. Betye Saar's *Aunt Jemima* series has become one of the key achievements in recent African-American art. First begun in the early 1970s, as a response to the derogatory figure of the "Black Mammy," the series initially expressed Saar's determination, as she herself puts it, "to transform a negative, demeaning figure into a positive, empowered woman," thus reversing the significance imposed by tradition. More recently, in a return to the same image, Saar made a new and even more powerful series, which she entitled *Workers and Warriors: The Return of Aunt Jemima.*

In this series the eponymous Aunt Jemima appears on vintage washboards, a tool symbolic of hard labor. Through it black women could win some economic independence, working in their own homes rather than in the houses of white employers, but it was also an emblem of poverty and their position at the bottom of the economic ladder. *Lest We Forget, Upon Who's Shoulders, We Now Stand* emphasizes the importance of claiming and building upon past struggles for empowerment and dignity. The

The Mary Cassatt retrospective at the Art Institute of Chicago included a study for her monumental mural for the Women's Building at the 1893 Chicago World's Fair, a mural which—like so many of women's aesthetic achievements—has disappeared. This lost mural was entitled *Modern Woman*, and the study depicts a woman plucking fruit from a tree and handing it to a young woman, the fruit being a metaphor for knowledge, which the older woman is passing on to the next generation.

By now, my readers are aware that it is precisely this "passing on" to which I am deeply committed, hence my pleasure at the way in which Betye Saar, a woman artist of my generation, has transmitted to her daughters her own knowledge and love of the practice of art.

message is no longer simply one of faith but of pride and hopefulness. The artist claims the dignity of her subjects and offers that dignity to a new generation.

Bain Froid by Alison Saar makes its claim on African-American culture and history not through its forms but through its materials—hammered metal over wood, used by many tribal sculptors in Africa. The forms, however, are classical and, at first glance, characteristically "European"—a comparison can be made with the painting of a standing bather by Vanessa Bell (see page 161) from the opening years of the twentieth century, which has the same kind of calm monumentality and self-containment. Closer examination demonstrates that Alison Saar is here using elements of classic modernism which have hidden connections with African art—the head of her bather, for instance, looks like some of the ancient bronze and terra-cotta heads from Ife.

At the same time, Saar claims the right of the woman artist to make use of that now hugely controversial subject, the nude female figure. Representations of the nude have been a leitmotiv of this book, taken as a whole, and it seems fitting that the text should finish with yet another twist on this theme. For one thing, a representation of this sort made by a woman inevitably calls into question the simplistic idea that images are essentially uninflected—that, as Gertrude Stein might have put it, "a nude is a nude is a nude." This female nude does not, in logic, predicate the presence of the controlling male gaze. What happens when it is a woman whose gaze is the creative force? What happens when a member of her own gender looks at the work? These are not the easiest questions to answer, but they cannot simply be brushed aside, either by feminists or by their opponents. Looking at them squarely is one of the things this book is about. Asking questions is the necessary preliminary to finding answers.

> *The only way I could go into the water was if I was on my mother's back, my arms clasped tightly around her neck. It was only then that I could forget how big the sea was, how far down the bottom could be ... When we swam around in this way, I would think how much we were like the pictures of sea mammals I had seen, my mother and I, naked in the seawater.*
>
> JAMAICA KINCAID, 1983

top left: **ALISON SAAR**
Bain Froid (1991);
Jan Baum Gallery, Los Angeles

top right: **ALISON SAAR**
Chaos in the Kitchen (1998);
Jan Baum Gallery, Los Angeles

P O S T S C R I P T

Although we have now finished writing the book, I find I have a few additional comments to add, in particular about some of the challenges involved in working on this project. This is the first time I have ever written about work other than my own. Consequently, I had to become involved in the process of obtaining photographs of work we wished to reproduce, which was a real education.

The good news is that we worked with a fabulous picture researcher, Liz Eddison, who went above and beyond the call of duty in terms of procuring often hard-to-find pictures, no matter how many letters, phone calls, and faxes it required. However, she also had an education, in her case, as regards locating reproductions of art by women:

You wanted my comments on researching in photographic libraries for women artists. What I have found is that probably only a small percentage of the pictures that they carry are by women artists. I do not know the reason for this (i.e., whether paintings by women have not been available to be photographed or whether they have not been in such demand) but it has not made my job any easier.

It is important to realize that many authors of art books depend upon standard photographic libraries for the reproductions they include in their texts. In addition to there being a scarcity of art by women, the works that are generally available tend to be those images that reinforce traditional views of women, albeit created by women. Little oppositional imagery makes its way into these archives.

Only determined writers resort to the convoluted methods required to find images outside these traditional sources. Consequently, one would think that when an artist whose work is not often reproduced in major texts (or an artist's representative) is approached for a picture, the response would be positive—and frequently it was.

But I am unhappy to report that, too often, we encountered a stubborn recalcitrance, followed by the insistence that other pieces by that artist be included even when they weren't relevant to the book. Or there would be a total lack of response to our approaches, despite repeated letters and phone calls; or completely inappropriate monetary demands, which flew in the face of both the standards and the financial constraints imposed by the publisher.

Obviously, artists and their agents have the right to determine where work should be reproduced. What annoys me is the number of complaints I have heard over the years about a lack of inclusion. So one would think that when an offer is made, a more cooperative response might be in order. Of course, I would be the first to admit

that the present art system is not a fair one, as my comments in this book suggest. However, it seems important to understand the way in which the system works and then to decide how one is going to interact with it as far as possible without shooting oneself in the foot. Women artists are today producing a great deal of new and exciting art, and I believe that they need to give their works the widest possible exposure.

It would be entirely unconscionable of me to end my remarks without acknowledging my assistant, Stephanie Cook, to whom I am indebted for her help on this book. It is to her and her generation, along with succeeding generations of young women, that we dedicate this volume in the hope that you will not waste your time reinventing the wheel, as so many of your predecessors were forced to do.

Instead, we hope that you will build upon the information and iconography we have compiled, for we have done so with the intention that it might help you make a place for yourself in the world. However, if change seems to come about more slowly than you might hope, we urge you to look back at the long struggle which has brought you the freedom you now enjoy, and take courage from your foremothers. And remember—it's always darkest before the dawn.

BELOW: JUDY CHICAGO
It's Always Darkest Before the Dawn
(from *Resolutions: A Stitch in Time*, 1998)

INDEX

Figures in *italics* refer to illustrations.

193

ACKNOWLEDGMENTS

The publisher would like to thank the following for the use of pictures. Every effort has been made to trace copyright holders and request permission; we apologize for any omissions. We would be pleased to hear of any additions to this list.

Laura Aguilar p 104T;
AKG, London pp 84, 94, 97R, 106, 107, 116L, 128B / Bibliothèque Nationale, Paris 38T / Fundación Dolores Olmedo Patino, Mexico City 53 / Musée d'Orsay / Eric Lessing 61, 70 / Eric Lessing 18, 20, 23, 24, 26, 38B, 59T, 76B, 101, 144, 150B, 174T / Louvre, Paris 40, 102B / Musée de l'Orangerie, Paris 102T / Rheinisches Landesmuseum, Bonn 71B / Woburn Abbey, Bedfordshire 32;
Courtesy of Doris Ammann, Zurich p 146TL;
Courtesy of Thomas Ammann Fine Art, Zurich, private collection p 145R;
Tomie Arai p 182B;
Art Gallery of Ontario, Toronto, Gift from the Corporations' Subscription Fund, 1968 p 74;
Art Resource / National Museum of American Art, Smithsonian Institution, Washington, D.C. pp 42, 104B, 173, 181;
Ashmolean Museum, Oxford p 72B;
Santa Barraza p 183;
Jan Baum Gallery, Los Angeles p 187;
Bayerisches National Museum, Munich p 35;
Bibliothèque Nationale, Paris p 150T;
Birmingham Museum and Art Gallery, U.K. p 137;
Courtesy of Mary Boone Gallery, New York / Collection Ydessa Art Foundation, Toronto p 136 / Collection Museum of Contemporary Art, Los Angeles 168R;
Louise Bourgeois / Peter Bellamy p 141 / Duane Michals p 22L;
Alan Bowness, Hepworth Estate p 60B;
Bridgeman Art Library pp 4, 110R / Ashmolean Museum, Oxford, 60T / British Library, London 76T, 83 / Courtauld Gallery, London 92, 130B, 151L / Egyptian Museum, Cairo 33, 158T / Fitzwilliam Museum, Cambridge, U.K. 97L, 129 / Gemeentemuseum, The Hague 199R / Giraudon 155, 158R / Glasgow Art Gallery and Museum 165 / Graphische Sammlung Albertina, Vienna 131 / Collection of Mrs. Samuel E. Johnson 154B / Koninklijk Museum voor Schone Kunsten, Antwerp 48, 56 / Kunsthalle, Bremen, Germany 105 / Kunsthistorisches Museum, Vienna 80T, 115 / Louvre, Paris 27, 140, 158B, 166L / Manchester City Art Gallery, U.K. 25 / Musée d'Orsay, Paris 168L / Museo de América, Madrid 30L / Museo dell'Opera del Duomo, Florence 34B / National Archaeological Museum, Naples 91 / National Gallery of Art, Washington, D.C., Mellon Collection 133 / National Gallery, London 100, 135TL / National Gallery of Victoria, Melbourne, Australia 132 / National Portrait Gallery, London 134 / St. Peter's, Vatican City 63 / Orlando Museum of Art, Florida 120L / Philadelphia Museum of Art 74, 80B / private collection 95, 108L, 142L, 177 / Tretyakov Gallery, Moscow 154T / Uffizi Gallery, Florence 46, 116R, 117 / Wallace Collection, London 89;
J. E. Bulloz p 81;
Capitoline Museum, Rome pp 131T, 135BR;
Central Art Archives, Helsinki / Hannu Aaltonen p 121;
Zelda Cheadle Gallery, London p 149;
Christine Rose Gallery, New York / Renee Cox p 62;
Betsy Damon p 22R;
David David Gallery, Philadelphia / Superstock 159L;
Susan Dirk / Under the Light, courtesy of Tatistcheff Gallery, New York p 93;
Sokari Douglas Camp / Photography Peter White p 178;
Katherine Doyle p 124T;
Dumbarton Oaks Research Library and Collections, Washington, D.C. p 54;
Edimedia pp 6, 39, 57, 90, 110L, 125, 175;
E.T. Archive p 37 / Hittite Museum, Ankara 65B / Louvre, Paris 72T / Museo Correr, Venice 109 / Museum of Modern Art, New York 127 / National Archaeological Museum, Naples 78 / Victoria and Albert Museum, London 29;
Mary Evans Picture Library p 128T;
Fitzwilliam Museum, Cambridge, U.K. p 87;
Audrey Flack p 17;
Courtesy of Ronald Feldman Fine Arts, New York p 172B / Copyright Estate of Hannah Wilke. Photography Dennis Cowley 145L, 162B;
Flint Institute of Arts, Michigan / Gift of the Whiting Foundation pp 67, 32, 73;
Harmony Hammond / Photography D. James Dee p 176;
Hampton University Museum, Virginia p 41;
Mona Hatoum / Philippe Migeat p 147;
Courtesy of the Hispanic Society of America, New York p 34T;
Courtesy of Edwynn Houk Gallery, New York / Sally Mann p 163;
Howard University, The Permanent Collection, Gallery of Art, Washington, D.C. p 185;
Lin Jammet p 120R;
Robyn Kahukiwa p 59B;
Kunstmuseum Bern, Hermann und Margrit Rupf Stiftung p 139;
Photo courtesy of Suzanne Lacy p 98T;
Frances Lehman Loeb Art Center, Vassar College, Poughkeepsie, New York p 138T;

Library of Congress, Washington, D.C. p 85;
Yolanda M. Lopez p 31;
Michel de Lorenzo / Musée des Beaux-Arts, Nice p 118;
Courtesy of Luhring Augustine, New York / Janine Antoni p 167;
Margo Machida p 182T;
Courtesy of Matthew Marks Gallery, New York p 153B;
Marlborough Fine Art (London) Ltd / Paula Rego p 49;
Photograph © Mauritshuis, The Hague p 86;
Courtesy of the Estate of Aña Mendieta and Galerie Lelong, New York p 21;
Amelia Mesa-Bains p 36;
Courtesy of Metro Pictures / Cindy Sherman 151R;
Photograph courtesy of Robert Miller Gallery, New York / private collection p 51;
Moderna Museet, Stockholm pp 65T, 142R;
D. C. Moore Gallery, New York 143T;
Musée des Beaux-Arts, Strasbourg p 96;
Musées Royaux d'Art et d'Histoire, Brussels p 157;
Museo Nacional de Bellas Artes, Buenos Aires p 160T;
Museu Nacional d'Art de Catalunya, Barcelona p 77;
Museum Anna Nordlander, Skellefteå, Sweden p 67;
Courtesy of Museum of Indian Arts and Culture / Laboratory of Anthropology, Santa Fe, New Mexico /51455/13/ Blair Clark, photographer p 82B;
National Gallery of Art, Washington, D.C., Gift of Mr. & Mrs. Robert Woods Bliss p 114;
National Gallery Picture Library, London 135TC;
National Museum of Denmark, Copenhagen, Department of Ethnography, Photographer: John Lee p 179;
National Museum, Stockholm p 71T;
National Portrait Gallery, London, reproduced with permission of Curtis Brown Ltd, London, on behalf of the Estate of Dame Laura Knight. Copyright Laura Knight pp 2, 123;
National Portrait Gallery, London p 125;
Öffentliche Kunstsammlung, Basel, Martin Buhler p 113;
Photo courtesy of Pace Wildenstein, New York p 170;
The Pennsylvania Academy of the Fine Arts, Philadelphia, gift of the artist p 79;
Courtesy of Pilkington-Olsoff Fine Arts, Inc., New York p 152;
Courtesy Regen Projects, Los Angeles p 172T;
Rex Features / Sichov p 138B;
Photo RMN–R. G. Ojeda / Musée Picasso, Paris p 108R (97DE21457–1/16)
Isis Rodriguez p 111;
Courtesy of the artist and Michael Rosenfeld Gallery, New York / Photography Brian Forrest p 186;
Saatchi Gallery, London p 143B;
Saint Louis Art Museum, Missouri p 103;
Scala / National Gallery of Antique Art, Rome p 47L;
Christina Schlesinger p 174B;
Carolee Schneeman pp 19, 171T;
Courtesy of Cindy Sherman and Metro Pictures p 47R;
Courtesy of Shoshana Wayne Gallery, Santa Monica, California p 98B;
Gilbert and Lila Silverman Fluxus Collection, Detroit, Photographer: George Macunias p 171B;
Yong Soon Min p 180;
Courtesy of Galerie St. Etienne, New York p 99;
Stadtbibliothek, Frankfurt, Germany p 112;
Tate Gallery, London 1999 pp 60B, 69, 88, 119L, 161;
Richard Telles Fine Art, Los Angeles p 146B;
Courtesy Throckmorton Fine Art, New York p 52;
Through the Flower pp 50, 153T, 164, 167R, 169 / Donald Woodman 9, 11, 12, 13, 44/45, 64 (needlework by Jane Thompson), 66, 146TR, 189;
Nicholas Treadwell Gallery, London p 124BR;
Vancouver Art Gallery / Emily Carr Trust / Photographer: Trevor Mills p 58;
Victoria and Albert Picture Library, London p 82T;
Wadsworth Atheneum, Hartford, Connecticut / Gift of Mrs. Josephine M. J. Dodge p 43 / The Ella Gallup Sumner and Mary Caitlin Sumner Collection Fund 31R, 184;
Jonathan Waller p 55;
Ruth Weisberg p 160B;
Werner Forman Archive / National Museum of Anthropology, Mexico City p 28.

COPYRIGHT

ADAGP, Paris and DACS, London 1999 pp 69, 81, 110R, 132, 142L
Elizabeth Catlett / VAGA, New York / DACS, London 1999 p 41
DACS 1999 pp 50, 53, 120L, 139, 142R
Estate of Vanessa Bell, courtesy Henrietta Garnett, 1961
Estate of Gwen John 1999. All rights reserved p 119L
Willem de Kooning, ARS, NY and DACS, London 1999 p 127
Succession H. Matisse / DACS 1999 p 102T
Succession Picasso / DACS 1999 pp 95, 110L
Estate of Sir Stanley Spencer 1999. All rights reserved, DACS 1999 p 129.